D1585381

British Life Photography Awards

"…the British Life Photography Awards are a journey of discovery. They are about meeting people, going to places, getting up before dawn, going to bed too late, being out there, experiencing, learning, thinking on your feet and trying to understand how we live, work and play. They record interesting and meaningful aspects of daily life; the things that we like, and find most interesting." **HOMER SYKES**
Documentary Photographer

British Life Photography Awards

Portfolio 1

ilex

BRITISH LIFE PHOTOGRAPHY AWARDS

An Hachette UK Company
www.hachette.co.uk

First published in Great Britain in 2015 by
ILEX, a division of Octopus Publishing Group Ltd
Octopus Publishing Group
Carmelite House
50 Victoria Embankment
London, EC4Y 0DZ
www.octopusbooks.co.uk

Executive Publisher: Roly Allen
Editorial Director: Nick Jones
Associate Publisher: Adam Juniper
Senior Specialist Editor: Frank Gallaugher
Senior Project Editor: Natalia Price-Cabrera
Assistant Editor: Rachel Silverlight
Art Director: Julie Weir
Designer: Ginny Zeal
Senior Production Manager: Peter Hunt

ISBN 978-1-78157-264-1

A CIP catalogue record for this book is available from
the British Library

Printed and bound in the United Kingdom

10 9 8 7 6 5 4 3 2 1

CONTENTS

FOREWORD

I have been photographing British life for almost half a century. As a professional magazine reportage photographer during the 1970s, '80s and '90s, I was regularly on assignment for what used to be called the 'Sunday supplements' – *The Telegraph*, *The Sunday Times* and *The Observer* – as well as weekly news magazines, such as *Time*, *Newsweek*, *New Society* and *Now!*

During this time I travelled widely, working on news stories both at home and overseas, covering politics, conflict (and its aftermath), and stories about the people of Britain – the 'haves' and 'have nots' that make British life and society for me so interesting. Along with these magazine assignments, I always had my own documentary projects on the go, many of which were turned into books.

For a documentary photographer, the British Life Photography Awards are a journey of discovery. They are about meeting people, going to places, getting up before dawn, going to bed too late, being out there, experiencing, learning, thinking on your feet and trying to understand how we live, work and play. They record interesting and meaningful aspects of daily life; the things that we like, and find most interesting. More importantly, many of these pictures – including those published in this book – will live on forever, as a lasting visual record of the times we live in.

There has never been a better time to be recording Britain. Village life and rural society have changed, and the urbanisation of the countryside marches on. The landscape – once a haphazard patchwork of fields and pastures, bounded by ancient hedgerows, stonewalls and green lanes, ribboned together by streams and rivers – now so often encompasses the unedifying suburban sprawl that so many of us live in. As it gathers pace, modern executive dormitory estates pepper once-tranquil rural communities and new garden cities are setting down roots.

However, as old ways evolve (and some traditional aspects of our society die), so new customs are born, due to our ever-evolving multicultural society that sees new traditions, customs and ways of doing things brought to these islands by new Britons. Many cities are now teeming (filled almost to bursting point one sometimes thinks), yet others suffer seemingly terminal cultural and industrial decline.

British life is always changing. The digital age has democratised our love affair with photography, so what matters now is that you are out photographing the world around you; making more and better pictures of this land we live in.

HOMER SYKES
Documentary Photographer

INTRODUCTION

I have long felt that photography of 'British Life' has been a neglected area. Photographers besiege photo editors with requests to shoot stories in all corners of the globe, in search of 'amazing', 'enlightening' and 'incredible' images of faraway places. At the same time, my inbox is full to overflowing with photo features from Indonesia to Iceland, via the Arctic Circle.

Yet there is a wealth of photographic material sitting right here at home, and the various categories in the British Life Photography Awards are testament to that. The photographs we have seen are broad and diverse, and reveal layers of life that speak louder than any words about our country. From cream teas in Sussex to the brooding skies of Scotland, or the streets of London to Cotswold villages, a dry sense of British humour permeates many images. We are not that far removed from Bert Hardy's Blackpool Belles – the knotted hankies and 'knobbly knees' competitions may now be a thing of the past, but a sense of simple delights bringing laughter and a wry look at life is still a pleasure to observe.

So, rather than look overseas for potential material, I urge the huge number of incredibly talented photographers out there to stay at home and shoot stories that we know are just waiting to be made.

CAROLINE METCALFE
Director of Photography, Condé Nast Publications

ABOUT THE BRITISH LIFE PHOTOGRAPHY AWARDS

Welcome to the first portfolio of the British Life Photography Awards.

It has never been easier to capture images of our lives, wherever we go, creating photographs that we share and treasure. These photographs illustrate our memories and reflect the way we are, yet at the same time they are also a chronicle and snapshot of our time and society; beyond the personal memories they invoke, they document and communicate our life.

The inspiration for these awards is the renewed interest in photography that has been enabled by digital technology, along with a desire to revive a greater awareness of documentary photography. Whether thought-provoking, illuminating, poignant or humorous, this is a celebration of photographs that capture the very spirit and essence of British life – spontaneous, original and arresting images of our nation and people.

Documenting daily life has been a tradition for over a century, so just like the great documentary photographers of the past (and present), we want to encourage photographers to elevate the commonplace and familiar into something compelling or fascinating through the craft, creativity and discipline of photography. Whether it's a personal vision, an intimate portrait, a visual pun or a sequence of innovative images telling a story, it has been a great pleasure to see such varied work from both amateur and professional photographers from all walks of life.

I hope you get as much joy and interest out of this portfolio as myself and the judges.

MAGGIE GOWAN
BLPA Director

The aim of the awards:

- To showcase contemporary and imaginative images that capture the spirit of British life.

- To revive an interest in documentary and reportage photography.

- To highlight the relevance and importance of photography in raising awareness and informing about social issues.

- To inspire and motivate young people to develop a passion for photography.

For further information about the annual competition and exhibition, visit:
www.blpawards.com

Categories

Overall Winner

Young British Life Photographer

Rural Life

Urban Life

Street Life

Work in the Community

Brits on Holiday

Portraiture

Fashion

British Weather

Historic Britain

Documentary Series

With thanks to:

All the photographers who have participated in the awards, as well as the sponsors, supporters and judges

Matthew Chatfield
Website Manager, Facilitator and Chair of the Judging Panel

Carl Crawley
Website Lead Developer

Clare Webb
Technical Adviser and Manager

Victoria Skeet
Assistant Judge and Administrator

Jennie Hart
Assistant Judge and Administrator

Venetia Khan
Exhibitions Manager

Rebecca Moran
Social Media

Charlotte Salaman and Chris Hart
Design

This first portfolio is dedicated to David and Brenda Gowan, for their eternal inspiration and support and a household brimming with art and photography books.

THE JUDGING PANEL

LARA JADE

ADAM JUNIPER

JASON KEENE

DAVID LEVENSON

DANIEL LEZANO

JAEL MARSCHNER

CAROLINE METCALFE

SARA RUMENS

HOMER SYKES

VICKY WILKES

LARA JADE
Photographer

Whether it's her personal work, a commercial campaign or an editorial project, Lara's images contain an underlying sense of narrative that is "inspired by film noir, old masters in painting and photography, Romanticism and untouched beauty". In 2011, Lara moved from the UK to New York City, and now divides her time between the US and Europe, working for clients such as Goldsmiths, Littlewoods, Nanette Lepore, *Harrods Magazine*, *The Observer* and *Elle Singapore*.

ADAM JUNIPER
Associate Publisher, Ilex Press

With two decades of publishing experience, Adam is the Associate Publisher at Ilex Press, which has achieved an international reputation as a publisher of high-quality illustrated books. Ilex's photography titles that have sold many millions of copies and been translated into more than 25 languages in the company's 14 year history. Adam also runs ilex.photo, one of the largest publishers of creative photography eBooks, and every day he's developing photographic talent to share their skills in print, online and on video.

JASON KEENE
Area Sales Manager, Sony

Jason has 25 years' experience in the photography industry, initially in a retail background where he experienced the transition from manual to autofocus and film to digital. Jason took a sales role within wholesale photographic supply and then the photographic processing industry, but for the past six years he has been part of Sony's Digital Imaging division. During this time, Sony has introduced a broad range of professional and amateur cameras, bringing innovative technology to a wider audience.

DAVID LEVENSON
Photographer

David has been a photographer since he left school, learning his craft at Fleet Street press agency Fox Photos. He then moved to Keystone Press, covering news stories around London, including the Iranian Embassy siege, the Brixton riots and the early days of Lady Diana. Throughout the 1980s David specialised in photographing Princess Diana and the Royal Family. He now works with editorial and corporate clients such as the National Trust, AELTC, RSC, Legatum Institute, Heritage Lottery Fund, Getty Images and Bloomberg, shooting documentary style reportage.

DANIEL LEZANO
Editor, *Digital SLR Photography* magazine

Daniel has worked on photography magazines since the mid-1990s. After a short spell at *EOS* magazine he worked at *Practical Photography* as technical writer and later technical editor, before leaving to launch *Photography Monthly*, where he was editor until 2006. He has since been involved in launching *Digital SLR Photography* magazine, where he is currently the Editor. Daniel has sat on the judging panel of a number of national and international photography competitions, as well as regularly judging entries to competitions run by his magazine.

JAEL MARSCHNER
Group Picture Editor, *Time Out*

Most of Jael's work at *Time Out* focuses on researching, commissioning and art directing photography for the magazine, but it also includes website imagery, travel guide photography and stints on *Time Out New York* magazine. In the past she has been the Picture Editor for *The Sunday Times Travel Magazine* and worked on the *Evening Standard Magazine* Picture Desk. Jael has always had a keen eye for striking imagery and has worked with some of biggest photographers in the business. However, she is also always on the lookout for new talent.

CAROLINE METCALFE
Director of Photography, *Condé Nast* Publications

Caroline has worked at *Condé Nast Traveller* magazine since its launch in 1997. In this time, the magazine has won countless awards for its distinctive photography, covering lifestyle, food and drink, portraiture, interiors and stunning locations and landscapes. Caroline has also worked on many advertising campaigns and has been a judge on several of the most prestigious photographic competitions in the world including Travel Photographer of the Year, Sony World Photography Awards, Lord Mayor of London 2012 Olympic Photography Awards, Azerbaijan Through the Lens, and the John Kobal Portrait Award, amongst others.

SARA RUMENS
Consultant Editor

For the past 20 years, Sara has helped shape editorial photography, most recently as picture editor on *Grazia*. Prior to this, Sara spent seven years as editorial director of Magnum Photos, the world's foremost photographic agency, and also worked in New York on publications including *Rolling Stone* and *Interview Magazine*. She has previously sat on judging panels for the Ian Parry Award, the Observer Hodge Award and the Irish Press Awards.

HOMER SYKES
Documentary Photographer

Homer Sykes is a documentary photographer whose work spans almost five decades. He is known for his work for the 'weekend colour supplements' and has shot numerous magazine portraits of the famous – and not so famous – at home, at work and at play. Homer is the author (and co-author/photographer) of eight books about Britain, and in 2002 he set up his own self-publishing concern, Mansion Editions. To date Mansion Editions has published *On the Road Again* and Hunting with Hounds.

VICKY WILKES
Picture Editor, *Country Life* magazine

Vicky has worked on the *Country Life* picture desk for five years, having previously been at *The Saturday Telegraph Magazine*. Commissioning and researching high standard photography is key to a picture editor's role and Vicky is always on the look out for new photographers and different styles of photography that will compliment *Country Life*. Vicky has a strong passion for the British countryside and the people who call it their home.

SPONSORS

SONY

Sony is a global leader in photography, with a comprehensive range of digital cameras from compact and bridge to interchangeable lens models. The premium RX series, with ZEISS® lenses, large CMOS sensors and beautiful compact design ensure each image has razor-sharp detail, while the palm-sized α7 combines portability with capability in a landmark full-frame camera body that's half the weight of leading DSLRs. Whether you're taking a photo of friends at a picnic, your baby's first step or an unforgettable sunset from atop Mt. Kilimanjaro, there's a Sony camera that makes it easy.

Kristal Digital Imaging is Surrey's premier professional processing laboratory. This family-run, independent business was established in 2003, and its continued investment in the most up-to-date equipment ensures the highest quality results. With an ever-growing product range that includes standard photographic prints, photo books, acrylic panels and much more, Kristal strives to develop products that will keep existing customers and attract new clientele.

SUPPORTERS

Condé Nast Traveller

Condé Nast Traveller is home to award-winning journalism, travel writing and photography, taking its readers to destinations off the beaten track, both home and abroad. As Britain's best-selling, upmarket, monthly travel glossy, the magazine provides inspiration and advice for discerning travellers looking for unique travel experiences. The most authoritative and influential travel and *lifestyle magazine in the world, readers turn to Condé Nast Traveller* for an edited choice of the world's best restaurants, hotels, spas, shops, museums and adventures.

ilex

In 11 years of publishing under its own imprint, Ilex Press has made itself the essential voice for creatives everywhere. Its first books were manuals for digital and web designers, and remaining true those origins, Ilex continues to publish in this sphere. Its offerings have since been enriched by a comprehensive photography list, acclaimed illustrated biographies, exciting interactive titles, professional reference, and a unique stationery and gift line. What all these books share is a commitment to creative excellence, and to the highest standards of writing, editorial, design and production.

Digital SLR Photography

The UK's leading digital SLR focused publication, catering for all abilities from beginners through to professional photographers. *Digital SLR Photography* aims to enthuse, educate and inform readers, through high quality insightful content written by photography experts. With a blend of news, features and detailed reviews, *Digital SLR Photography* provides an unparalleled resource for the UK's ever-growing photography fraternity.

COUNTRY LIFE

Since its launch in 1897, *Country Life* has been the world's most celebrated magazine of the British way of life; its countryside, properties and gardens. Its matchless authority, exquisite photography and world-class writing have ensured its position as one of the nation's truly great magazines. *Country Life*'s readers have always sought the best things in life, from food and antiques to the finest properties and estates.

Time Out London

Time Out is the ultimate insider guide for inspiring you to keep up and join in with all that's new and best in your city.

Founded by Tony Elliot, in London in 1968, *Time Out* has grown into a global media group that spans 70 cities across 37 countries with a monthly combined audience in excess of 33 million people.

No one knows the city better than *Time Out*. The business is uniquely positioned to provide the platform and marketplace for inspiring people to make the most of their own city. This is achieved through a distribution network that includes a growing online presence, mobile applications, magazines, events and partnerships.

OVERALL WINNER

→ DAVID YEO / WINNER

Vroom with a View
Tewkesbury, Gloucestershire

This quintessentially British caravan reflects all that is good about the British countryside. Its wallpapered interior makes it amazingly quirky, while the girl looks out of the window. The caravan shelters under a blossoming horse chestnut tree, which adds to the many shades of green around it.

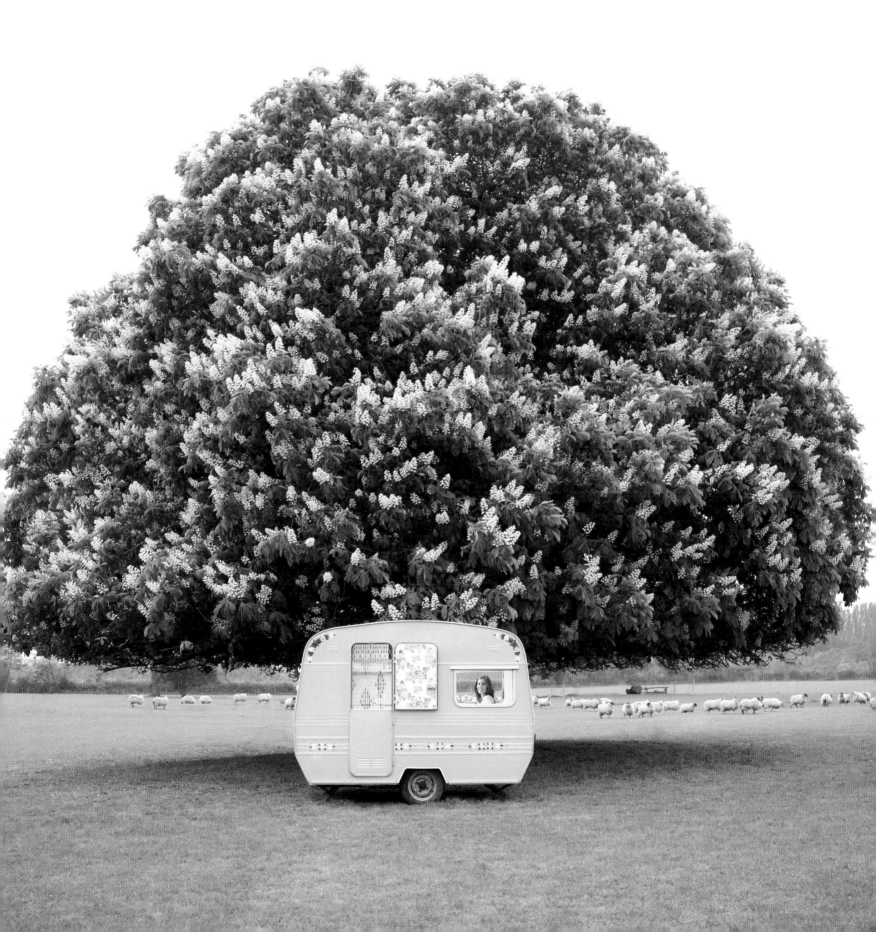

YOUNG PHOTOGRAPHER AWARD

→ ELLA TURVILLE / WINNER

Lord of the Flies
Brighton, East Sussex

This is a close-up of my brother on Brighton beach. The photograph came about when he found this stone and came running over to show me. I didn't have my camera in my hand at that moment, but asked him to repeat his unusual pose so I could take this shot using flash.

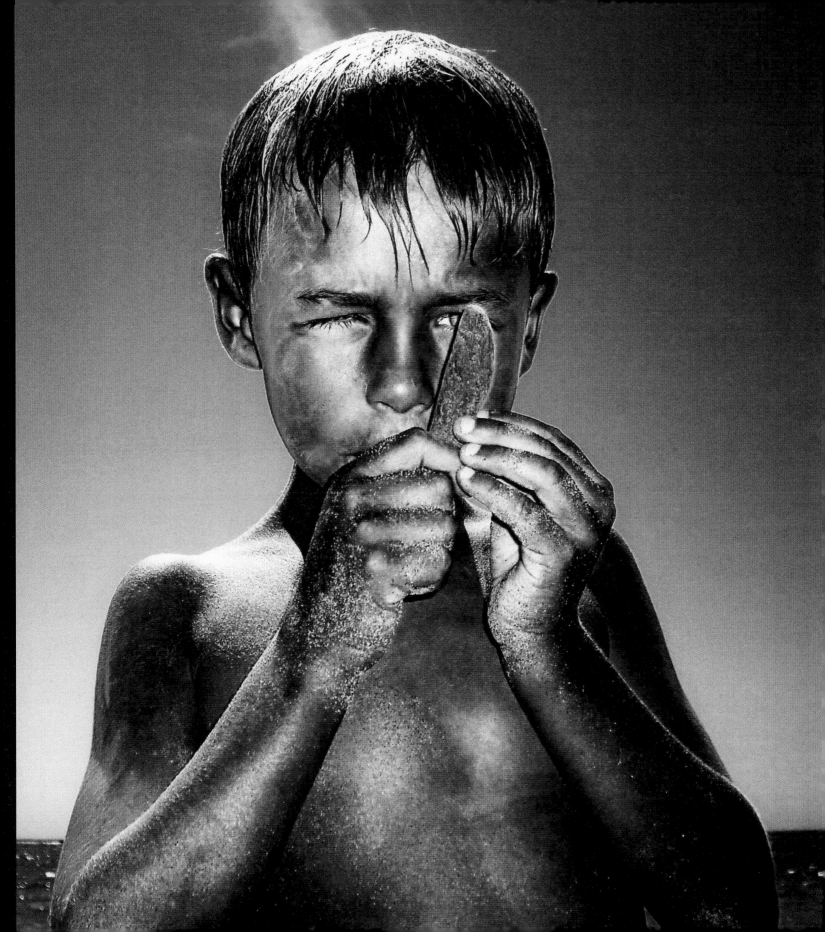

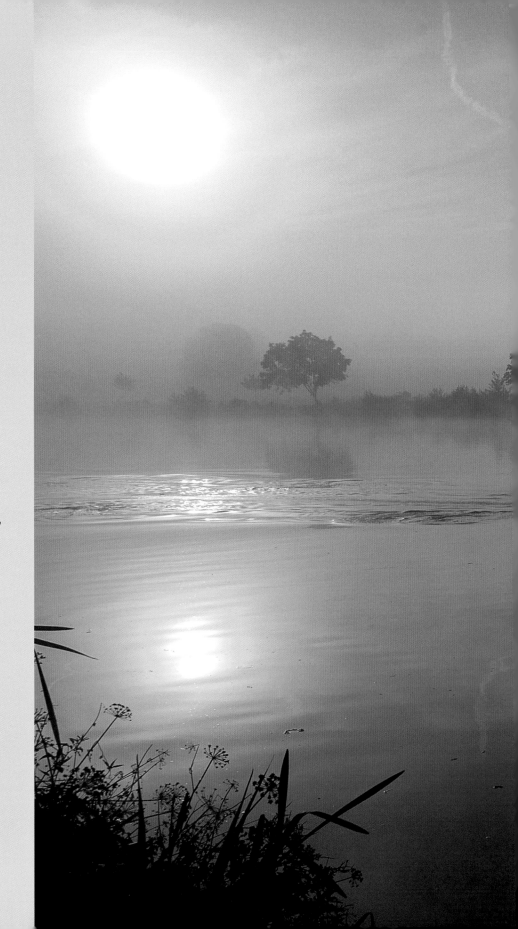

1

RURAL LIFE

Rural Life covers all aspects of life within the villages and small communities outside our towns and cities.

It captures the relationship between people, the land and the coast, including agriculture, farming, fishing, local trade, country fairs, crafts, events, traditions, customs, culture, sport and leisure.

JIM DONAHUE / WINNER

Early Morning Rowers
Henley on Thames, Buckinghamshire

I wanted to capture an atmospheric image of early morning rowers on the River Thames for a book I am working on about Henley life. I took advantage of the morning mist that is common in early autumn. I first tried shooting from the Berkshire side of the river, but found the mist was too heavy to see rowers clearly. I moved to the Buckinghamshire side and by then the conditions brightened enough to create this image.

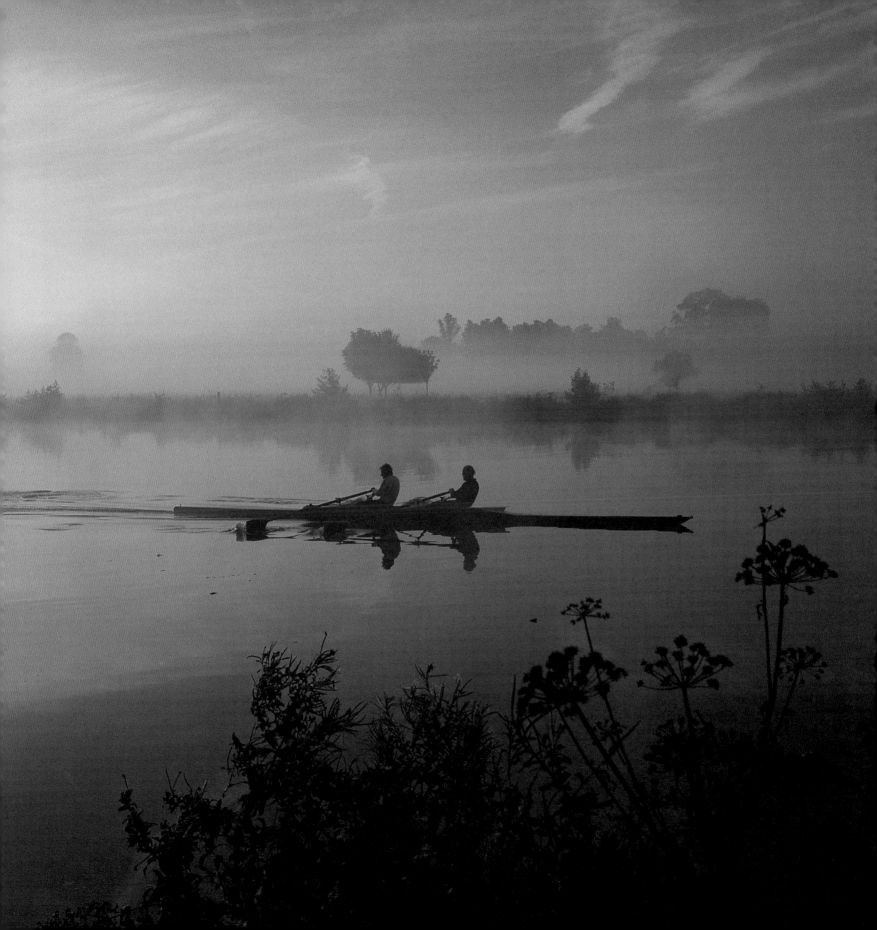

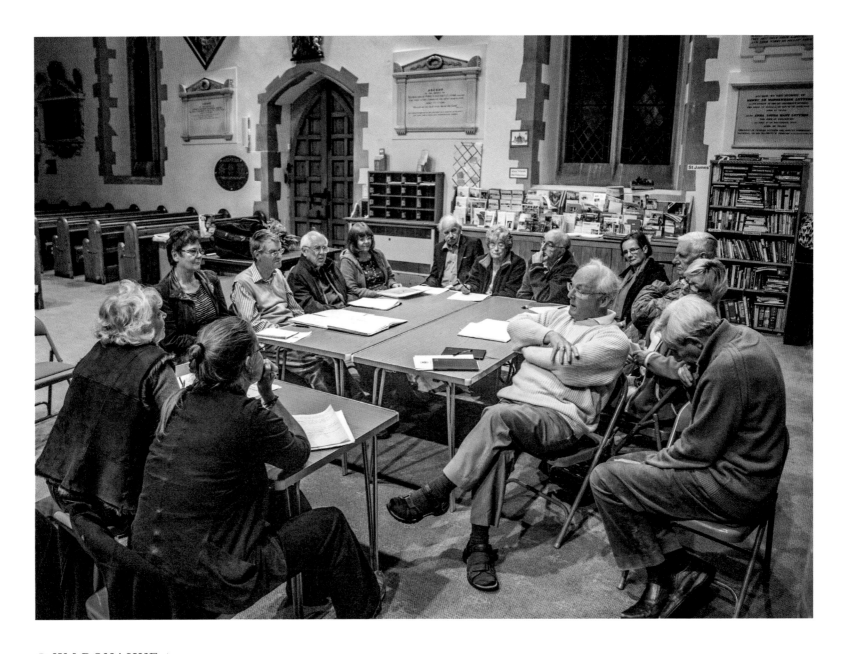

⊕ JIM DONAHUE / HIGHLY COMMENDED

Pangbourne Historical Society
St James Church, Pangbourne, Berkshire

I wanted to capture village life in Pangbourne, which includes
many volunteer groups. This is the Pangbourne Historical Society's
AGM, where they were debating (among other things) who should
have the task of being the chairman for the next year. I like the fact
that this image captures the seriousness with which they are taking
the subject.

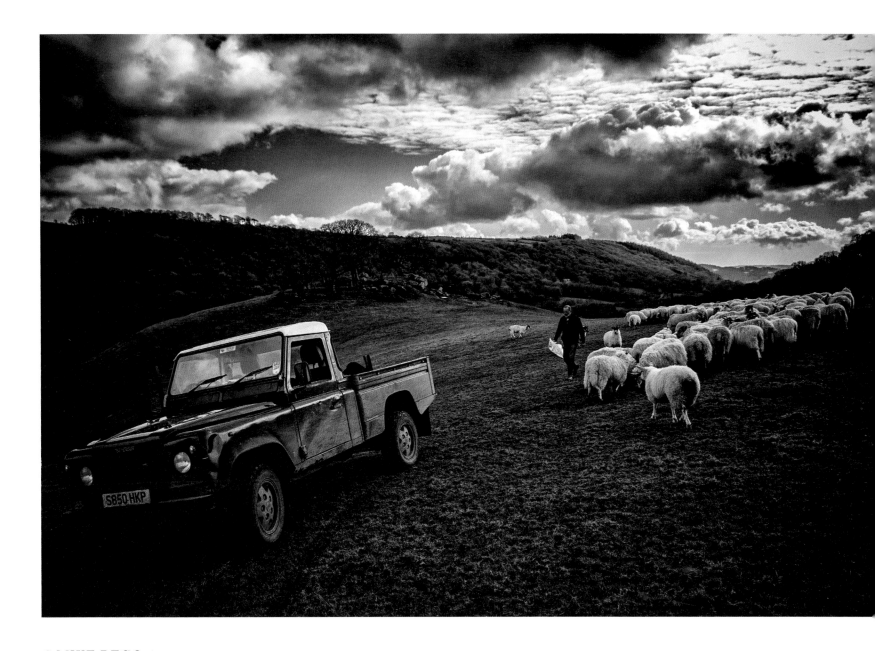

⊕ MIKE REGO / HIGHLY COMMENDED

Tom Hunt Feeding His Sheep
Wray Barton, Dartmoor, Devon

This is farmer Tom Hunt feeding his sheep on a crisp and
bright spring morning. With the sun shining directly up the
valley, I positioned myself to capture both Tom's Land Rover
and the sheep, balancing the contrast in the foreground with
the high contrast of the sky.

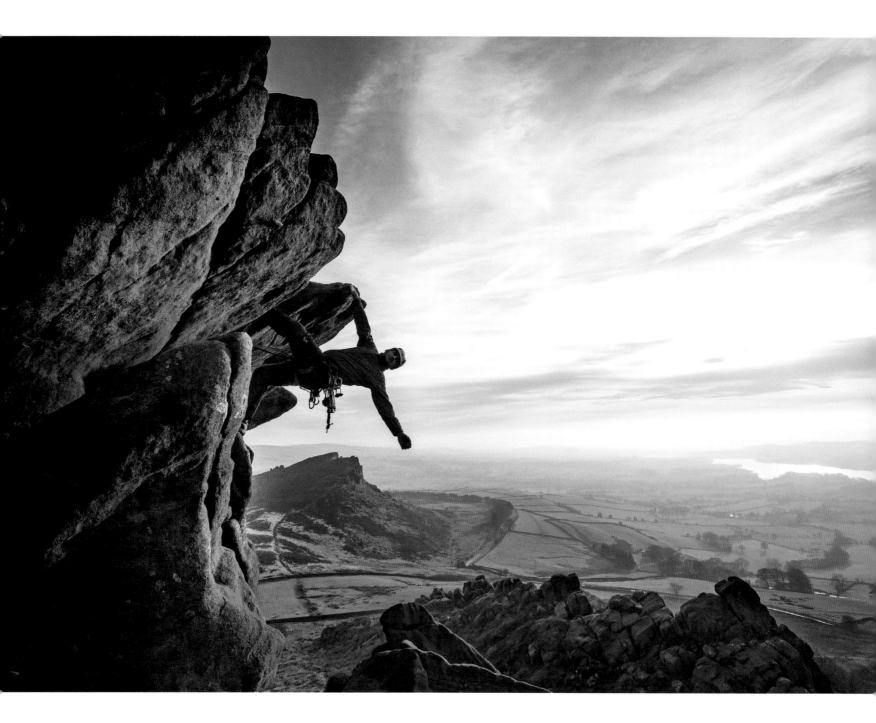

⬆ ROY RILEY / HIGHLY COMMENDED

Climbing at the Roaches
The Roaches, Staffordshire

A climber hangs off the side of the
Roaches in Staffordshire as the winter
sun goes down over the county.

→ CHRISSIE WESTGATE

HIGHLY COMMENDED

At the WI Hall
Mersea Island, Essex

This is our local Women's Institute Hall, which typifies rural living. The piano has seen better days, the flowers are plastic, and our lovely Queen is surrounded by a faded red velvet frame. The curtains, carpeted walls and overhead electric heater round it all off.

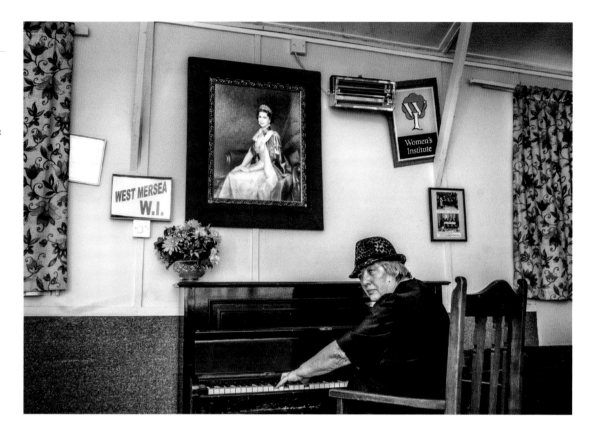

→ MIKE REGO

HIGHLY COMMENDED

Beating the Bounds
Easdon Down, Dartmoor, Devon

During the Diamond Jubilee celebrations in 2012, a group of villagers met up to picnic and 'beat the bounds' on some of the parish boundary stones on Easdon Down, Dartmoor. All of the children were competing to be chosen to be 'bumped' on the stones, making it difficult to get an unobstructed line of sight. The curiosity of the little boy framed in the background shows just what a strange custom this is.

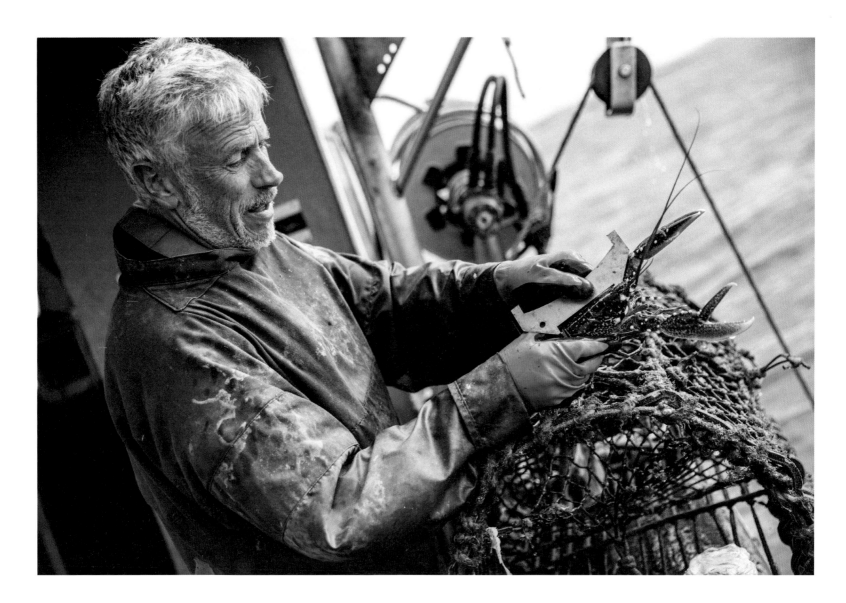

↑ SAEED RASHID / HIGHLY COMMENDED

Catch of the Day
Lyme Bay, Dorset

I had been working with Lyme Bay Fisheries and Conservation Reserve, who work with local fishermen to reconcile the needs of the environment and the industry. I went out with Aubrey Banfield to capture a day in his life, sailing from West Bay on the Dorset coast on a bright sunny day in May. This image sees Aubrey checking his catch to ensure the lobsters are of legal size to land.

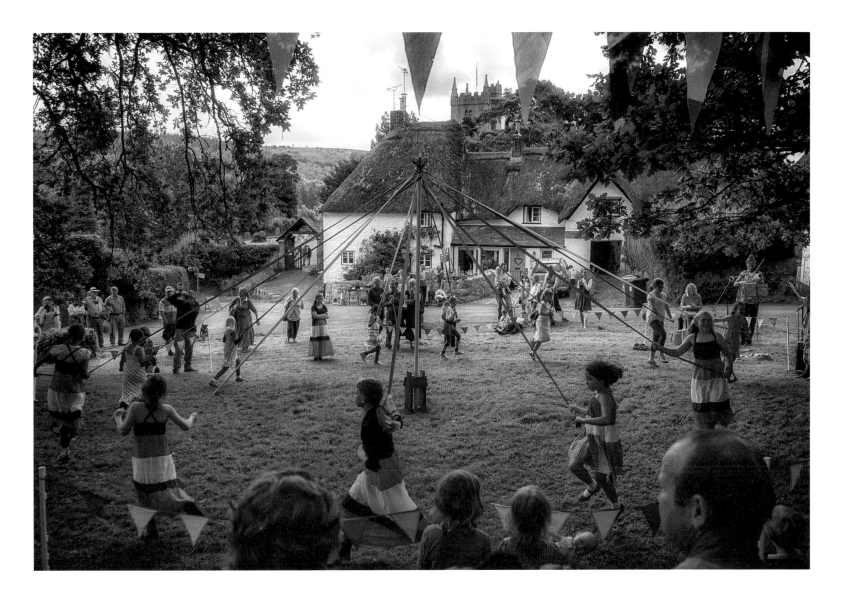

● MIKE REGO / HIGHLY COMMENDED

Maypole Dancing Display
North Bovey, Dartmoor, Devon

Local children celebrate the Queen's Diamond Jubilee by
demonstrating their maypole dancing skills on the village green
(or 'plaistow' as it was once known). It was a slightly overcast
day and the weak, direct sunlight and contrasting foreground
shadows made the exposure difficult. I overcame this by using
a stepladder to reduce the amount of sky in the frame and alter
the perspective. This provided a less chaotic composition, with
the bunting and audience framing the scene.

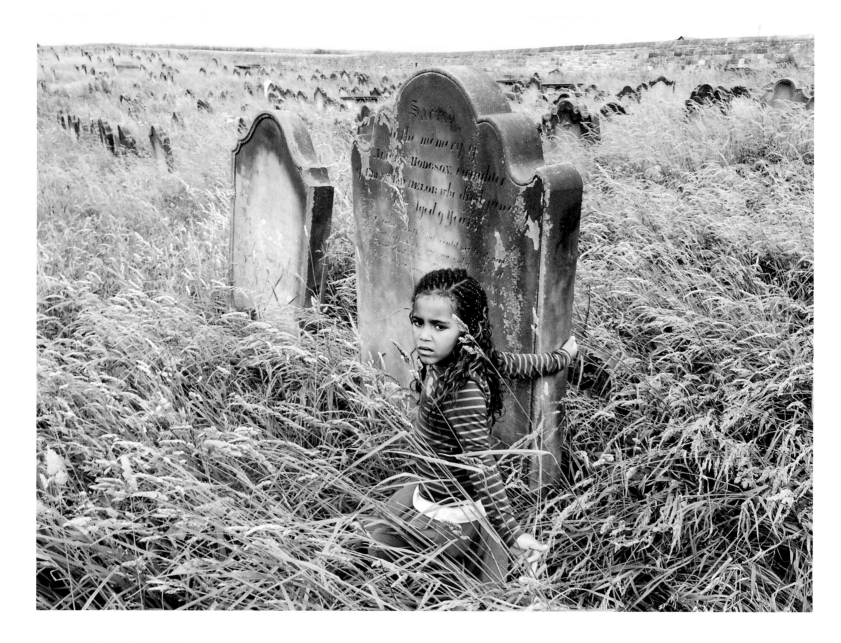

⊕ KARYN PICKLES / HIGHLY COMMENDED

Loss
Whitby, Yorkshire

This is our adopted daughter, Tarike, who lost her biological mother when she was eight months old. In Ethiopia, Tarike means 'the history / longing to be blessed with a child from God'. Tarike was desperately wanted, but sadly her biological mother died. Knowing her mother has a grave, Tarike asked me: "Mummy, is this Mummy Addis's gravestone?" With camera in hand at that exact moment, I captured her longing and complete feeling of loss.

HEATHER BUCKLEY

Goodwood Revival
Goodwood, West Sussex

A couple at the Goodwood Revival, 2014; a colourful event where just about everyone dresses up.

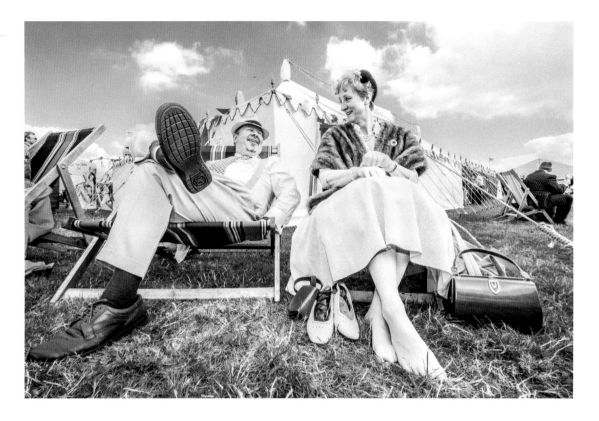

JIM DONAHUE

River Singers at Henley Festival
Henley on Thames, Berkshire

Henley Festival takes place the week following the Henley Royal Regatta, using the grounds and facilities set up for the regatta in early July. It features big-name music acts, as well as a variety of visual and performing artists. As the river is central to Henley life and the regatta, these floating singers (with some impressive Henley riverside mansions in the background) represent the atmosphere well.

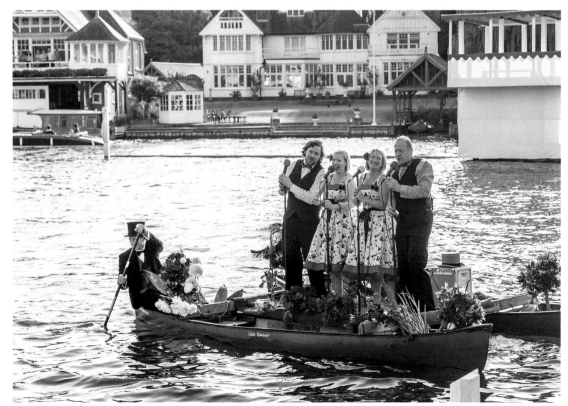

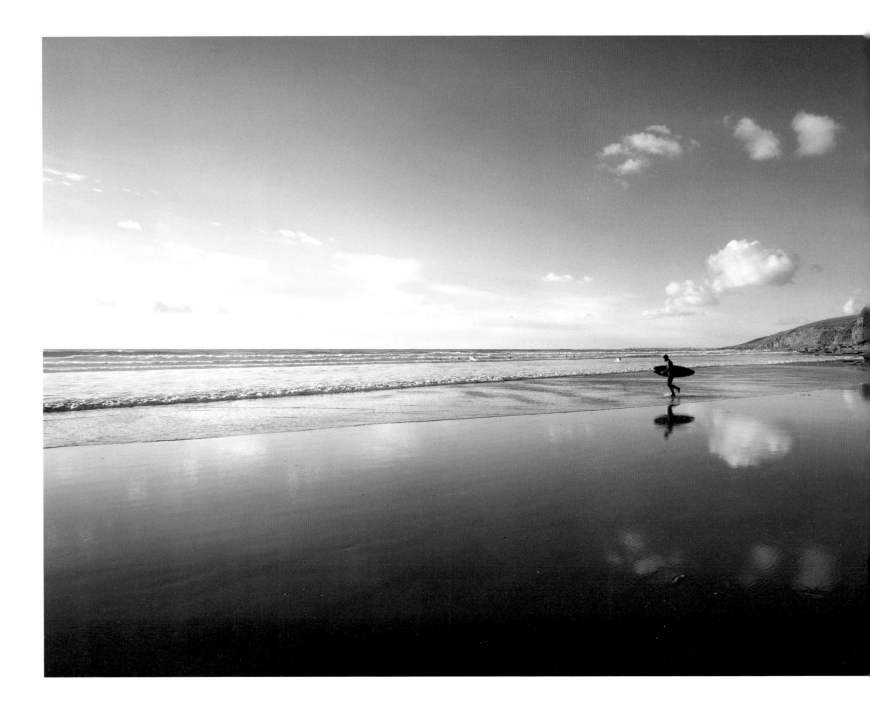

⬆ NIGEL PUGH

Run the Wheel
Southerndown Beach, Vale of Glamorgan

It was November and the sky was dotted with random clouds,
mirrored on the beach. I saw an order occur, forming a circle
of clouds, and timed this shot when the surfer entered the ring.
I felt the circle – unseen by the surfer – contributed to his motion.

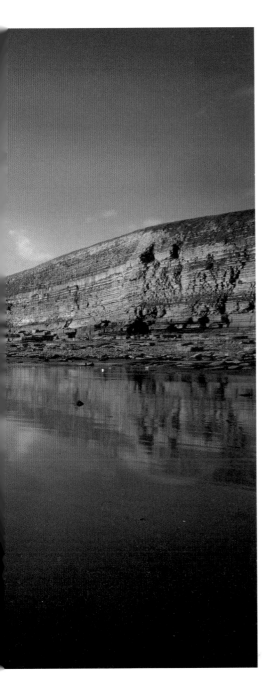

JONATHAN BUISSON

Brighton Morris Men at the King's Head
King's Head Inn, The Green, Bledington, Chipping Norton, Oxfordshire

These are the Brighton Morris Men dancing in the traditional Cotswold style during Ducklington Morris' Day of Dance. During the day, six Morris sides visit various pubs to dance. Being a dancer myself helps me follow the moves for the best action shots.

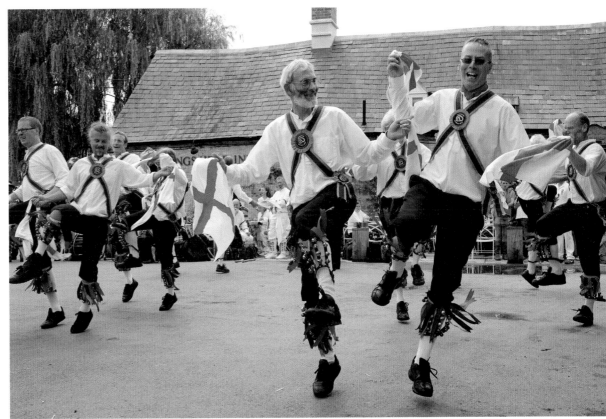

⊙ HEATHER BUCKLEY

Tea at Birling Gap
Birling Gap, East Sussex

Tea with Chantal Lonsdale at Birling Gap
tea rooms after walking the dogs. I love
playing with foreground and background
perspective in my photographs.

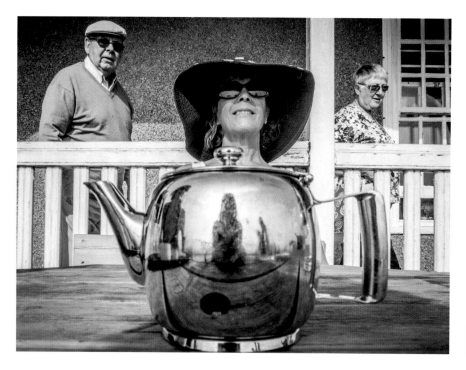

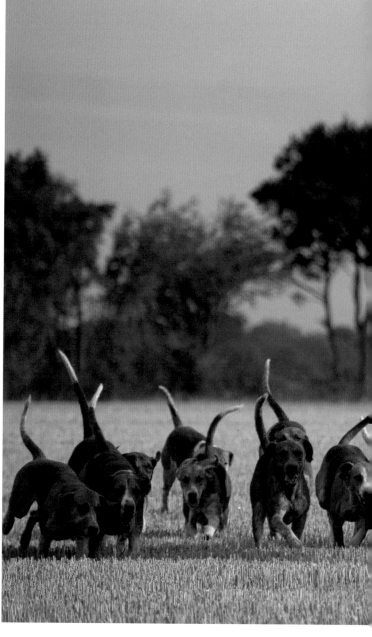

⊙ PAUL MACNEIL

Morning Exercise
Essex

Hounds from The Essex Hunt with huntsman Robert on a cubbing
exercise. It was a beautiful clear morning and the stubble field made
the scene look as though it could be the Serengeti. I love the various
forms this group takes when exercising – this is my favourite from
a series of photographs.

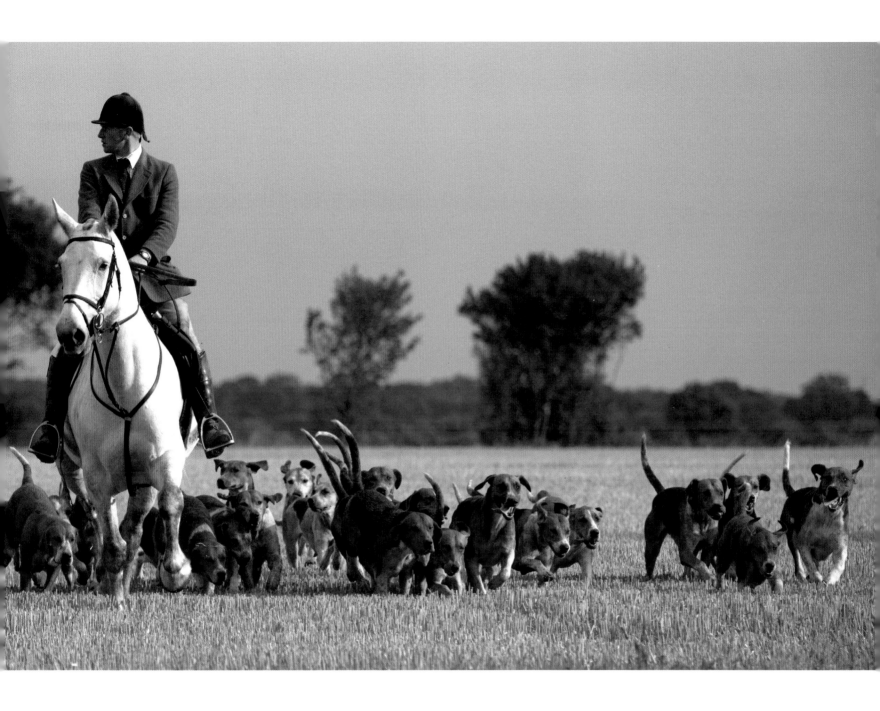

2
URBAN LIFE

Architecture and the built environment are an integral part of urban society, conveying mood, atmosphere and history.

Against this backdrop are events, festivals and the conflict of old and new customs and cultures. This is the *Urban Life* that illustrates our towns and cities at work.

TERRY WOOD / WINNER

The Shard in Winter
London

It was a cold, crisp day in winter 2013. I was walking along Cheapside in the City of London when I glanced left and discovered the glassy blue Shard appearing like an upturned icicle between City buildings. The low clouds gave the building a mesmeric, almost Alpine appearance.

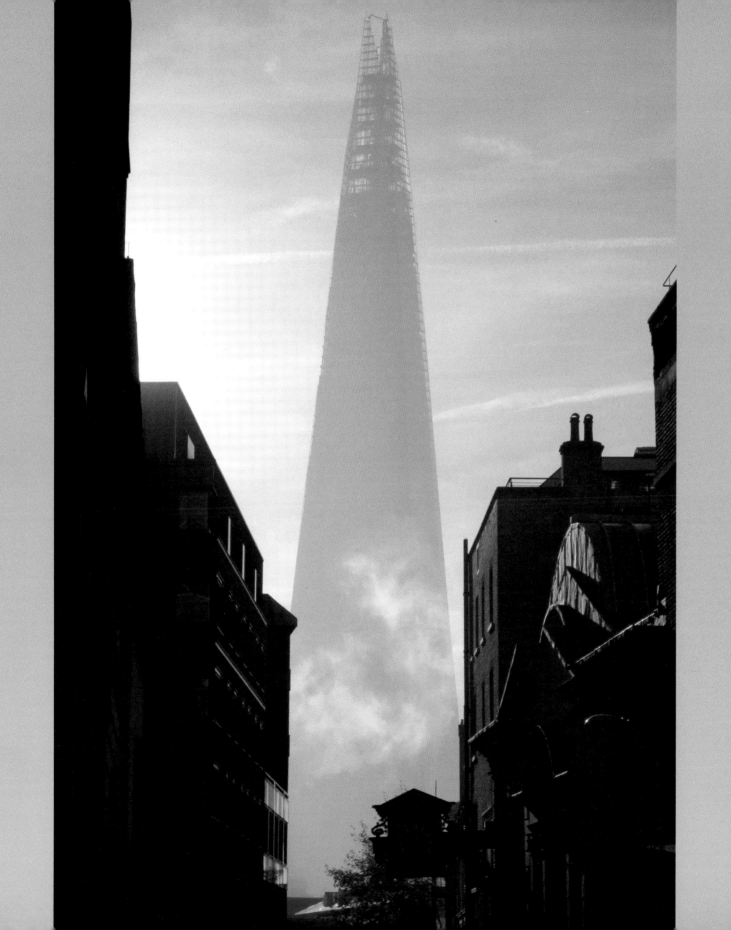

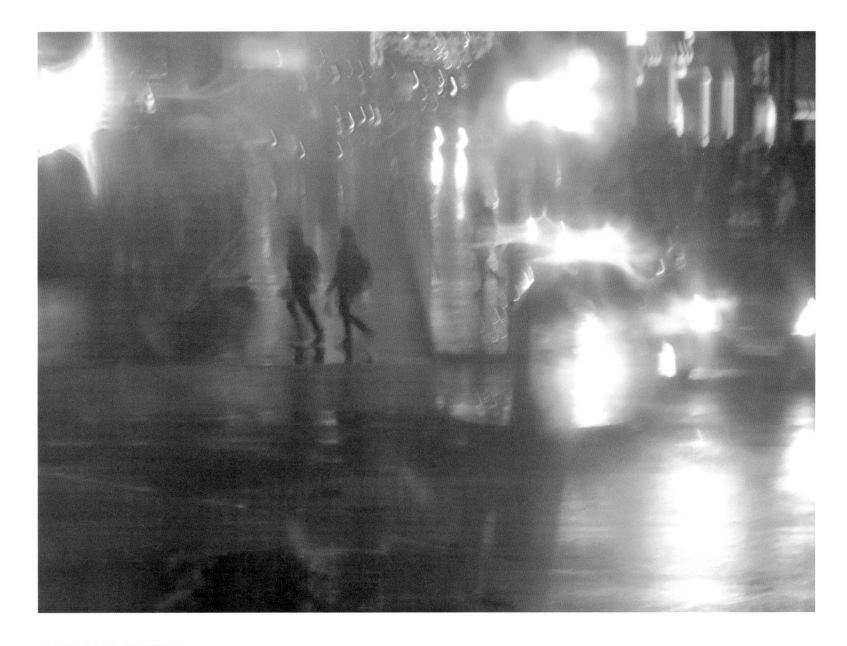

What Do You Give Someone Who Has Everything?
Oxford Circus, London

This is part of a series I am working on called 'Dirty Pictures'.
These photographs are usually taken through a window, often
in bad weather and often from a moving platform (I took this from
the top deck of the 159 bus to Streatham at Christmas). I take quite
a few photographs like this and try to layer the image with elements
such as reflections. Sometimes the image comes through, but other
times it doesn't – it's more about how one sees and experiences
an environment.

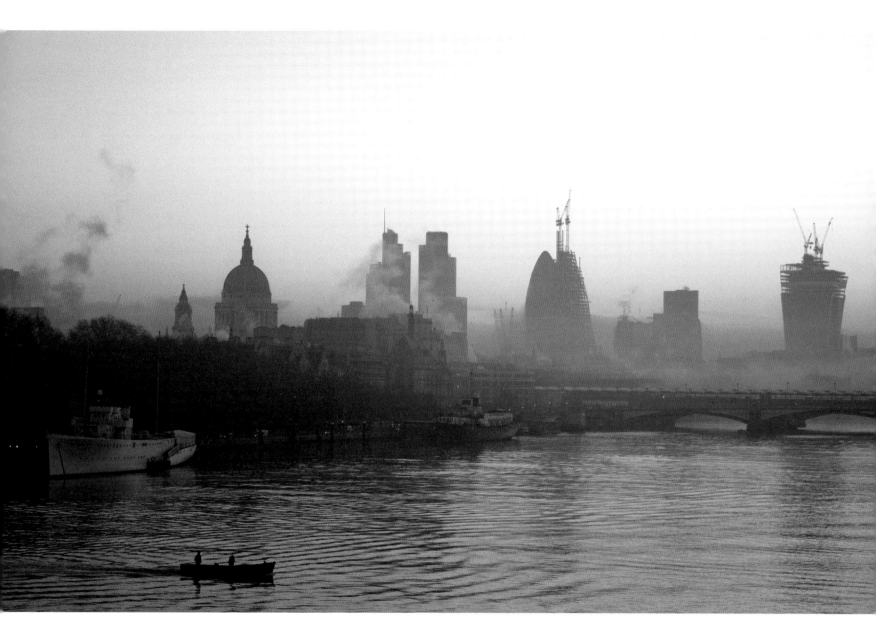

⊕ JOHN GREENE / HIGHLY COMMENDED

Misty Thames
River Thames, London

I was walking to work on a cold and frosty February morning,
and as I crossed Waterloo Bridge I was met by this very special
view. The early morning light, the silhouetted London landmarks
and the wisps of steam rising off the buildings captivated me.
I remember I wasn't wearing gloves and as a result my hands
were stinging with the cold.

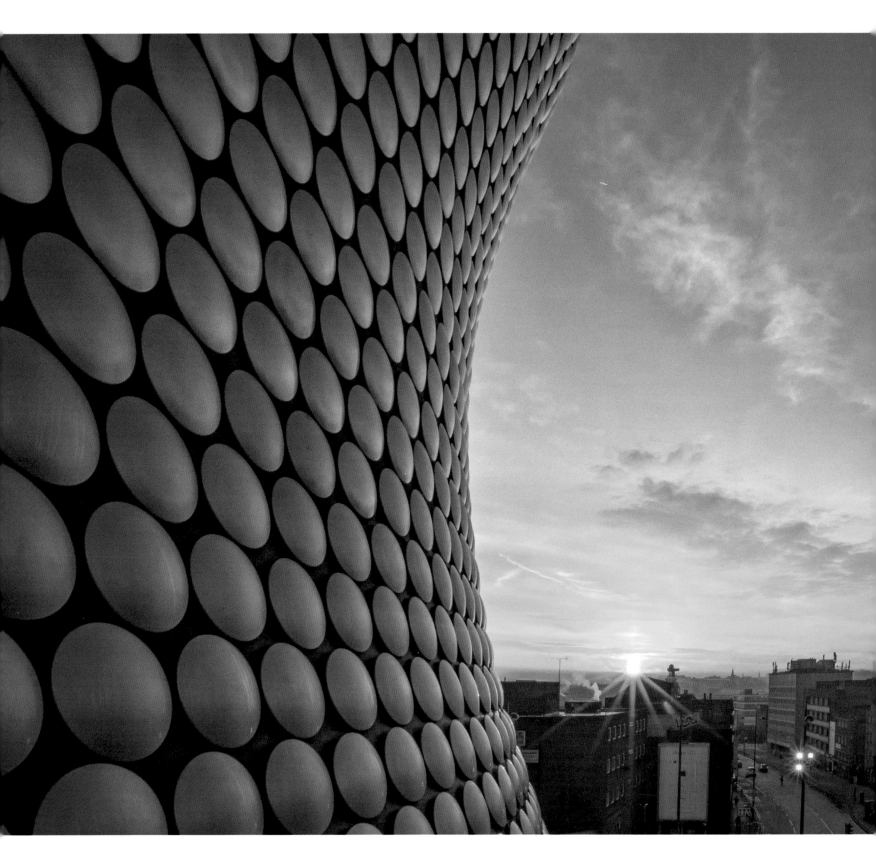

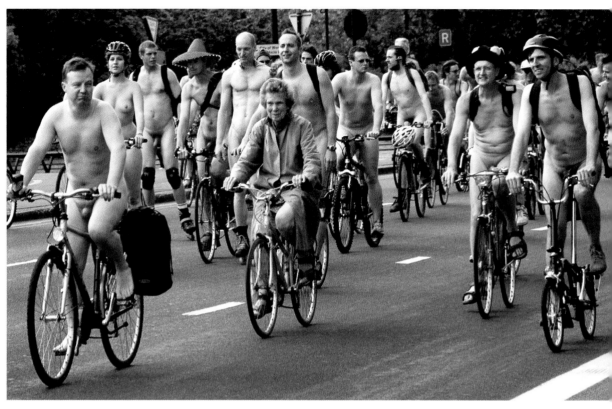

⬆ JANINE WIEDEL / HIGHLY COMMENDED

As Bare as You Dare
Park Lane, London

The second annual World Naked Bike Ride. The aim of the event was to protest against our dependency on oil, as well as to celebrate the power and individuality of the human body. Today, over fifty cities around the world take part, drawing attention to cycling as an environmentally friendly form of transport.
 The following year, the woman at the centre of the shot felt reassured enough to leave her clothes behind.

⬅ VERITY E. MILLIGAN / HIGHLY COMMENDED

Selfridges at Sunrise
Selfridges Building, The Bull Ring, Birmingham,
West Midlands

I woke early to the promise of fog and wandered the quiet streets of Birmingham. The fog started to lift as the sunrise glowed behind, and I made my way to the iconic Selfridges building. By chance, the sun peeked just above the fog as I arrived, allowing me to capture the fog and sun combined.

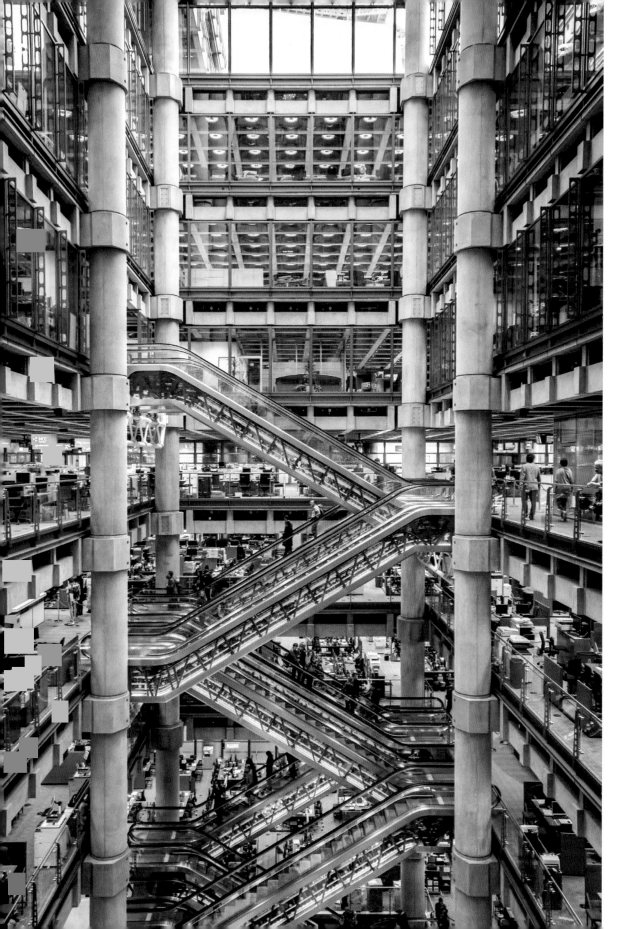

JAMES RIDER
HIGHLY COMMENDED

Temple to Capitalism
Lloyd's Building, London

The Lloyd's building is one of the most iconic skyscrapers in London. Home to the Lloyd's insurance market, it is centred around this vast, 60-metre high atrium – a powerful temple to capitalism. Although normally closed to visitors, this image was taken during the annual Open House London festival when many of London's great buildings are opened to the public. With all the desks empty it had a strange, desolate atmosphere.

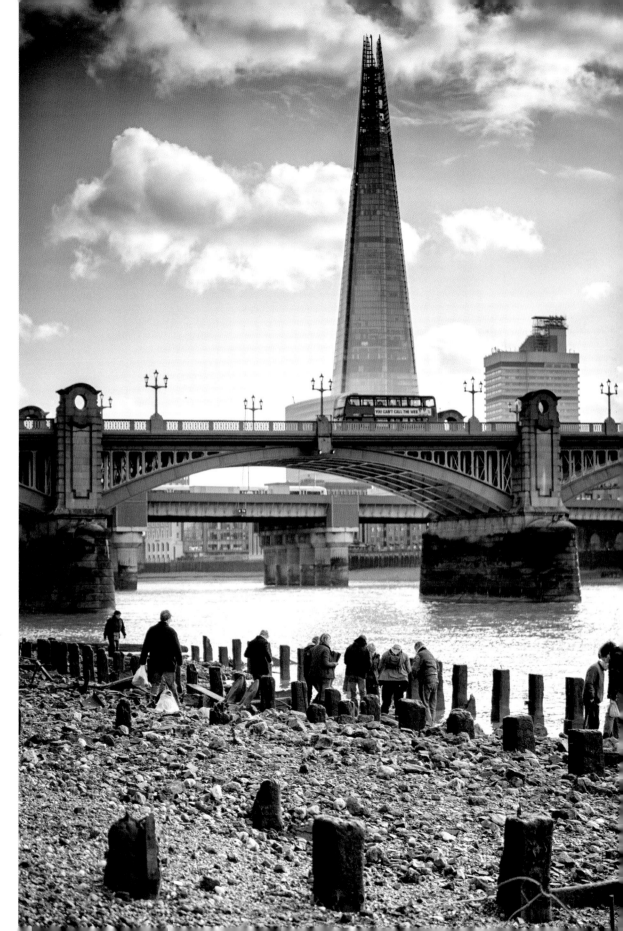

LOUIS DAVID BERK

Modern Mudlarks
Thames Bank, London

The River Thames at low tide is possibly one of the best free attractions in London. The beach is strewn with Victorian clay pipe stems, broken pottery, ironmongery, animal and even human bones, all churned up by the tide.

Here, modern mudlarks scavenge the river mud for treasure, emulating the foreshore industry of the Victorians. I shot this with a wide aperture to give it a softer, 'dreamy' effect, as if looking back in time.

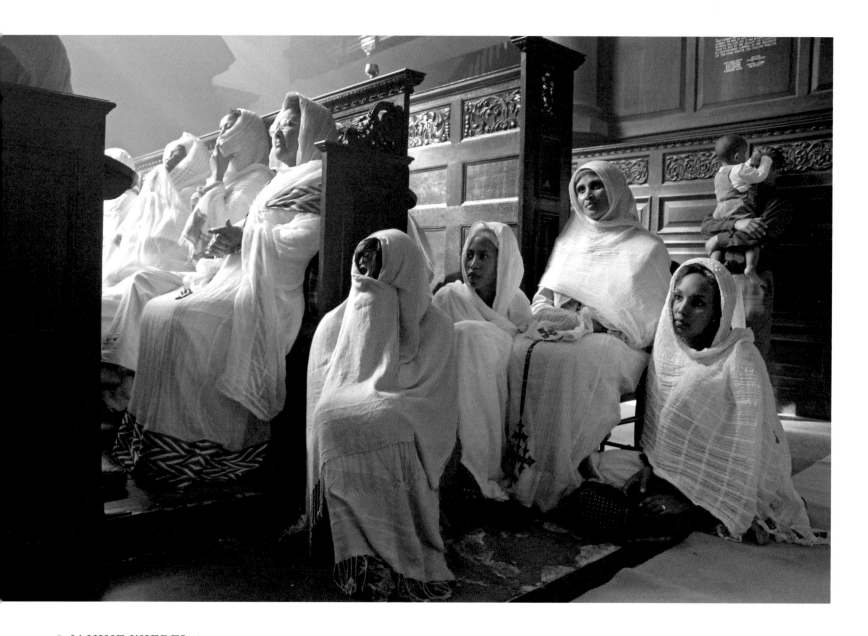

⊕ JANINE WIEDEL / HIGHLY COMMENDED

St Mary of Zion
St Mary of Zion, the Ethiopian Orthodox Tewahedo Church,
London

This photograph was part of a project I did on the Rastafarian
community in London. Many Rastas are members of the Ethiopian
Orthodox Church. The photographs were taken barefooted and
veiled, and as silently as possible during a five-hour service.

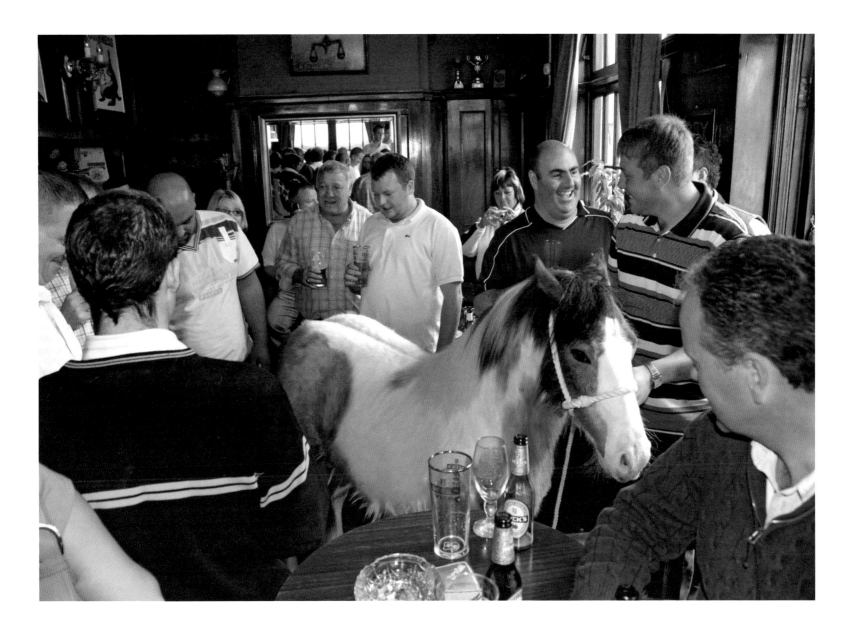

⬆ JANINE WIEDEL

Flanagans Pub
Battersea, South London

A piebald Welsh Cob pony drinking in
Flanagans pub in Battersea, during the
annual horse-trading event that takes
place over the May Day weekend.

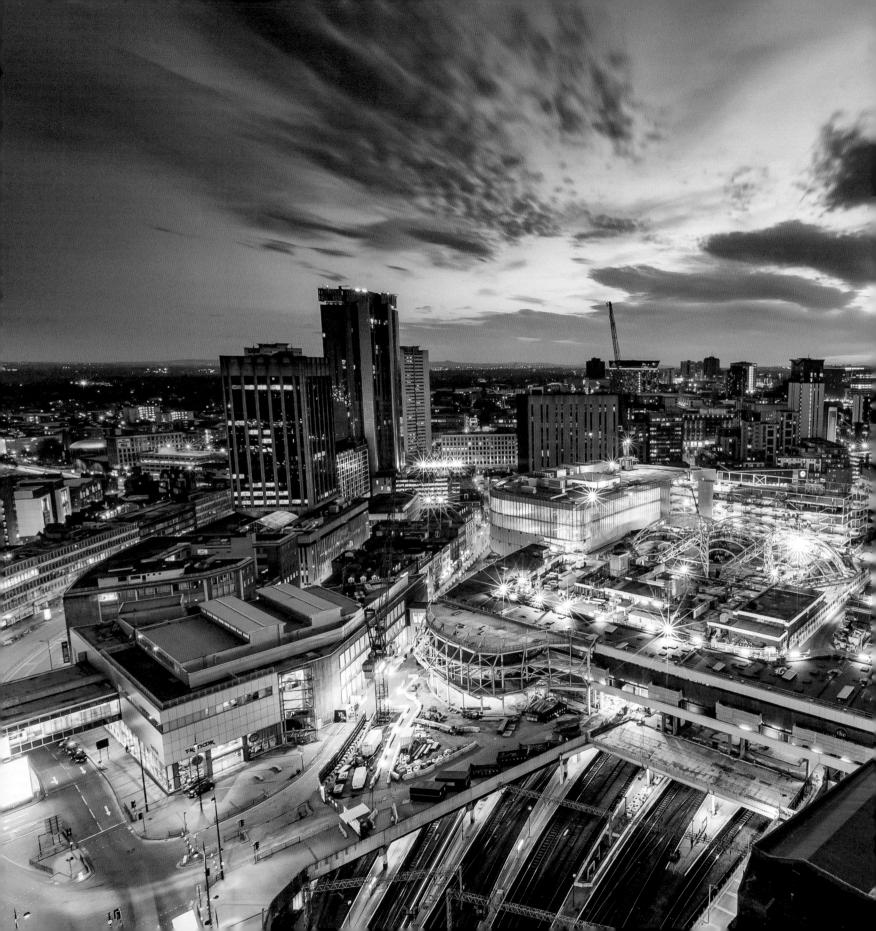

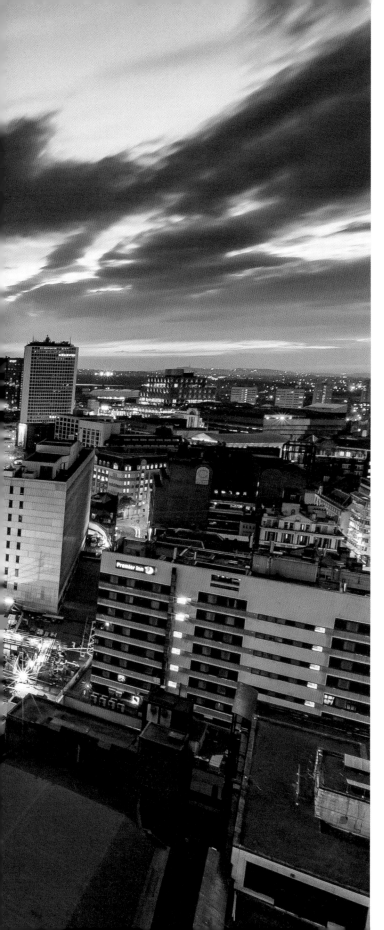

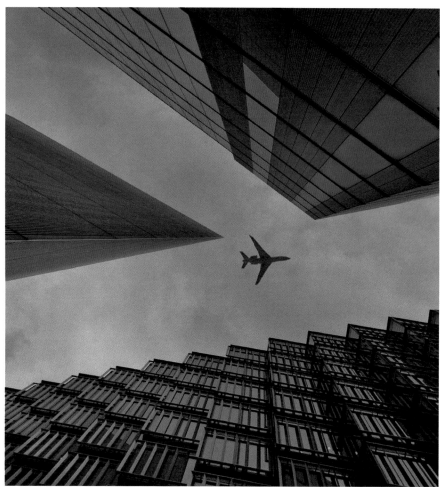

⬅ VERITY E. MILLIGAN

Birmingham at Twilight
Birmingham City Centre, West Midlands

I was standing on top of Birmingham's Rotunda building, looking out across the changing city as the sun began to set and dusk approached. As the light faded, the city began to light up, especially the New Street development directly below. At that moment the sprawling expanse of urban life was in full view.

⬆ ANSA GOHAR

Plane Amidst the Giants of More London Riverside
More London Riverside, London

I took this while looking up at the office buildings at More London Riverside, as a plane passed by. I only had my phone with me, but loved the symmetry of the architecture and the 'blue mood'.

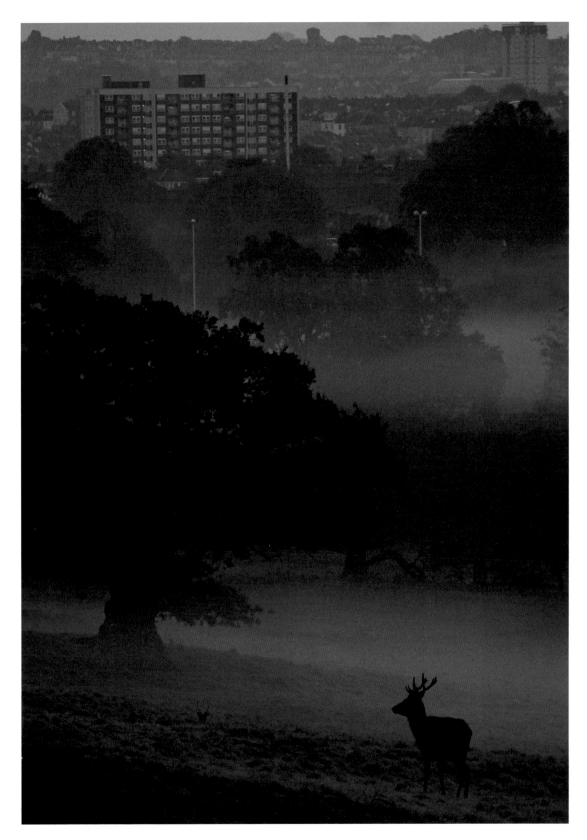

On the Edge of the City
Ashton Court, Bristol

I was walking through Ashton Court early one autumn morning with my camera when I stumbled across this red deer. The contrast between the wild animal and the built-up city in the background really tells a story about nature and urbanisation.

GEORGE PARFITT

**A Present Day Perspective
of Industrial Britain**
Newcastle upon Tyne, Tyne and Wear

This photograph shows the High Level
Bridge in Newcastle upon Tyne, which
was designed by Robert Stephenson
during the latter stages of the Industrial
Revolution. I have been told that although
the engineer would have applied basic
structural principles when designing
the bridge, the only way to truly test its
stability was for someone to drive across
it in a train.

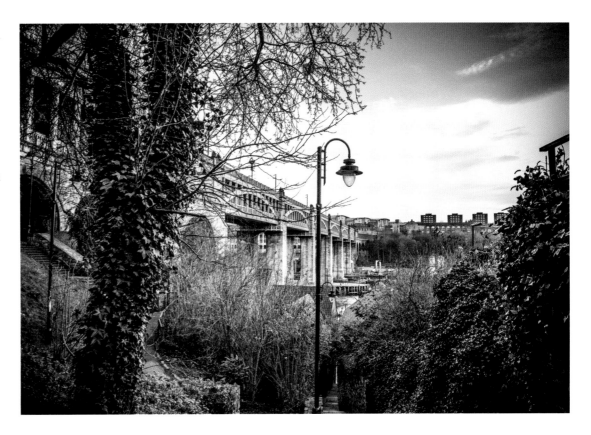

DAVID HOFFMAN

Anarchy
City Hall, London

Anarchist protests outside City Hall
as the results of London's Mayoral
election are awaited.

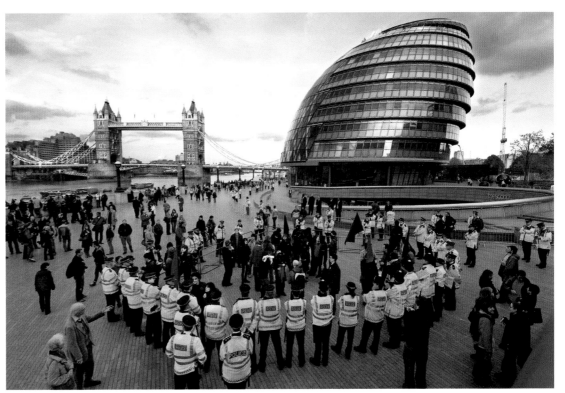

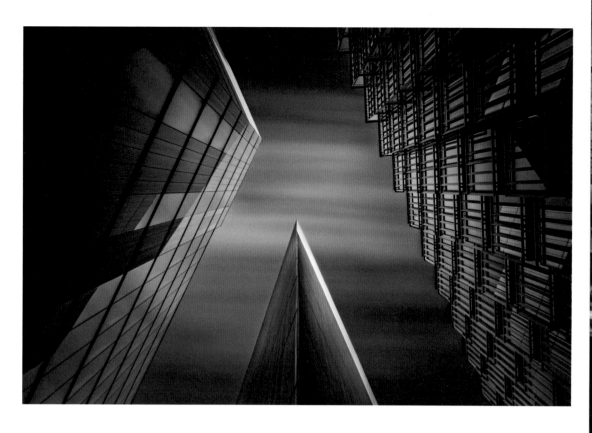

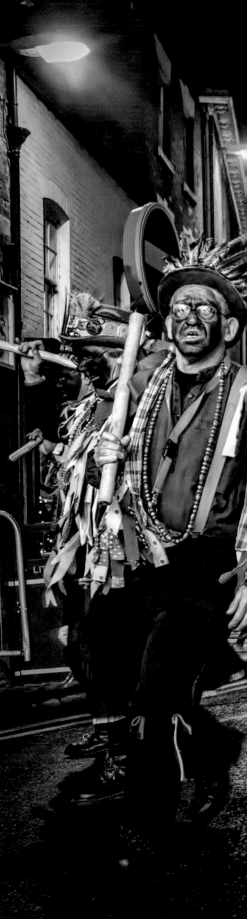

⬆ NAOUFAL SELMANI

The Rise
More London Riverside, London

The striking architectural design of
More London has enhanced the London
skyline, with its glass-sided structures
maximising the light and river views.

I worked in the area for three years
and went back to take a photograph that
represented my experience. Each building
represents a year, with the moving clouds
representing time and the reflected light
representing the moment I was enlightened
and realised I needed to move on.

➡ ED PHILLIPS

Warwick Victorian Evening
Warwick, Warwickshire

This is Plum Jerkum, Warwick's own
mixed Border Morris side, performing
at the town's annual Victorian Evening.
Freezing the action required a high ISO
setting and I also added flash, which
I bounced off the face of a nearby building.
Sitting in the road to shoot from a low
angle also helped give a feeling of being
'part of the action'.

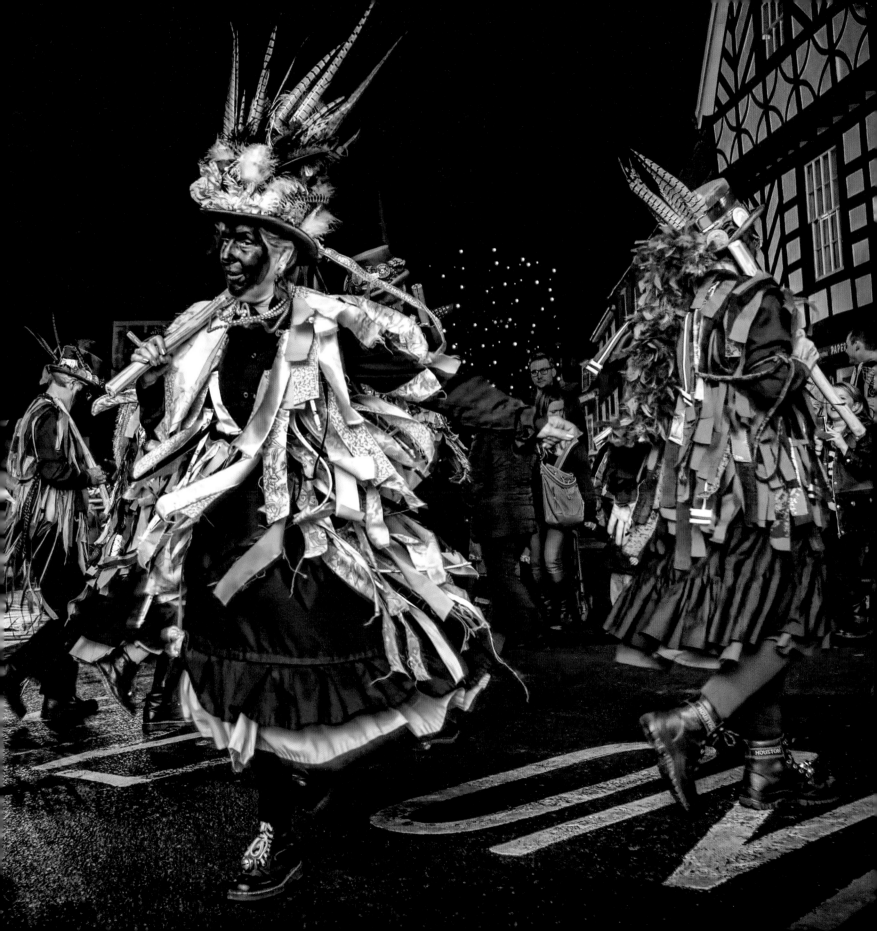

3

STREET LIFE

Candid images of everyday life on
the street, be it a crowded market,
a city park or lively café culture.

Street Life provides us with a true
reflection of people from all walks
of life within our multicultural and
cosmopolitan society.

⊙ LINDA WISDOM / WINNER

Yellow Rain
Maida Vale, London

I took this from my apartment window.
I often look out when it rains, as I love
the reflections – moody weather and
umbrellas feature a lot in my work! I
never really paid much interest to the
yellow-painted grid on the road until
this man walked past with his umbrella
in the right place at the right time.

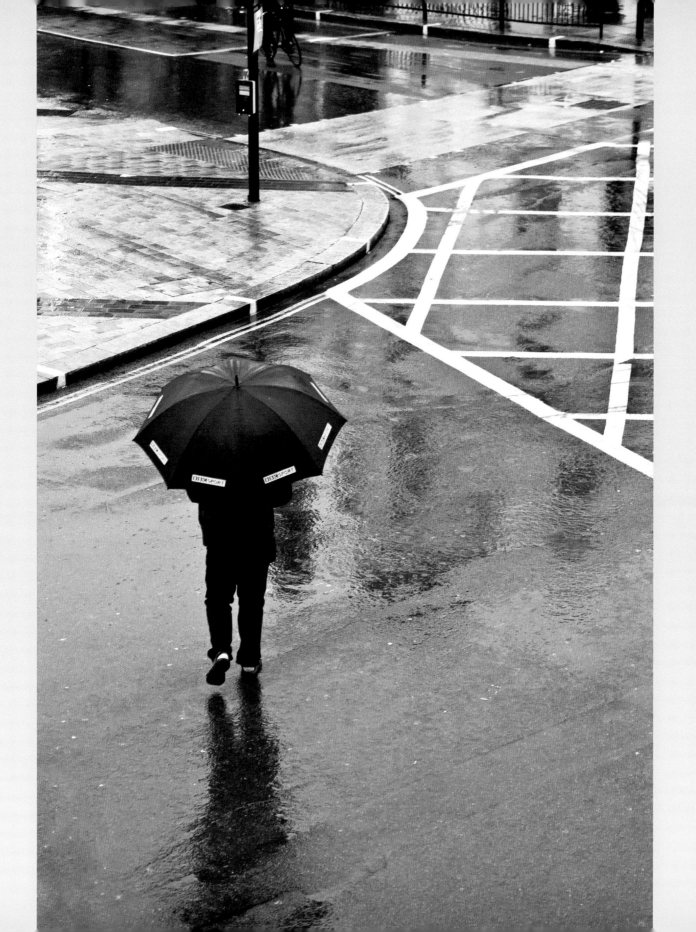

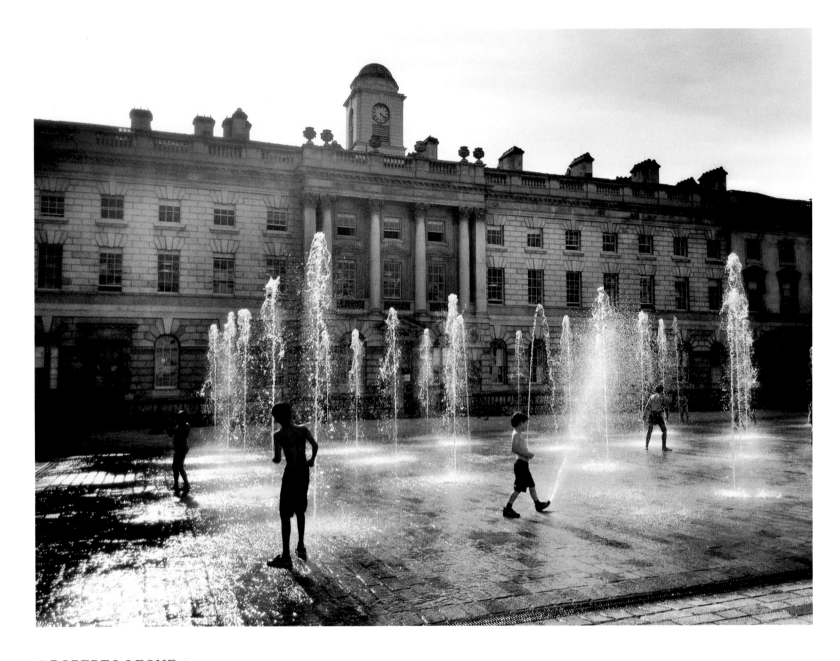

⬆ ROBERTO LEONE / HIGHLY COMMENDED

Summer in the City
Somerset House, London

The summer of 2013 was a scorcher. Here, kids kicked off their
shoes and shirts, and an austere courtyard was transformed into
a water park.

⬆ GERARD COLLETT / HIGHLY COMMENDED

Orange, White and Blue
Victoria Station, London

When I caught sight of two identical heads of orange hair from the other side of the station, I made the conscious decision to miss my train to take this shot. I was amazed to discover that the women were not only dressed identically, but drank and applied makeup in almost perfect synchronicity. I am an identical twin myself, so feel a certain affinity towards twins if I see them in the street!

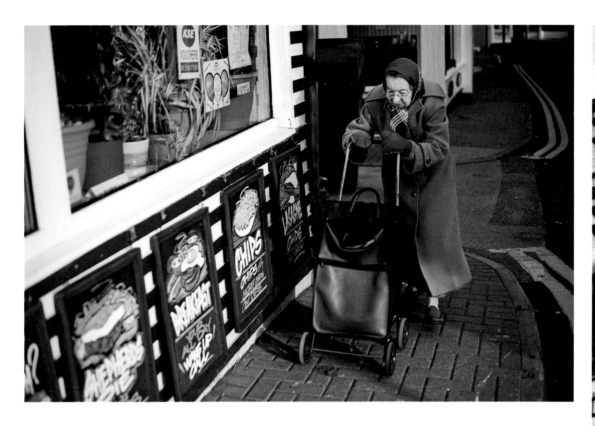

⬆ XUESONG LIAO
HIGHLY COMMENDED

A Trolley Is My Best Companion
Broadstairs, Kent

It was a cold winter morning when
I photographed this lonely old lady
pushing her shopping trolley past
a fish and chip restaurant in this
seaside town.

➡ SIMON PEACOCK
HIGHLY COMMENDED

Untitled
Oxford Circus, London

We are surrounded by beauty. It's there
in the unnoticed and the overlooked;
a fleeting expression or moment of
spontaneity. Blink your eyes and it
is gone. Forever.

My subjects are strangers. As
photographs, they become my friends.
I move quickly, seizing the moment to
capture people candidly, naturally –
as I see them.

Oxford Circus is a vibrant and
busy place, full of energy and vitality.
I will often shoot at the same spot.

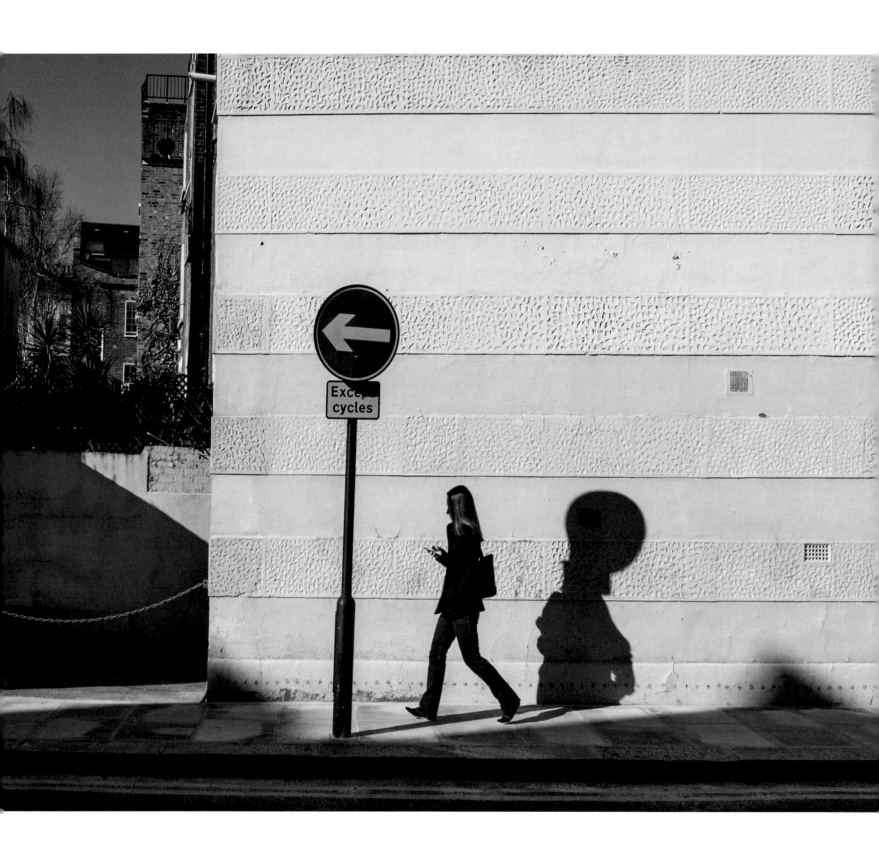

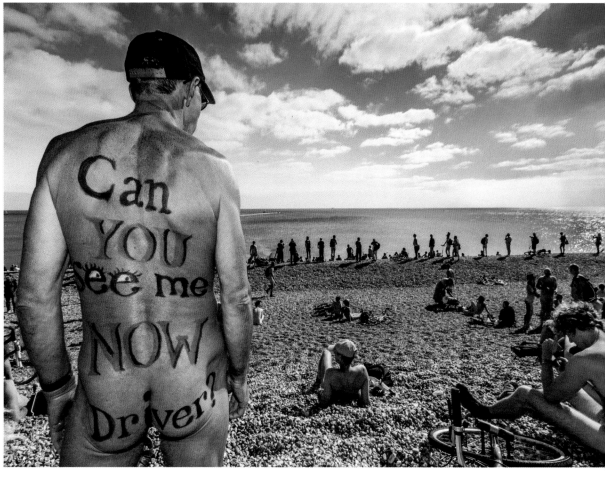

◔ TOM FOX
HIGHLY COMMENDED

Alien Shadow
Holland Street, London

They say that the best camera is the one
you have with you; I keep one with me at
all times. On this occasion I was taken
by the strong, hard shadows on the white
wall, and knew that a story could come
from it if I was patient.

◔ HEATHER BUCKLEY
HIGHLY COMMENDED

Can You See Me Now Driver?
Brighton, East Sussex

Participants cool off at the naturist beach
in Brighton after the Naked Bike Ride.

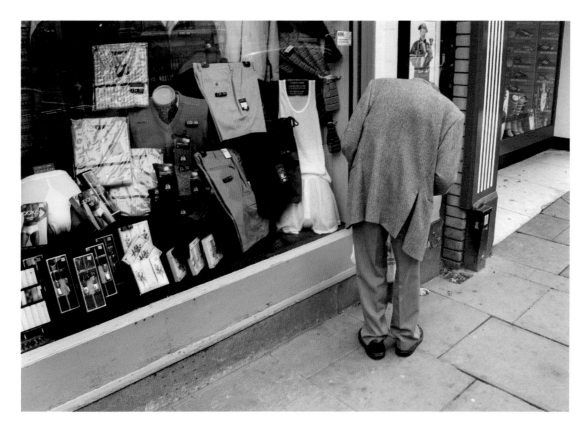

DAVID BARRETT
HIGHLY COMMENDED

While All Around Are Losing Theirs
Gloucester City Centre, Gloucestershire

This picture was captured in Gloucester city centre, which I visit on a regular basis in search of street photography subjects. The city's diverse population rarely fails to surprise me visually – in this instance I love the way that the contents of the shop window seem to echo the man in the street.

GERARD COLLETT
HIGHLY COMMENDED

Father and Daughter
Victoria Station, London

I shall probably never know the identities of this man and the little girl he is holding so lovingly, who is presumably his daughter. One guess as to the circumstances surrounding this chance encounter is that they are on their way to the passport office, situated behind the station – it is in the direct path of his line of sight. This would perhaps explain their suitcase and the expression on his face.

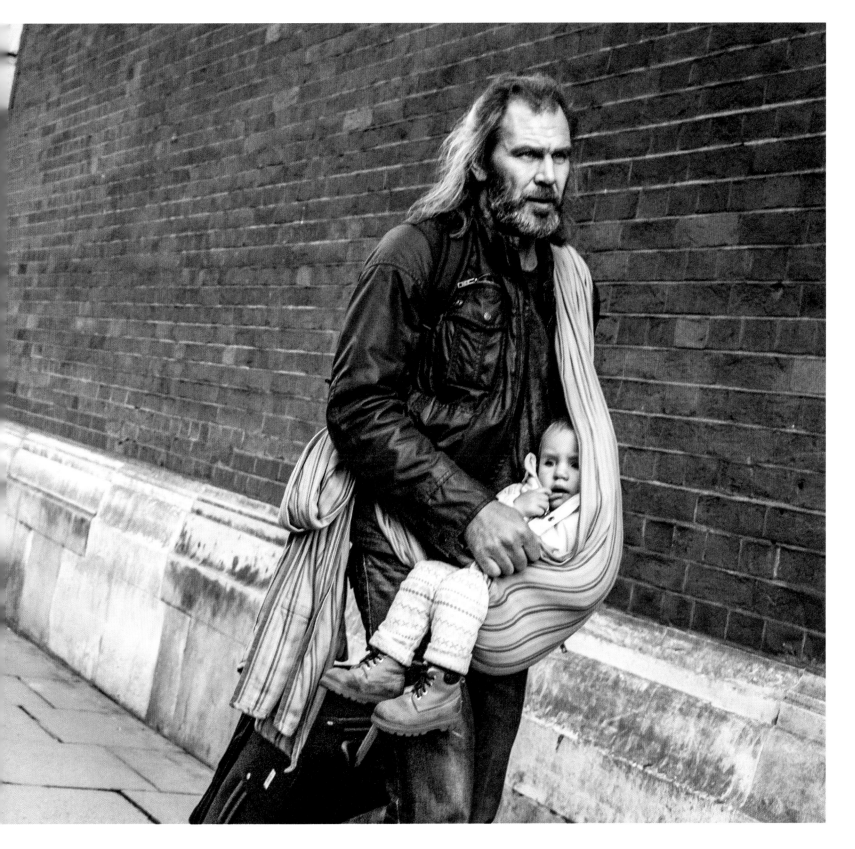

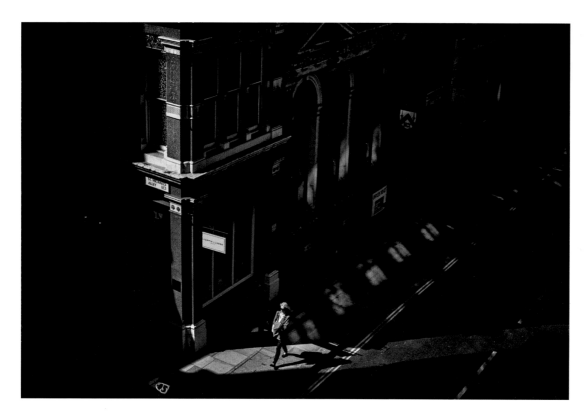

JAN ROCKAR

In the Spotlight
London

I noticed this stream of light acting like a spotlight on anyone walking through it, and knew it had the potential to make a great photograph. When this attractive girl stepped into the light I knew that this was 'the moment', although I barely had the time to set up my camera, frame the shot and make the exposure.

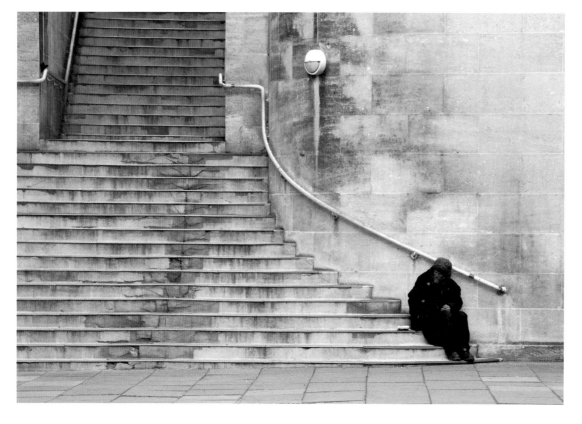

SIMON MADDISON

No Fixed Abode
Embankment, London

A homeless man sitting at the bottom of a flight of stairs on the Embankment, photographed from the other side of the road. Is he resting from walking down them, or before attempting the climb up?

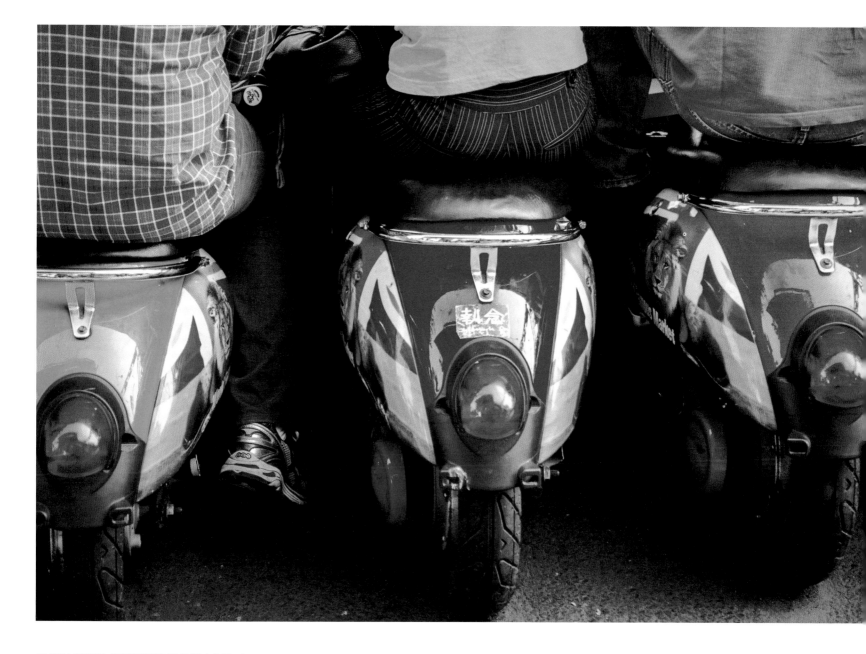

⬆ WAYNE HENRY DONALD / HIGHLY COMMENDED

Bums on Seats
Camden, London

This is a candid shot of two men and a woman on scooter-shaped seats in London, which was taken as part of a collection of street photographs around the city. I was drawn to this scene by the contrast between the mundane and the iconic, and because it echoed the cheekiness of the old British seaside postcards. It was a crowded area, so I had to be quick to get a clear shot and avoid being jostled by the crowd.

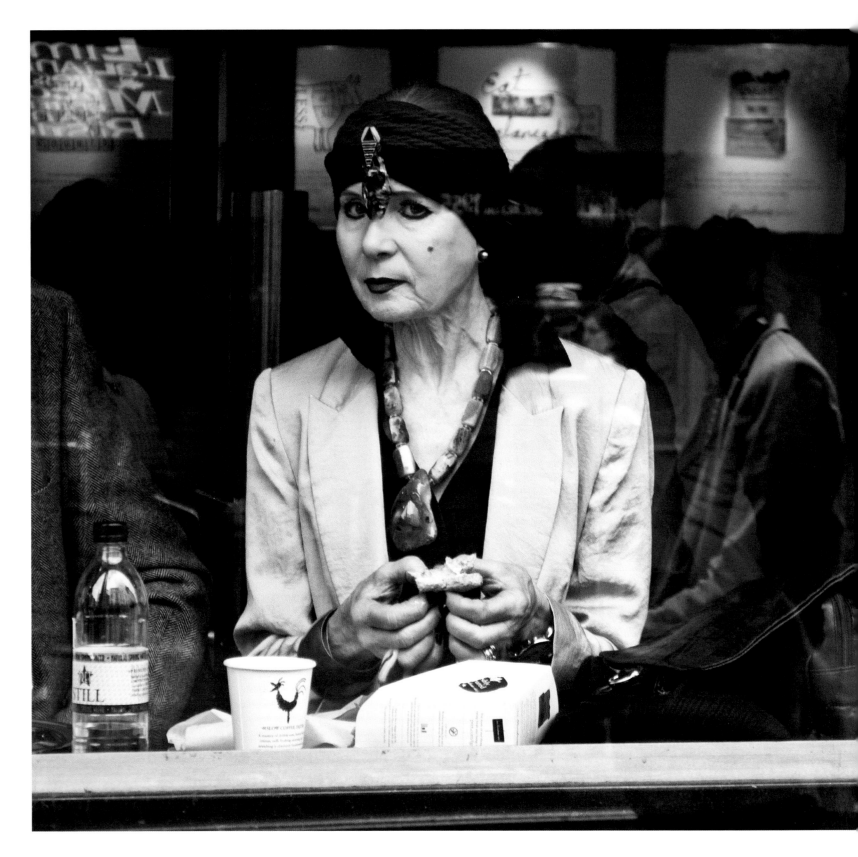

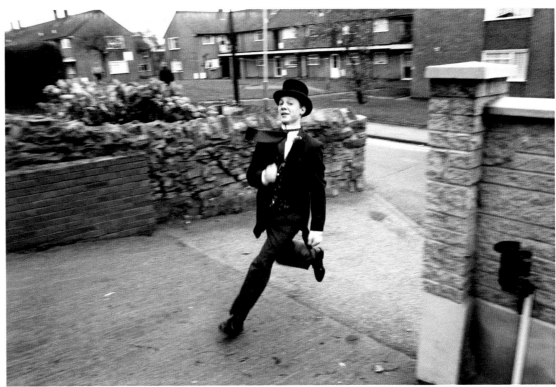

⊖ LINDA WISDOM

Elegant Lady in Café Window
Leicester Square, London

I was walking through central London when I saw this lady in a café. Her appearance was very striking and I automatically knew I had to take a photo. I tried to take it candidly, without her knowing, but she looked up at me. I actually think the eye contact makes the shot, as her stare is quite intense.

⊕ CONOR MASTERSON

A Groomsman Runs to His Brother's Wedding
Sutton in Ashfield, Mansfield Town, Nottinghamshire

We were getting in the car to drive to a wedding, but one of the groomsmen had forgotten his hat and needed to go back to the house. I saw him doing a comical run as he returned and took a shot as he ran around the corner.

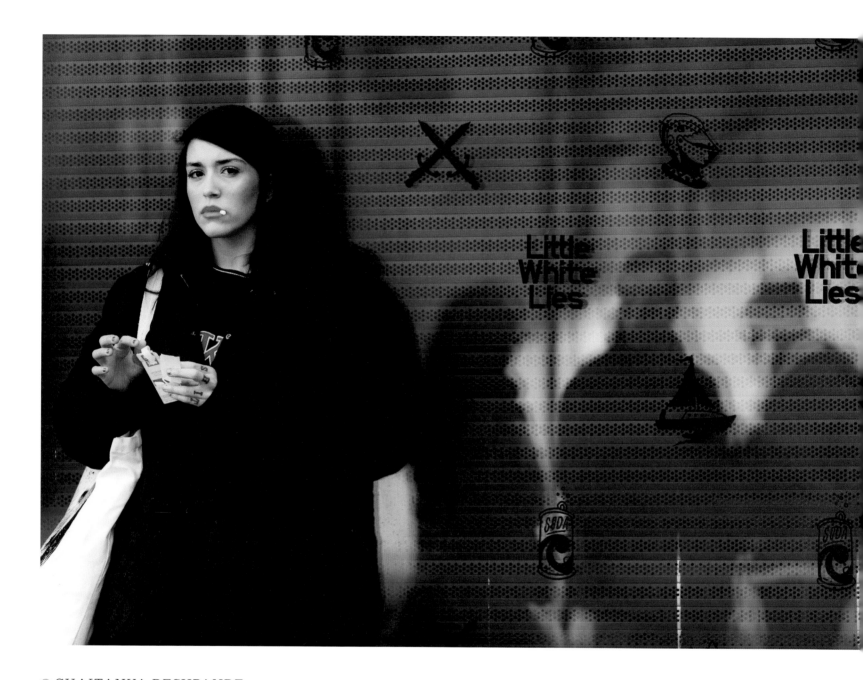

⊕ CHAITANYA DESHPANDE

Merry Christmas
East London

Taken in East London, at the height of the pre-Christmas festivities. Santas were everywhere, but this young woman didn't seem to care about the Christmas spirit. Completely at ease with herself and her surroundings, with telling tattoos on her knuckles and a defiant look on her face, the writing on the shutter behind her could almost express her inner feelings.

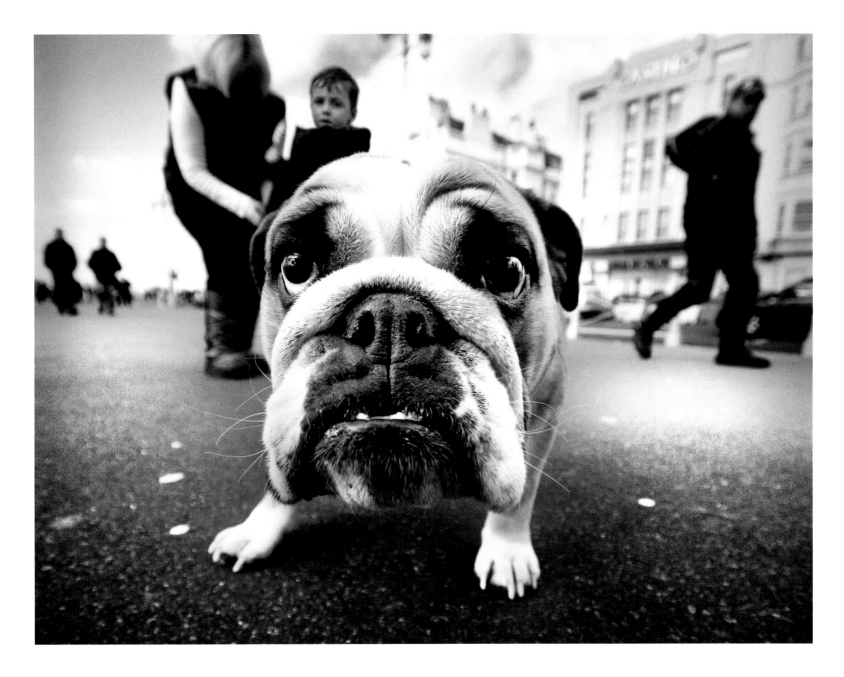

⊕ JERRY WEBB

Bulldog on the Seafront
Brighton, East Sussex

I spent an afternoon photographing dogs and their owners on
Brighton seafront. Dog owners are usually very obliging if you
ask, and if you push a wide-angle lens right up to the dog's nose
you get a dramatic and/or humorous picture. Because of the wide
angle it will inevitably incorporate the owner as well.

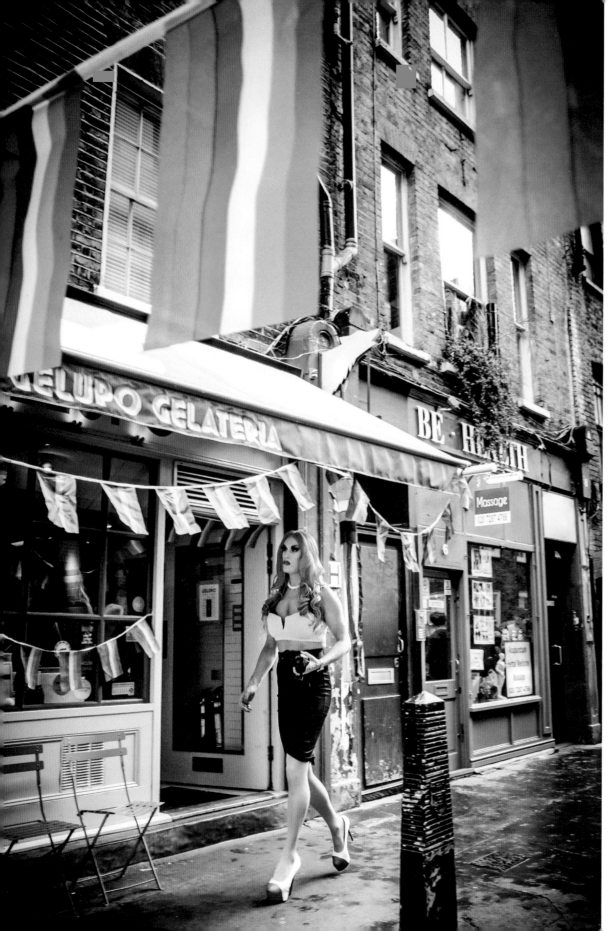

NOEMI GAGO

#FreedomtoBe Yourself
Soho, London

Every year, the London Pride Festival dawns with an explosion of colour. The festival's epicentre is Soho, and it was there that I saw her, among the vibrant rainbow banners, as she walked with elegance and pride.

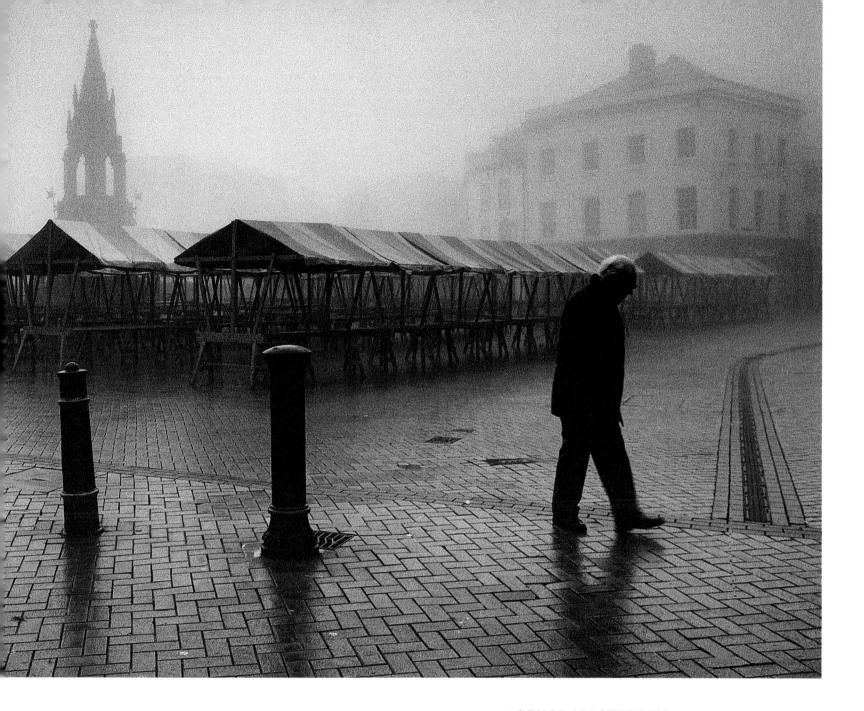

⊕ CONOR MASTERSON

Foggy Sunday Morning in Mansfield
Mansfield Town Centre, Nottinghamshire

I had recently emigrated from Ireland to work in Mansfield and
went out to explore the town on a Sunday. There was a dense
fog everywhere and all the shops were closed. This man walked
through the scene and I took up a position that balanced his figure
with the bollards to make a simple composition.

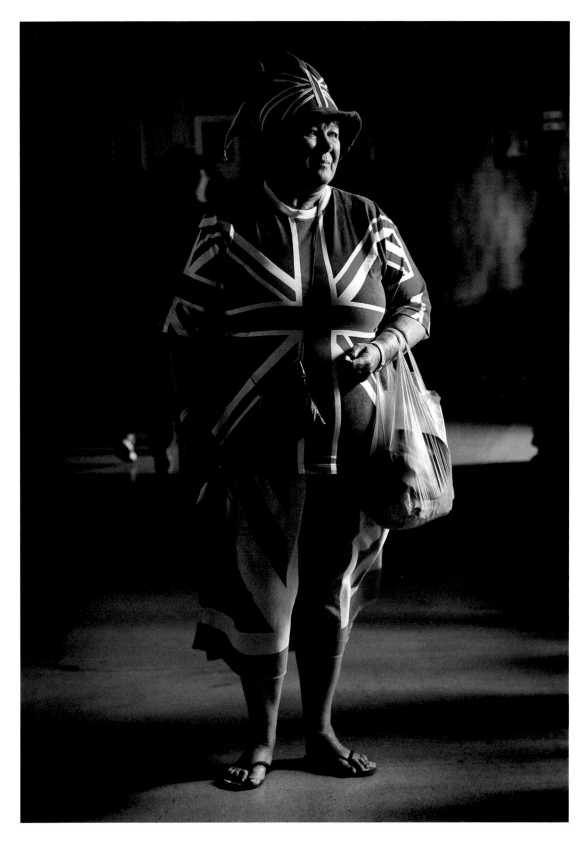

Tennis Mania
Wimbledon, London

An avid tennis fan waits in the wings
of Centre Court, ahead of Andy Murray's
second-round match against Slovenia's
Blaž Rola at the annual Wimbledon
Tennis Championships.

HEATHER BUCKLEY

Smoking Sausages
Brighton, East Sussex

A street trader at the Streets of Brighton event during Brighton Fringe. Using a wide-angle lens allowed me to create a frame with the sausages in the foreground and the smoke at either side.

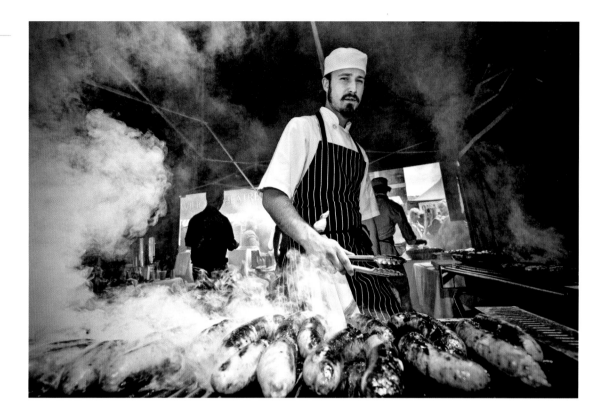

NOEMI GAGO

Canal
Little Venice, London

This picture was taken from one of the many elevated walkways that cross the canal in Little Venice, London. Even though the couple sitting on the bench are enjoying a romantic Sunday evening together, overlooking the canal, their focus is on their smartphones.

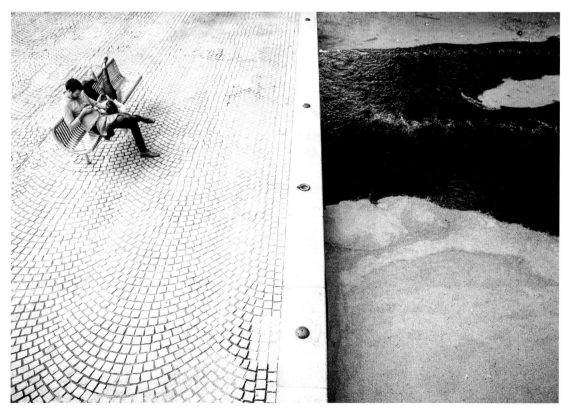

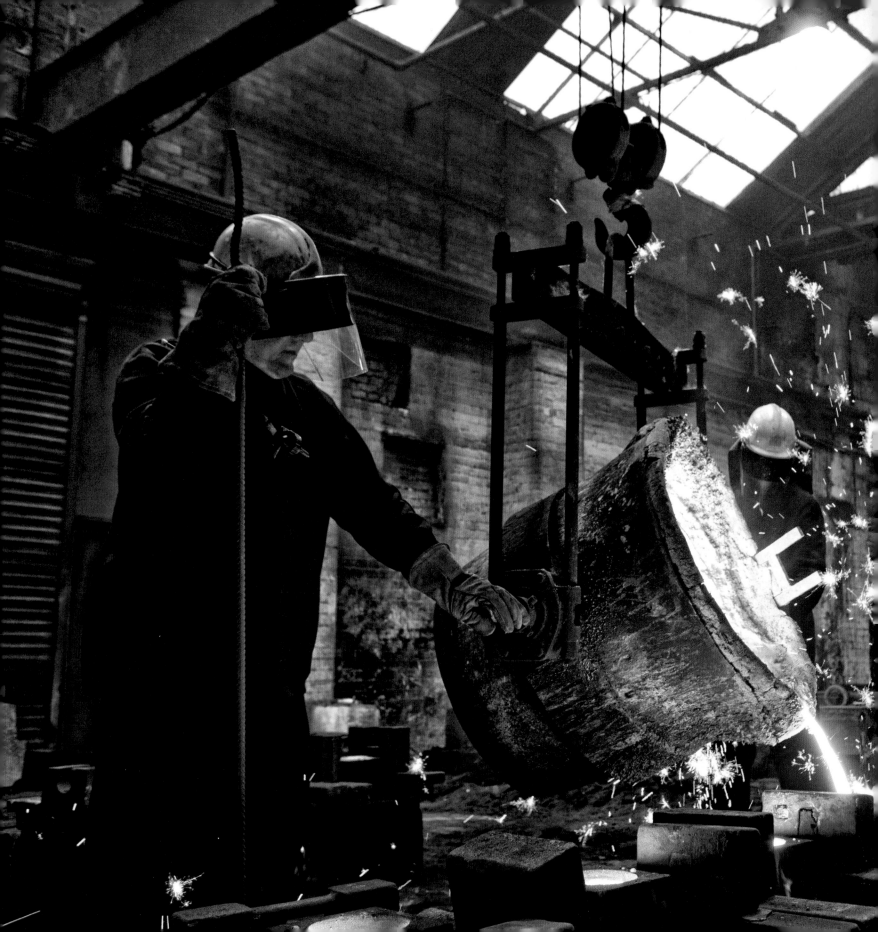

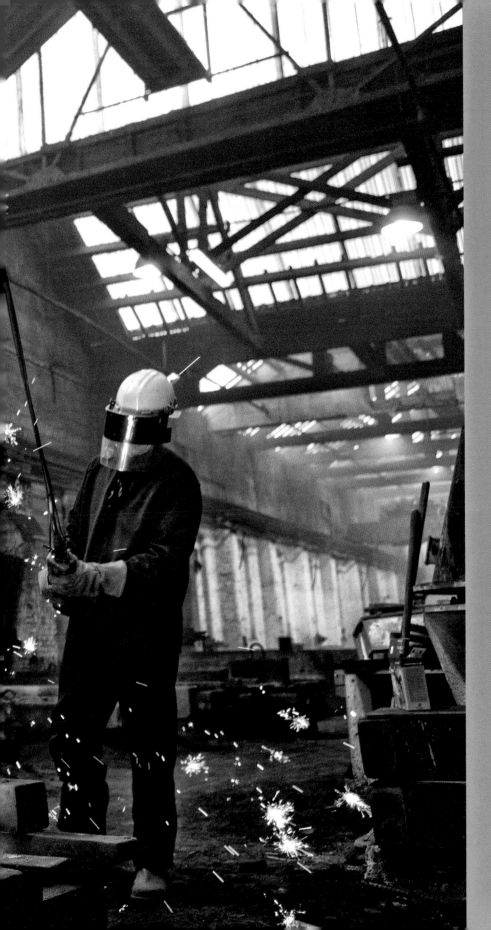

4
WORK IN THE COMMUNITY

Whether it's industry and trade, communications, the arts, science and technology, health, education, transport or the leisure industry, *Work in the Community* documents the essence of working life, its diversity, and its relevance within the community.

 STEVE MORGAN / WINNER

Foundrymen
Hargreaves Foundry, Halifax, West Yorkshire

Hargreaves General Ironfounders was established in 1896; this photograph shows today's foundrymen pouring the iron into moulds for cast iron drainage products. The conditions are challenging – it's hot, grimy and heavy work – but the foundry workers are proud of the manual nature of their work. As one pointed out to me with a smile: "This is real work, lad."

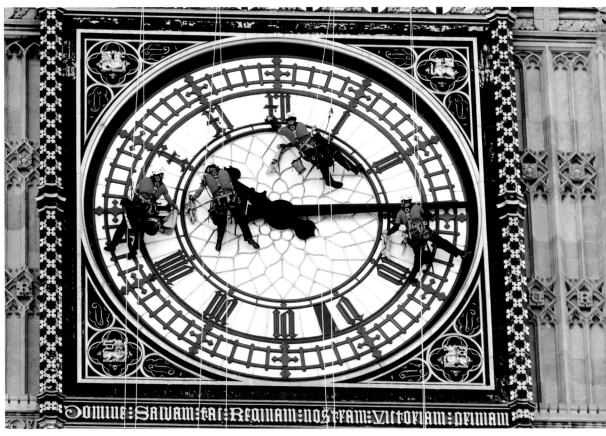

⬆ NAOUFAL SELMANI

HIGHLY COMMENDED

Head for Heights
Houses of Parliament, London

Wearing earplugs to muffle the chimes of Big Ben, and armed with buckets and cloths, a team of abseilers is busy cleaning one of the clock faces at the Houses of Parliament in London. I forgot my lens hood as I rushed to Westminster to capture this scene, so shot from a shaded position to try and avoid lens flare.

⬅ ROY RILEY / HIGHLY COMMENDED

Stuffed Animals Go to Auction
Bodmin, Cornwall

Auctioneers catalogue some of the larger exhibits from a collection of stuffed animals, prior to auction.

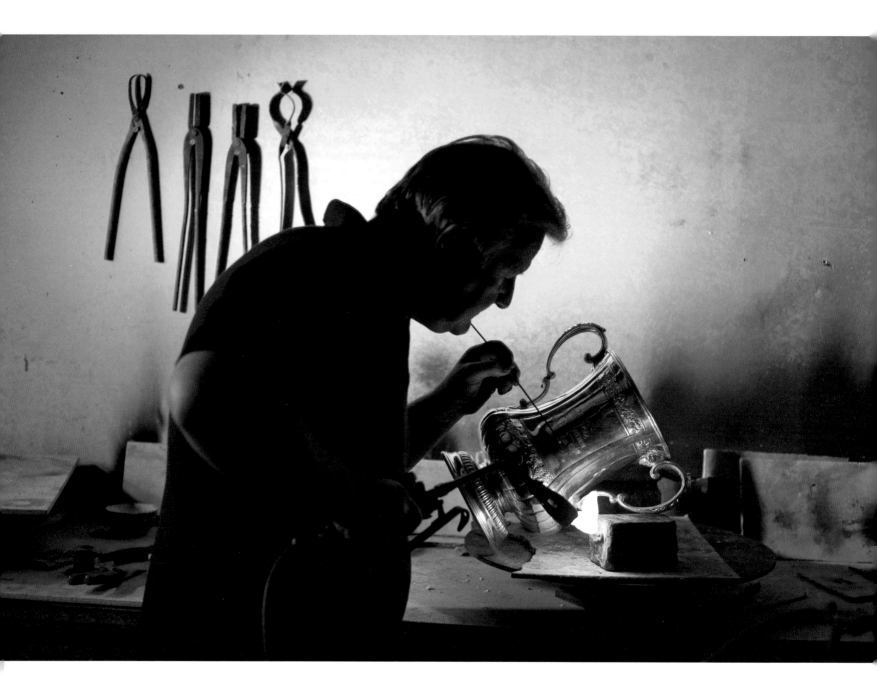

⬆ AMIT LENNON / HIGHLY COMMENDED

FA Cup Repair
Oxford Circus, London

Each year, the FA Cup is sent to Thomas Lyte Silver to be repaired and polished before the FA Cup Final. The company uses very traditional methods to repair this trophy, as well as many others. Here, Kevin Williams examines the damage on the trophy and heats the silver needed to repair it.

JON BROOK

The Unofficial Mayor of Bentham
Station Road, Bentham, North Yorkshire

The butcher is often found sitting here, blocking the narrow pavement. Passers-by who are forced into close proximity often feel the need to converse with him and can frequently be seen sitting with him on his windowsill sharing the time of day. As a result, there isn't much going on in this small market town that he doesn't know about.

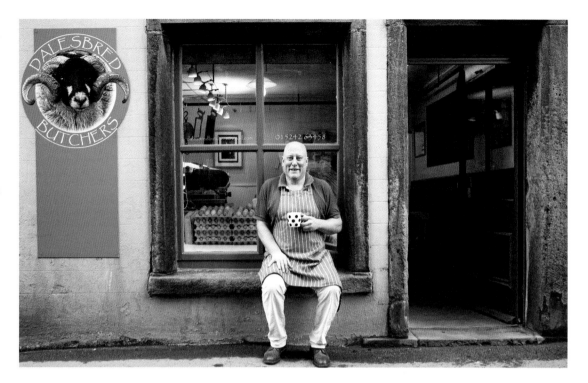

LIZ DRAKE

Furniture Restorer's Workshop
Reeves Antiques, Church Street, Warwick

This furniture restorer's workshop is reached by climbing steps constructed in Cromwellian times. Every available wall, floor and ceiling space is used to store furniture parts that will one day prove vital in restoring a piece of antique furniture. Alexander, the furniture restorer seen at the left of frame, has worked here for thirty-four years. I love the gentle light, the tranquillity of the space and the timelessness of the scene.

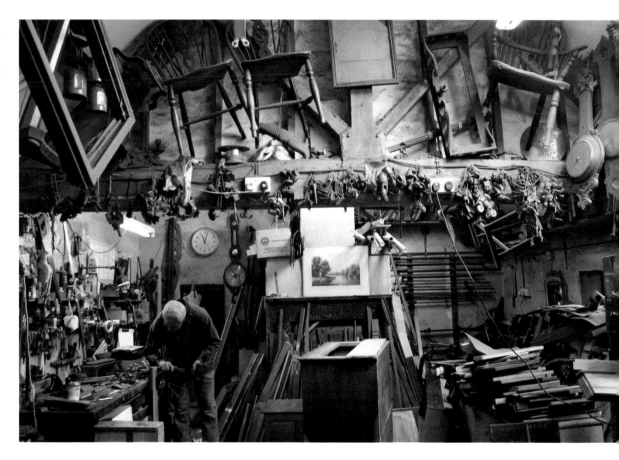

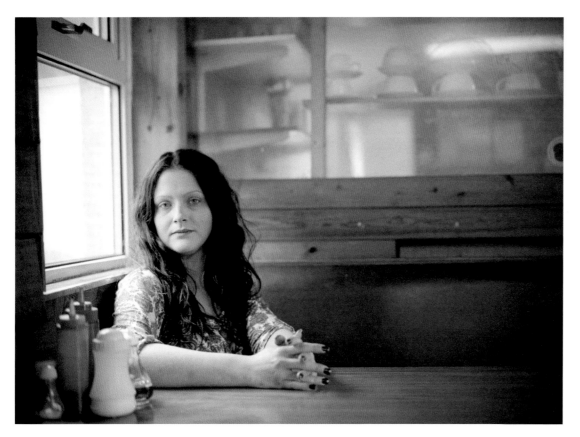

Nicola
Cottage Café, Llanddowror,
Carmarthenshire

Venturing down the A477 – a winding,
tree-lined road – I came across the
Cottage Café. It was around 4pm and
the café was coming to a close. I talked
to the staff, and Nicola agreed to sit for
a portrait. Her relaxed style and intense
pose really worked in the situation and
the sauce bottles, cups on the shelves
and burns on her arms enhance the
sense of location.

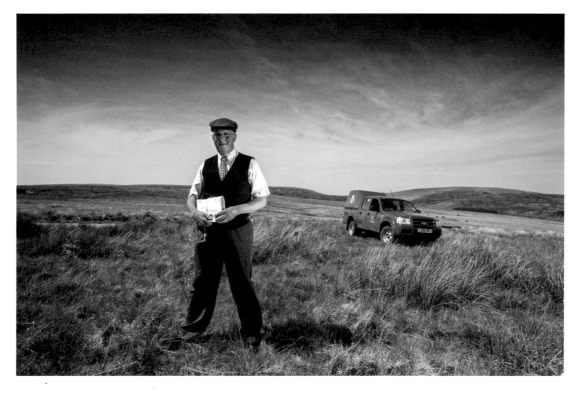

◐ STEVE MORGAN

**Andrew: Postman on the Tops
at Widdop**
Widdop, near Hebden Bridge,
West Yorkshire

Andrew is a postman who works out of
the Hebden Bridge Post Office. One of
his rounds takes him up to the farms and
houses that dot the South Pennines. The
posties were concerned about the effects
of privatisation on the deliveries to the
more remote households.

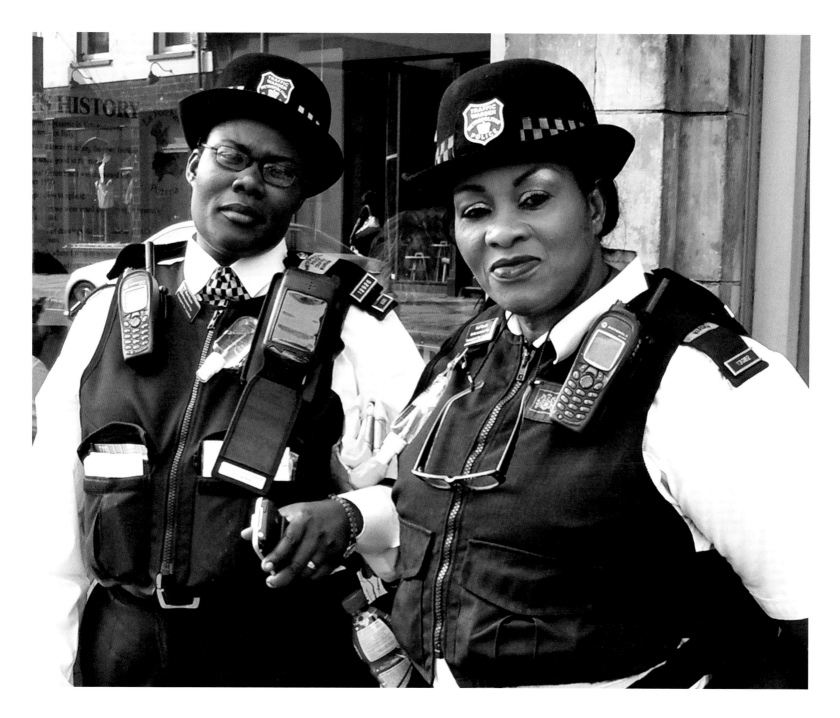

⊕ SIMON MADDISON

Community Safety, Islington Style
Islington, London

These community safety officers were spotted on Upper Street
in Islington, N1. Although they were both quite imposing with
all their gadgets, they were happy to be photographed.

5
BRITS ON HOLIDAY

Brits on Holiday captures British people away from work, whether that's a day trip, weekend break, Easter, Christmas or a traditional 'bucket-and-spade' trip to the coast.

➔ HEATHER BUCKLEY / WINNER

Brighton Pier
Brighton, East Sussex

Having fun with friends on Brighton Pier, 2014. I'll often crack a joke and take the shot immediately after.

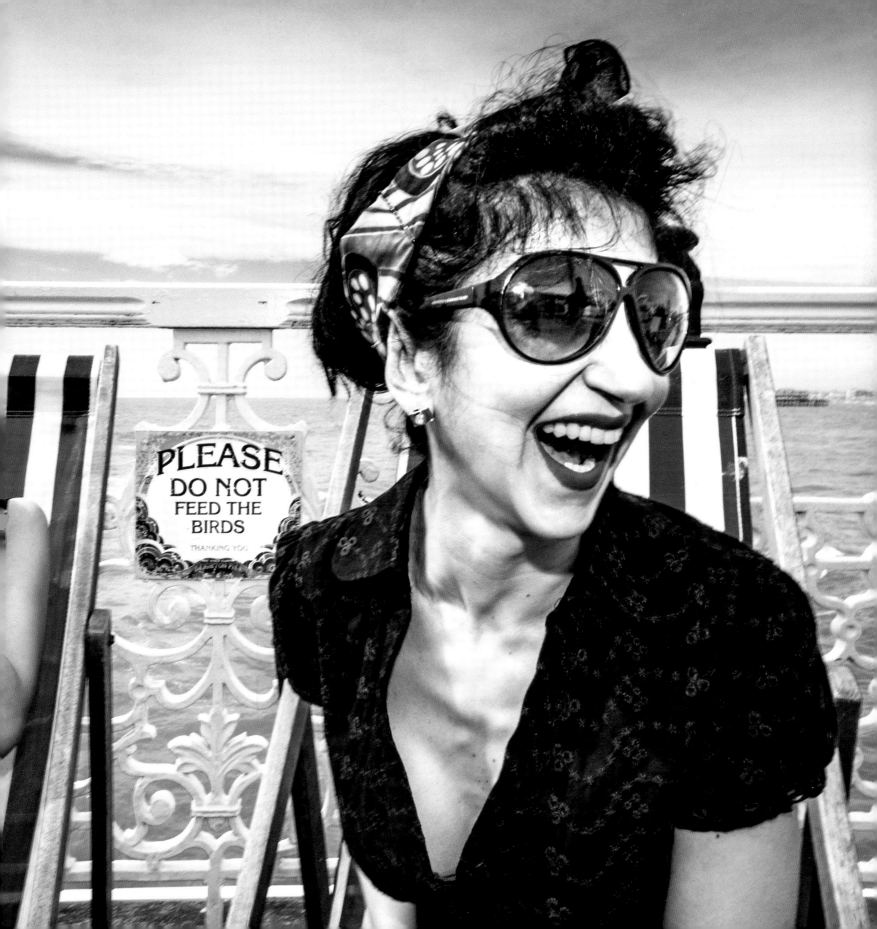

PLEASE
DO NOT
FEED THE
BIRDS

THANKING YOU

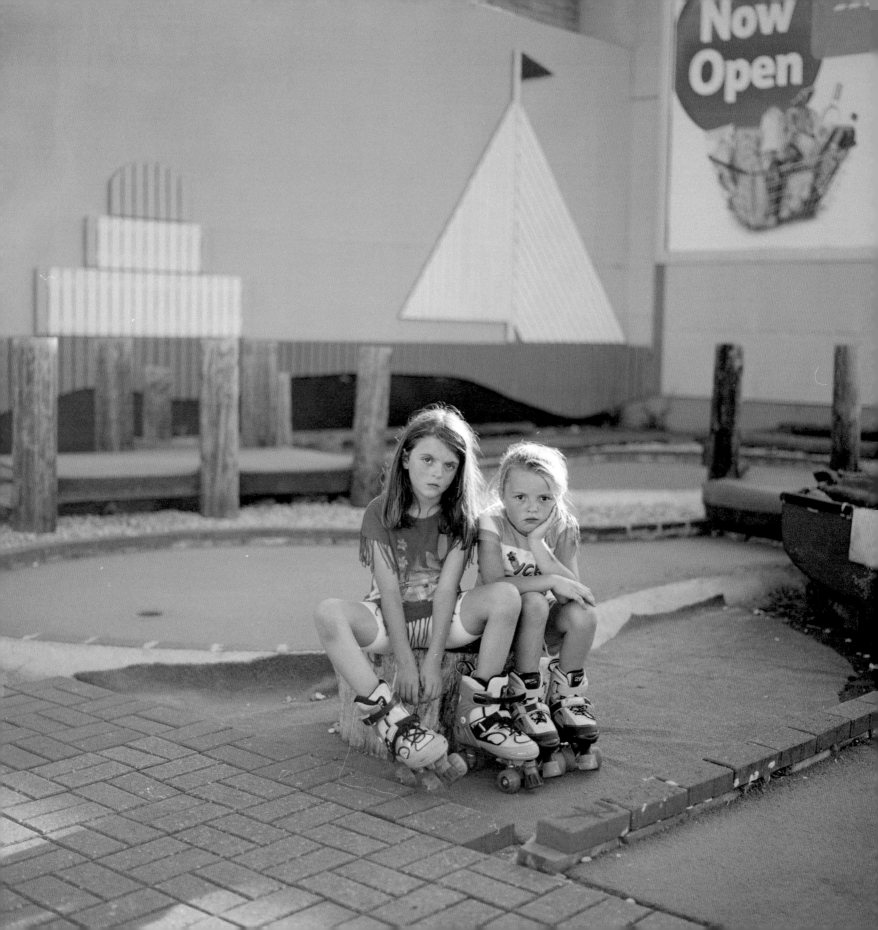

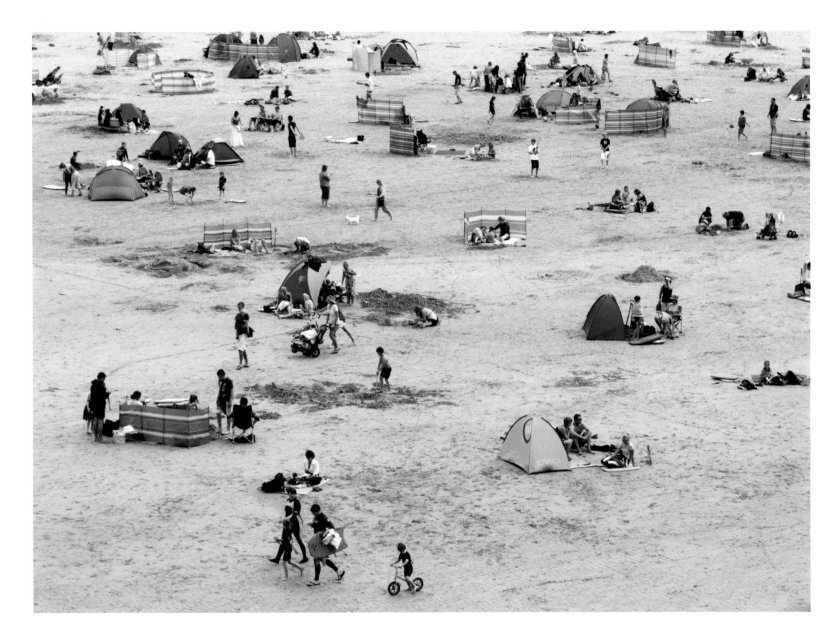

○ LAURA PANNACK / HIGHLY COMMENDED

Herne Bay
Herne Bay, Kent

I took this image on an escape to Herne Bay as part of my *Walks* series. For this project I go to a train station, close my eyes, press a button on the ticket machine and then venture to the destination I've chosen.

 This shot was taken at the start of my walk, when I spotted the two girls rollerblading around a mini golf course. I spoke with their parents and waited until the girls grew tired. Then, as they sat down, I asked to take their picture.

○ NADIA MACKENZIE / HIGHLY COMMENDED

Holidaymakers at Mawgan Porth
Mawgan Porth, Cornwall

I was drawn to the spacing between the holidaymakers, as people arrived and set up their coloured windbreaks for the day.

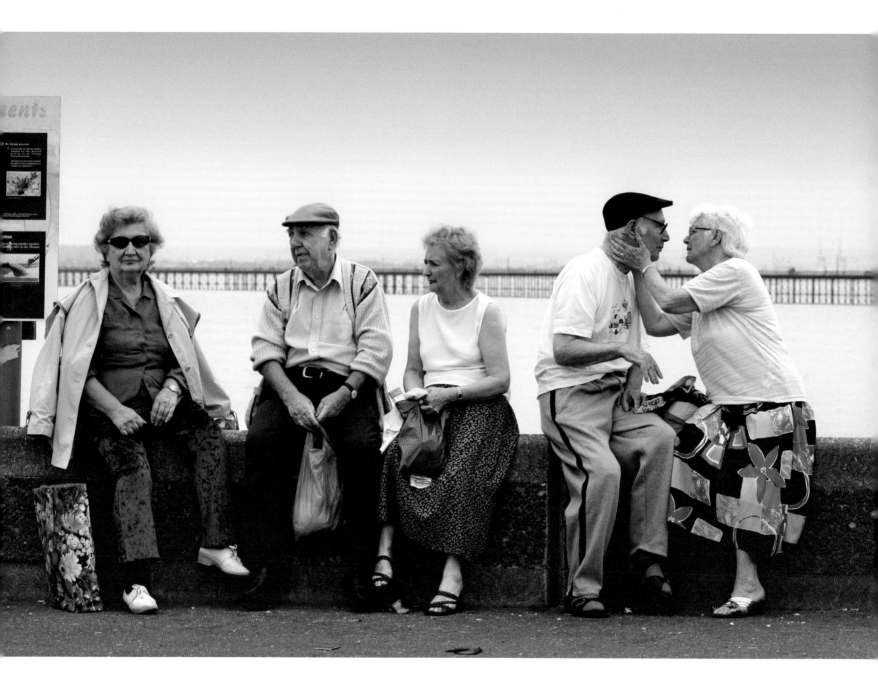

⬆ BRIAN HARRIS

HIGHLY COMMENDED

The Kiss
Southend-on-Sea, Essex

Pensioners enjoy a day out on the front
at Southend-on-Sea. I took this while
I was developing a set of images
showing *The Kiss*.

JASPER WHITE

HIGHLY COMMENDED

Xmas
Corby, Northamptonshire

The image was taken on Christmas Day. It shows my father lying on the sofa, content, with his feet up and Santa hat on. I felt I had to capture it, so set my camera up on a tripod opposite and took this photograph of him sleeping.

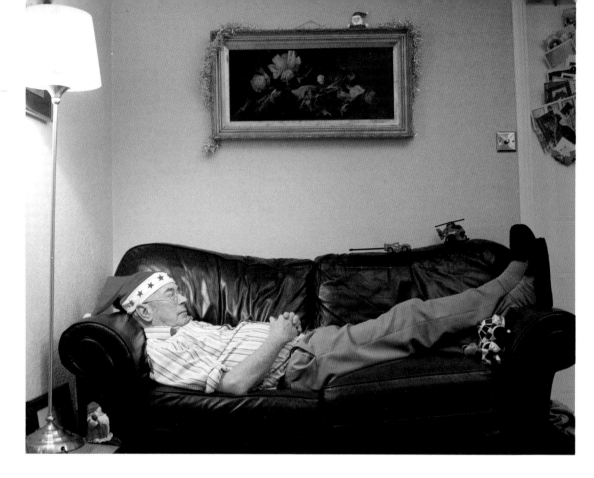

GEORGE TURNBULL

HIGHLY COMMENDED

Swinging Britain
South Bank, London

The South Bank in London has become a very active environment, with large crowds gathering there to enjoy the carnival atmosphere, especially on summer evenings, weekends and holidays. The high swings were relatively new when I took this, but they provide an attraction that reflects the 'fun of the fair' as Brits enjoy themselves in a very traditional way, reaching and surpassing the height of nearby buildings.

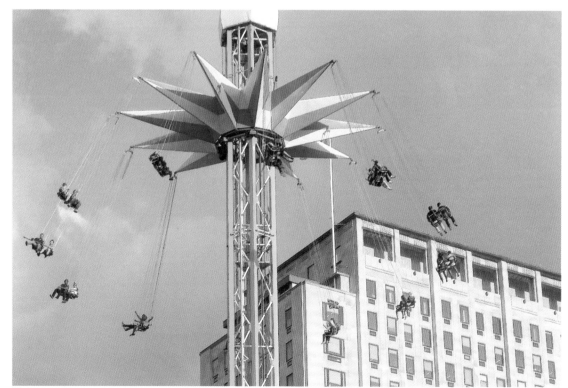

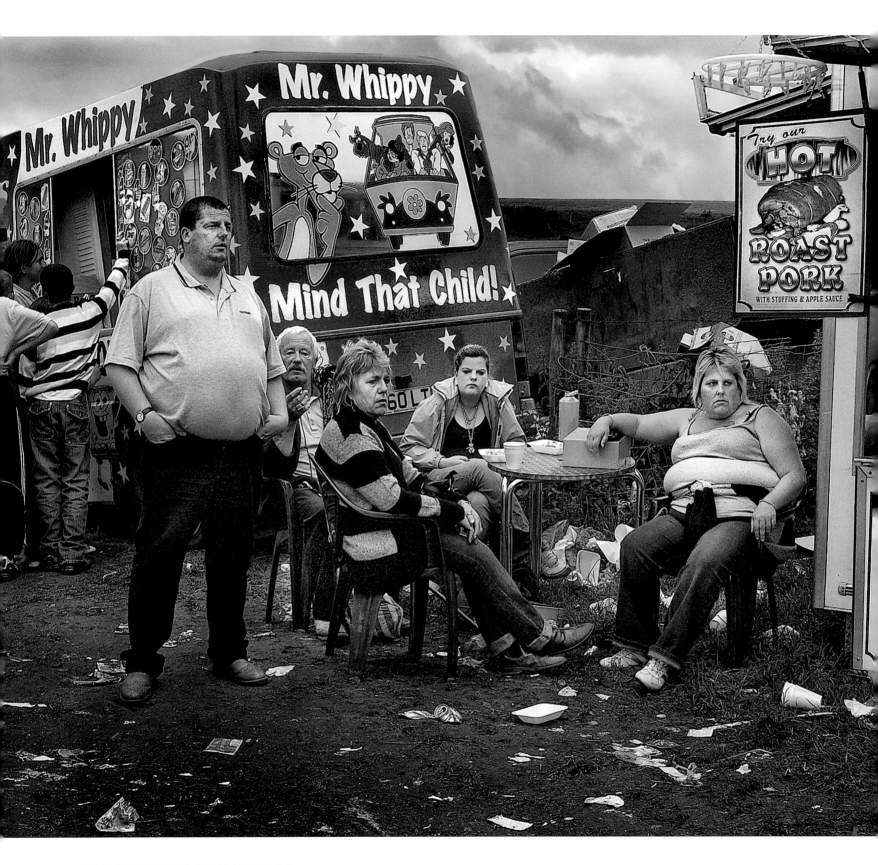

PAUL HARRIS
HIGHLY COMMENDED

Tolcarne Beach
Tolcarne Beach, Newquay, Cornwall

The beach and huts on Newquay's Tolcarne Beach caught my eye at the start of the new holiday season in Cornwall. Young surfers and school children were out in force and fresh spring greenery on the nearby cliffs added colour and shape to the image.

CHRISSIE WESTGATE
HIGHLY COMMENDED

Fast Food
Appleby, Cumbria

Wandering through Appleby Horse Fair I came across this wonderful scene. I call it *Fast Food* because there are so many elements that come together to depict that culture, from Mr. Whippy and roast pork, to chips and rubbish! I love the way the character on the back of the ice cream van appears to be looking quizzically at the gentleman; it is an image that needs to be looked into.

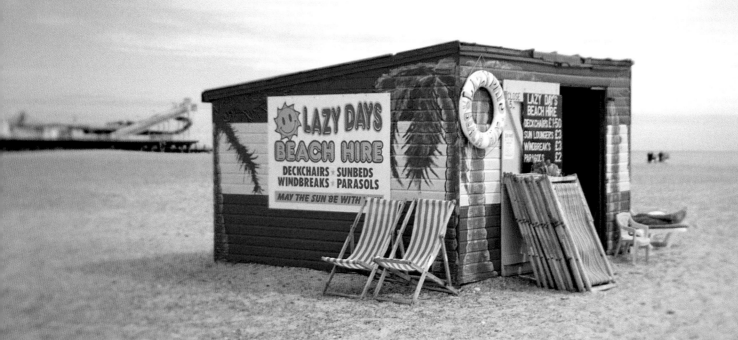

ZOË BARKER
HIGHLY COMMENDED

Lazy Days
Great Yarmouth, Norfolk

Shot on 120-format film using a low-tech plastic camera. The vignetting, odd focus and slight warping are all created naturally by this very basic camera.

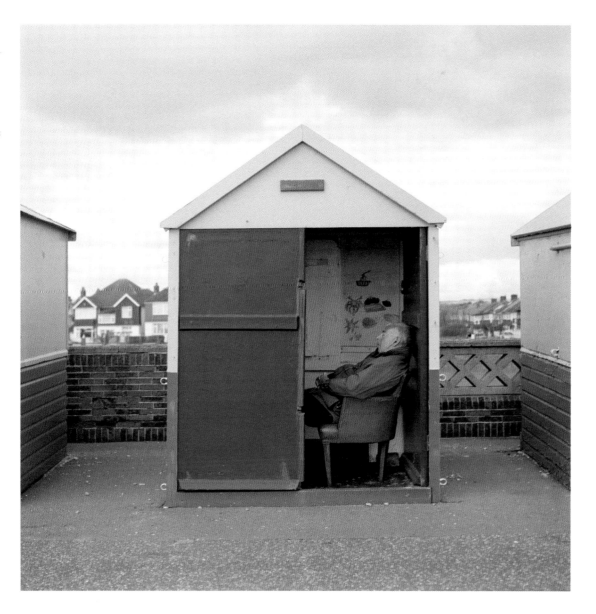

LAURA PANNACK

Simple Pleasures
Hove, East Sussex

This photograph is from an exercise I embark on to further my practice and remind myself to engage with my surroundings, remain curious and ultimately enjoy the art of image making. This was taken on a stroll in Hove where the sun (occasionally) shone and the calm Sunday vibe seemed to bring out locals who relished the peace and quiet of their beach huts.

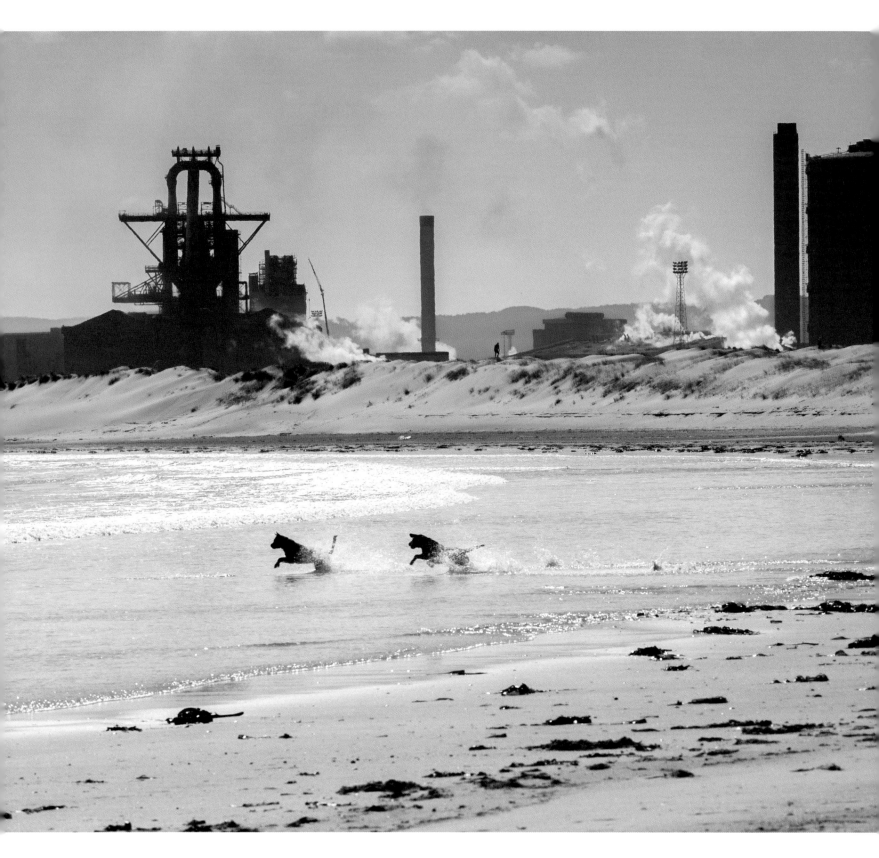

PAUL HARRIS

Surf Dogs
Teesside, Redcar and Cleveland,
North Yorkshire

A pair of labradors chase sticks into the
sea in front of the Teesside Steelworks,
one year on from its reopening in 2012.
This visit was the start of a collaboration
with two other photographers to record
the culture and landscape along the Tees
Estuary, stretching from South Gare to
the Tees Barrage.

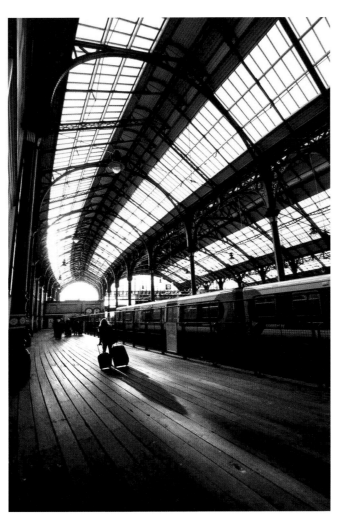

PAUL CAHILL

Girl at Station
Brighton Station, Brighton, East Sussex

The low winter sun that was shining
through the station was perfect for this
photograph. I just waited until this woman
walked through, and tried to capture her
and her shadow at the perfect moment.

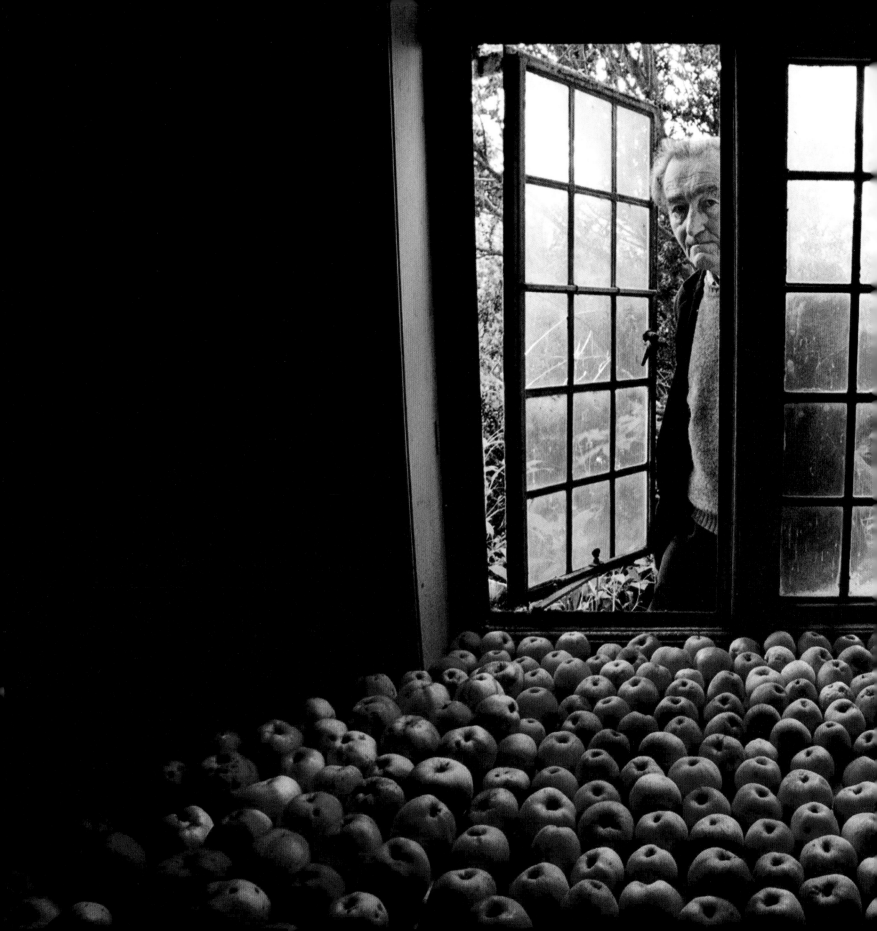

6
PORTRAITURE

The face of Britain: portraits of any age that capture character, spirit and soul.

⊛ BRIAN HARRIS / WINNER

Michael Hamburger
Suffolk

Michael Hamburger MBE was a poet, critic, academic and translator who I photographed at his home in Suffolk in 2000 – he passed away in 2007. The apples came from a tree that his friend, the poet Ted Hughes, had provided the seed for many years earlier. He was very proud to show his apples off to me and my six-year-old son, Jacob, who held up a reflector to cast back some golden light.

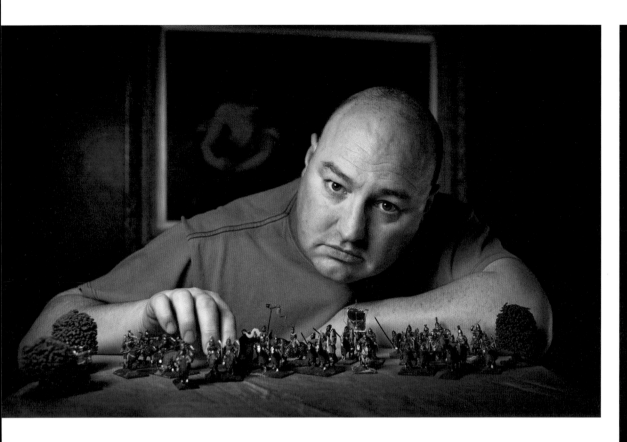

JON BROOK
HIGHLY COMMENDED

Big Dave, World Champion Wargamer
Bentham, North Yorkshire

As with many wargamers, Dave paints the figures that make up his armies – in wargaming circles this is often considered as much a part of the hobby as fighting the battles. Dave asked me to photograph individual pieces so that he could show his work to others. In exchange he agreed to pose for me when we finished.

STEVE MORGAN
HIGHLY COMMENDED

Foundryman
Hargreaves Foundry,
Halifax, West Yorkshire

This is part of a personal project on the Hargreaves Foundry in Halifax, West Yorkshire. The work of the foundrymen can be hard and is undertaken in testing physical conditions.

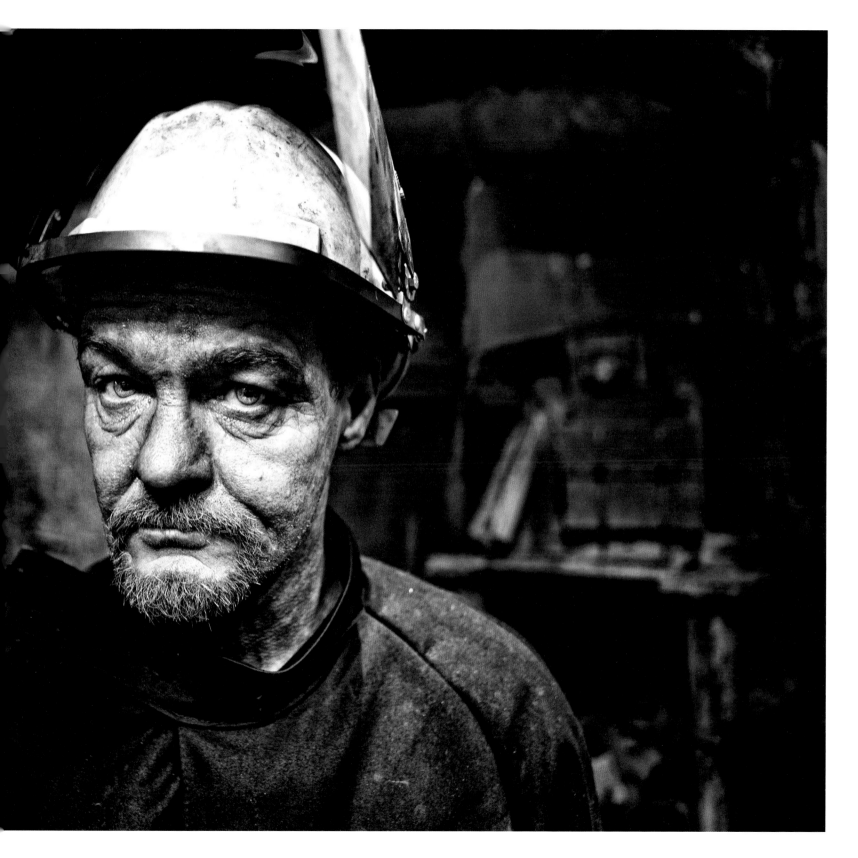

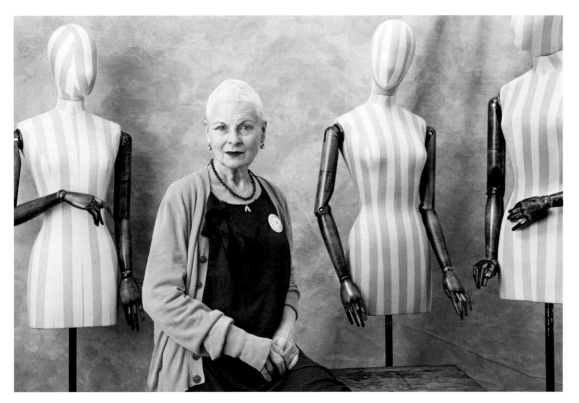

REBECCA MILLER

Vivienne Westwood
London

This was taken for the *Hollywood Reporter* to illustrate a piece about Vivienne Westwood and her muse, Christina Hendricks. When I went to see the studio I saw all these mannequins that were specifically made for Vivienne. I knew I had to use them in a portrait with her – I love the way they appear to be interacting with her.

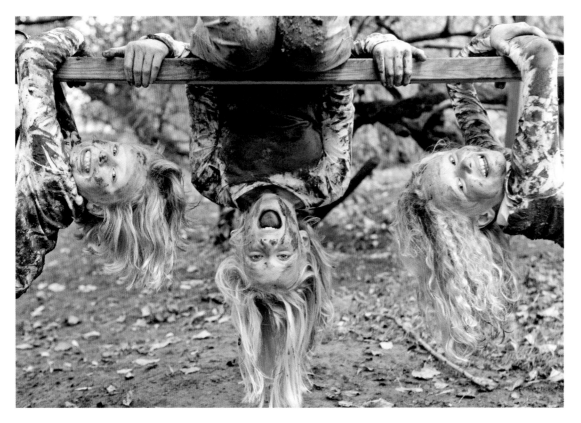

MILLIE PILKINGTON
HIGHLY COMMENDED

Three Urchins
Kings Stag, Dorset

My aim was to photograph these children playing carefree in the woods in a way that captured their inner spirit, energy, life, naughtiness, and sense of fun and adventure. I wanted them all in white tops (to show the mud) and blue jeans – so we had to be quick before they got too dirty. It was a cold, dark and gloomy day in November, so I had to push the ISO quite high.

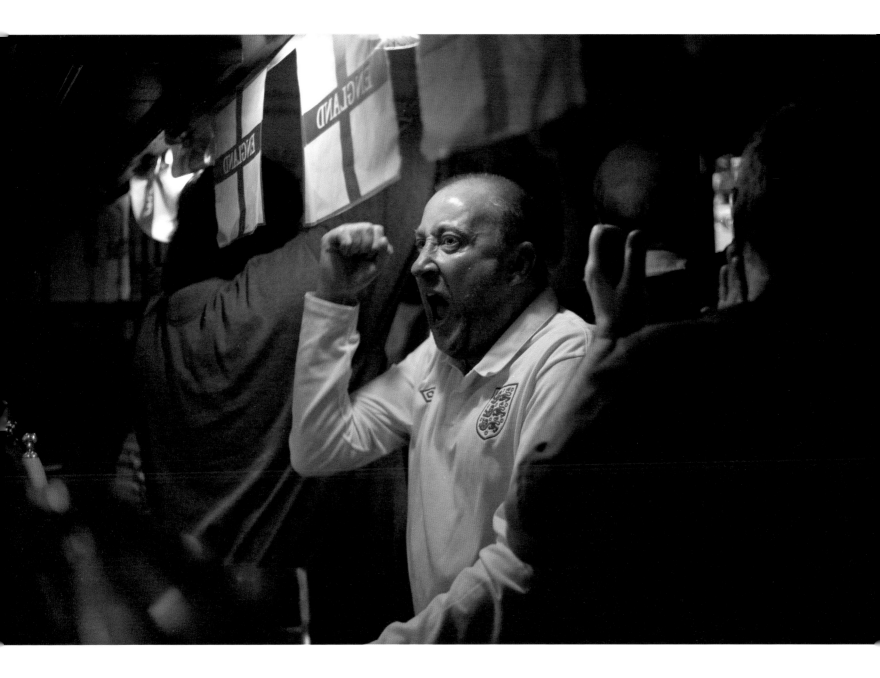

⬆ THOMAS DRYDEN KELSEY / HIGHLY COMMENDED

England World Cup Goal
Marlborough, Wiltshire

This is Andrew "Planky" Plank celebrating England's goal against
Italy during the 2014 World Cup. I waited close to the bar, where
the light was better to capture the fans' reactions. It was crowded
that evening and I was waiting for a decisive moment to capture
an England fan's emotion – I have known Planky for years and
think this sums up his passion as a true England fan!

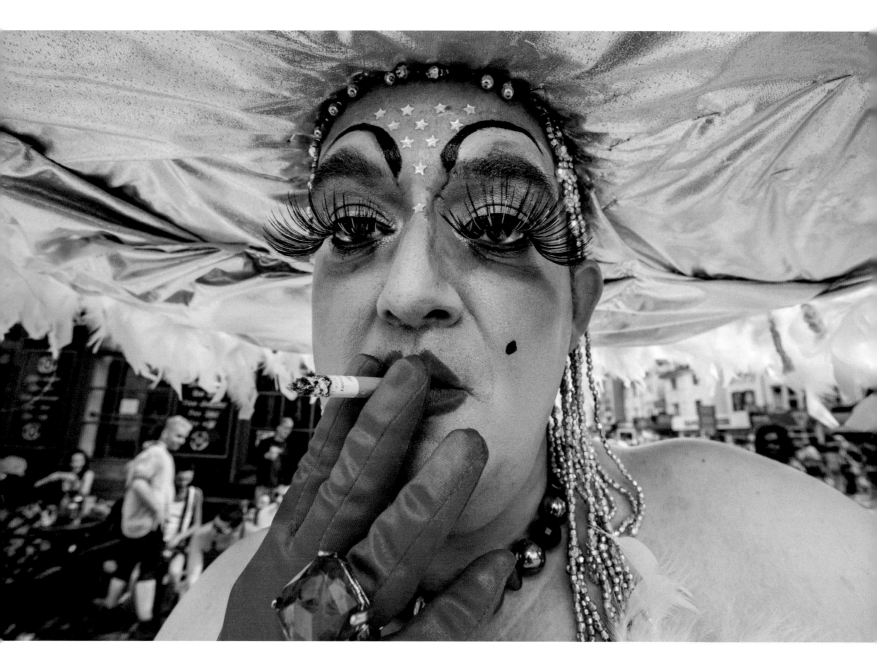

HEATHER BUCKLEY / HIGHLY COMMENDED

After the Parade
Brighton, East Sussex

Taking a break after the Brighton Pride festival. I often
ask strangers if I can take their portrait in the street.

MILLIE PILKINGTON / HIGHLY COMMENDED

Scrap Merchant and Collector
Lyons Gate, Dorset

This vocational portrait was taken for my book, *Great Faces
of Dorset*. This nonagenarian runs a scrap yard with more junk
inside his house than I could ever have imagined. I loved the
shabby doorway and the 'garage sale' writing on the window,
so felt this was a suitable place to pose him – the surroundings
look as old as their owner.

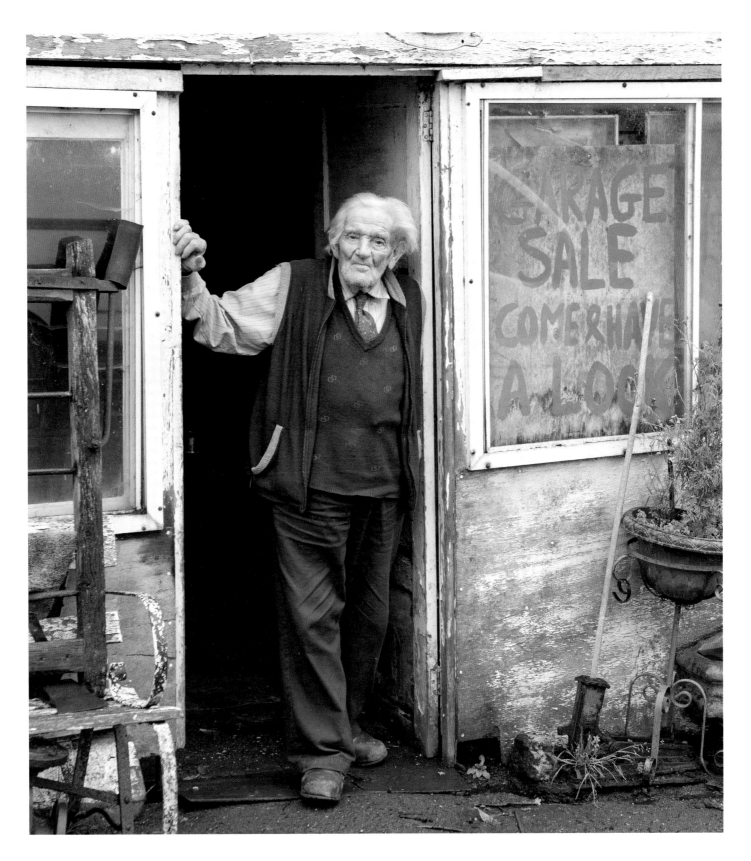

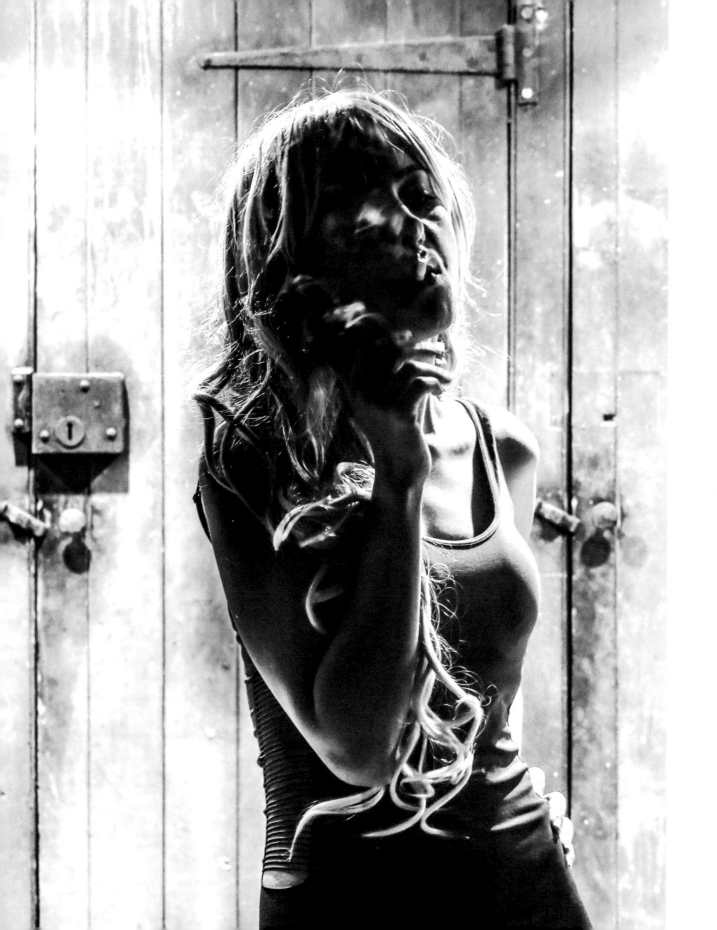

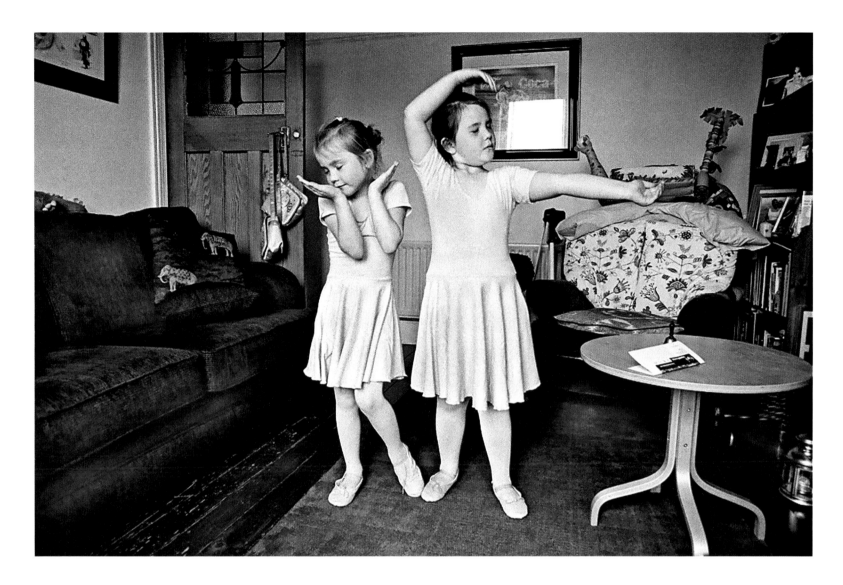

HEATHER BUCKLEY

HIGHLY COMMENDED

Sheema
Lewes, East Sussex

While Sheema was smoking, I noticed the potential for back lighting in the garage. The lighting is simply strip lighting between the doors and my subject.

ALASTAIR McCOOK

HIGHLY COMMENDED

Annie and Holly Dancing
Portrush, County Antrim

These are my daughters Holly and Annie practising at home before going to their weekly ballet class. I asked them to show me their best moves and photographed what happened using my old Canon AE-1 Program, loaded with 400 ASA Ilford film. I sat with my back to the sitting room window and used the natural light that was falling into the room. I love their lack of self-consciousness; this is my favourite photograph of them.

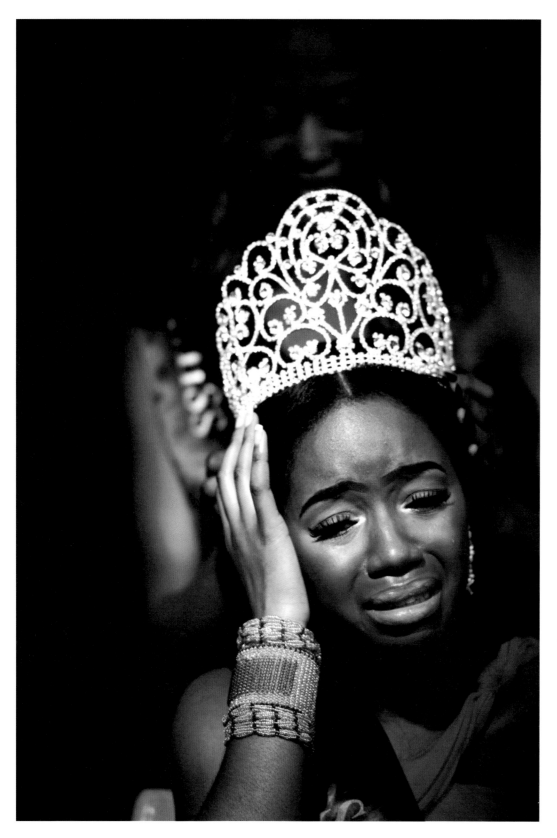

THOMAS DRYDEN KELSEY

The Crowning of Miss Teen Zimbabwe
London

I contacted Miss Teen Zimbabwe to let me document the pageant, which celebrates the beauty of first and second generations of Zimbabwean girls living in the UK. The final part of the event is the crowning of the winner by the previous year's winner of the beauty pageant. This is the emotional moment when the crown was placed on the 2012 winner.

DAVID YEO / HIGHLY COMMENDED

The Nuns
Bristol

My old neighbours – selfless women and great confidence boosters. This was shot where they lived, in a big old house opposite me, with a place of worship in their front room. I thought black and white was a perfect choice to match the Nuns' habits. They were amazingly patient models, who swapped positions for numerous variations of this shot.

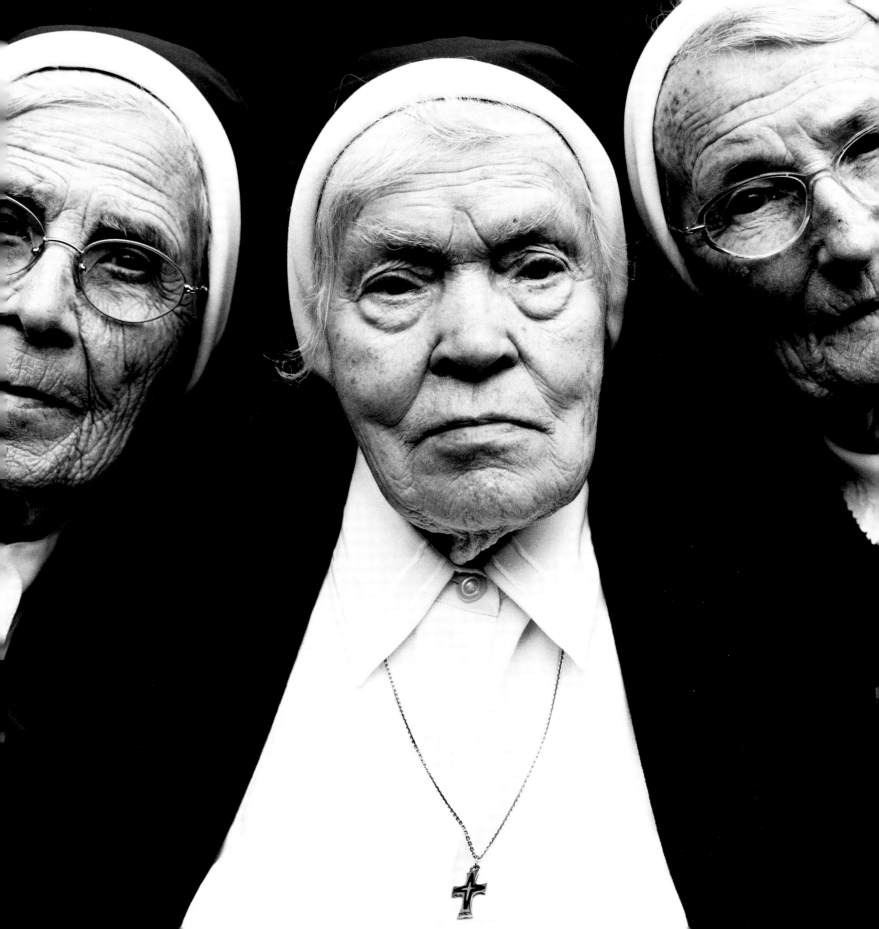

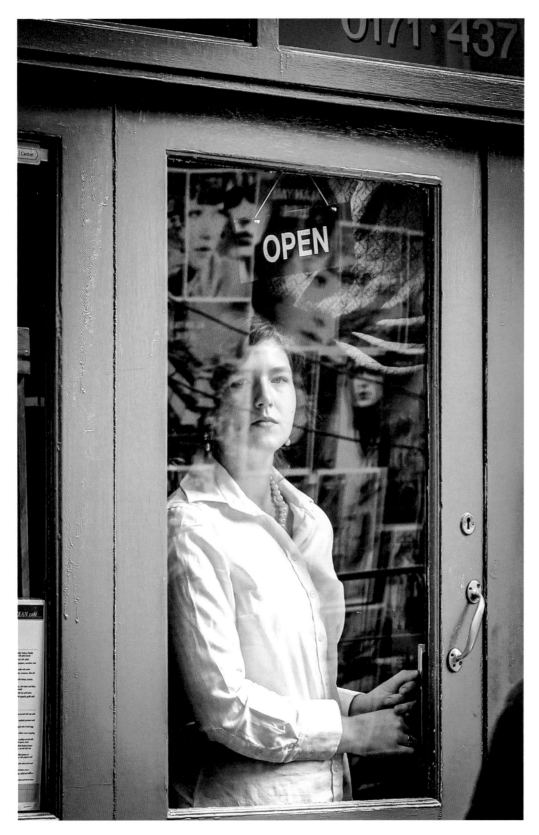

HIGHLY COMMENDED

Glance
Soho, London

Many things struck me when I found myself in front
of this scene. There was the pose, the class and the
perfect white skin of the woman watching people
passing by from the green shop window, as well
as the amazing reflections of the black-and-white
portraits on her face.

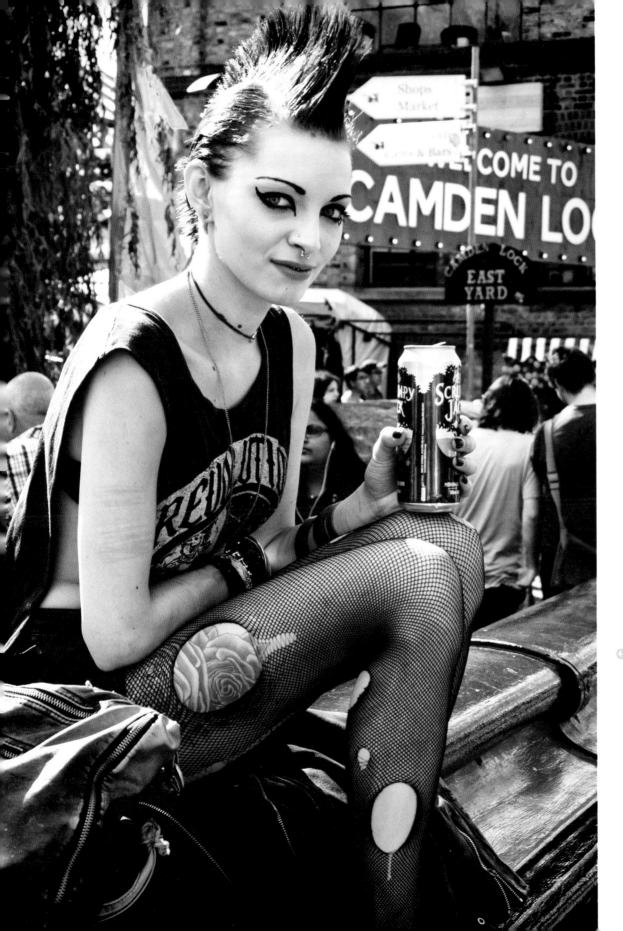

⊙ STEVE BECKETT

HIGHLY COMMENDED

Mohawk Girl
Camden Lock, London

The girl's name is Alice and I saw her
sitting on Camden Lock bridge talking to
a friend. She had such a distinctive image
I just had to take her picture. At first I
was going to take a candid shot, but
thought that wouldn't do her justice. So,
I approached Alice and asked if I could
take her photograph. She was happy to
oblige and in return I sent her a copy.

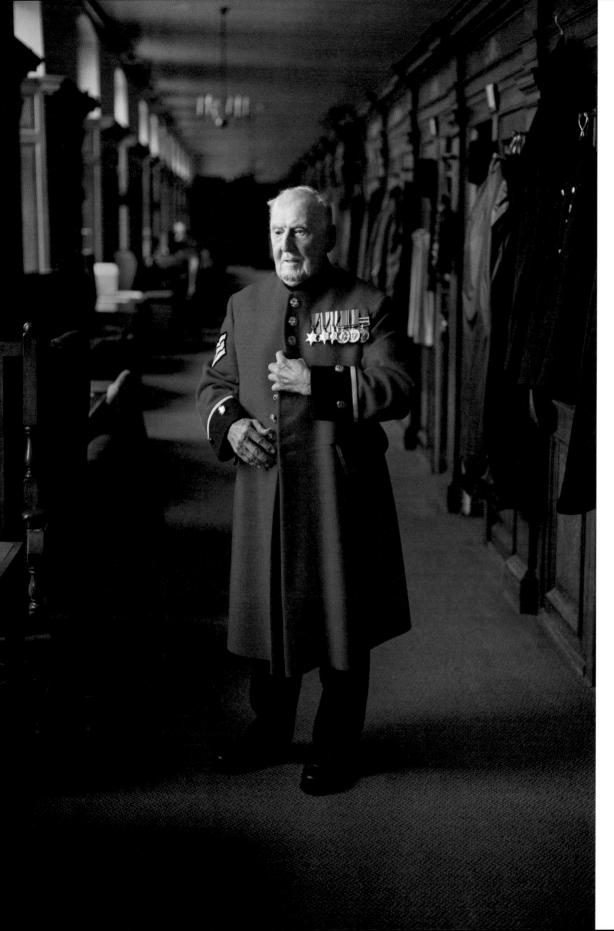

⊕ RICK PUSHINSKY
HIGHLY COMMENDED

Eric Rawlinson
Royal Hospital, Chelsea, London

This portrait of Eric Rawlinson, a former member of the Parachute Regiment, was taken by his berth in the Royal Hospital, Chelsea, for the *Telegraph Magazine*.

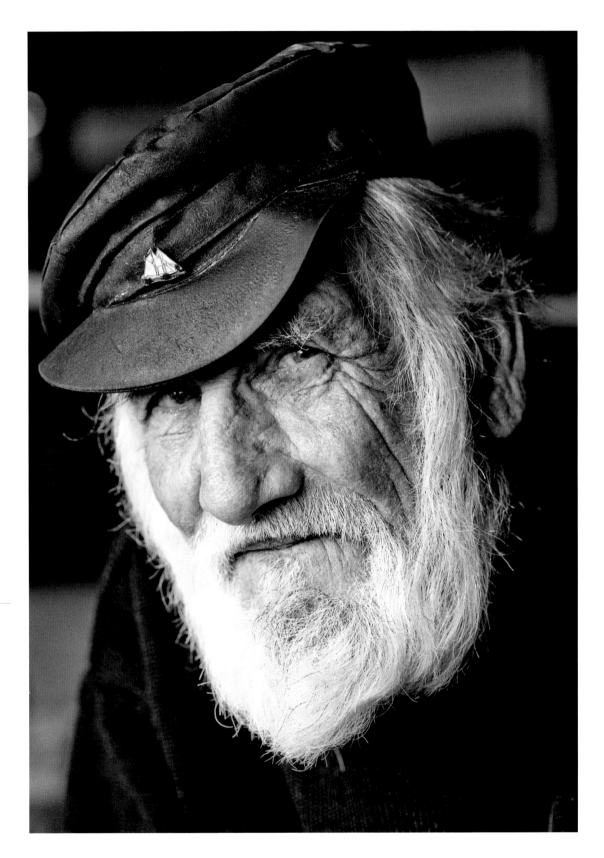

MILLIE PILKINGTON

HIGHLY COMMENDED

Ivor Charles,
Retired Fisherman and Actor
Weymouth, Dorset

A vocational portrait for my book *Great Faces of Dorset*. My objective was to convey the more serious side of this colourful fisherman; to get under the facade of his humour and twinkle, and capture his inner spirit and soul. It was a cold, but very sunny day, so I chose to shoot indoors using the light coming through a window. I find the strong contrasts of light and dark are better for creating mood.

⬆ CHRISSIE WESTGATE / HIGHLY COMMENDED

Charlie, Big Issue Seller
Colchester, Essex

Charlie is a wheelchair user who sells the *Big Issue* on the streets
of Colchester. I asked if I could take some pictures of him, but he
appeared hesitant. After we had chatted for a while he changed
his mind, saying, "Can you make me look like a film star?" When
Charlie saw the image he said with a wry grin that I "hadn't done
too bad".

Party Twins
Kent

I liked the stunning contrast of the girls' pale faces and dresses against the dark December evening. They stood to attention, patiently being photographed, but were desperate to go to the party; defiant and angelic at the same time.

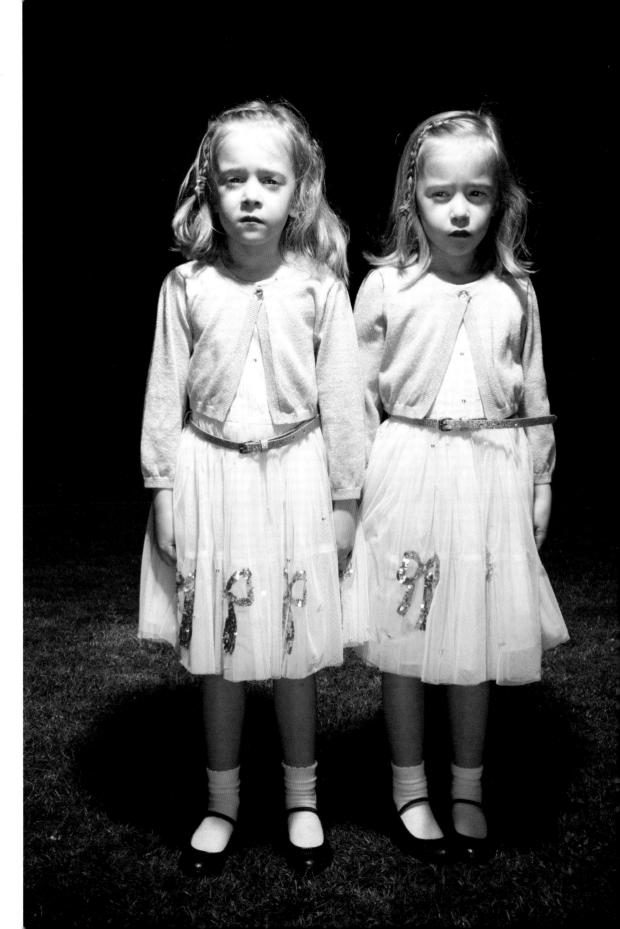

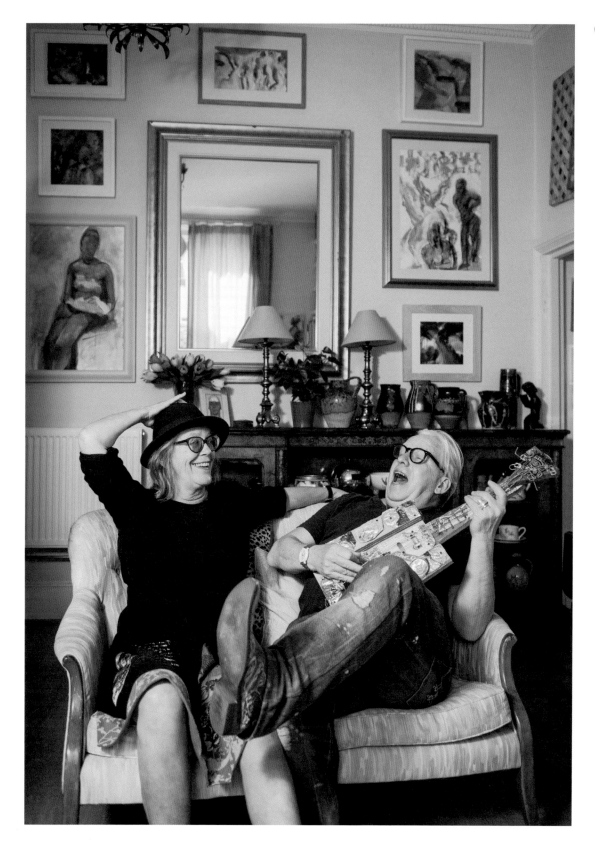

Margot & Ken
Putney, London

Margot and Ken Cox are two hugely
talented and charismatic artists, who
I photographed inside their home in
Putney, London, for a personal project.
 I shot the image very quickly, with
Ken spontaneously strumming a guitar
he had made from tin cans. It was very
simply lit, with a single flash fired into
an umbrella, helped out by two terrific
subjects looking fabulous! I feel like
I captured them perfectly.

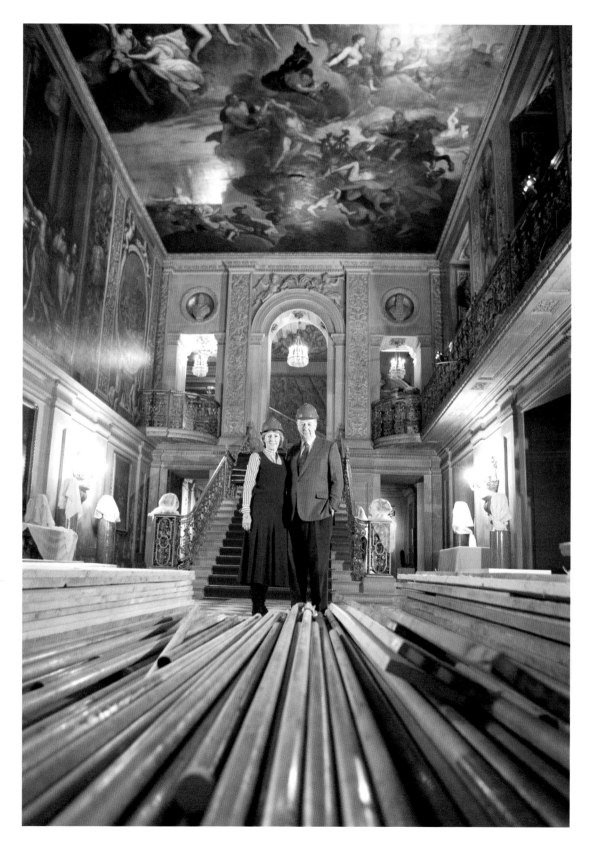

⬭ STEVE MORGAN

HIGHLY COMMENDED

Duke & Duchess of Devonshire – Restoration

Chatsworth House, Derbyshire

This is a photograph of the Duke and Duchess of Devonshire at Chatsworth House in Derbyshire, which I was commissioned to take for *The Sunday Times Magazine* during the £15m facelift of their stately home. The Duke took a little persuading to wear the hard hat, but after a little encouragement from the Duchess he relented. The room was very large and very dark, and I only had ten minutes to take the shot, making this a high-pressure job.

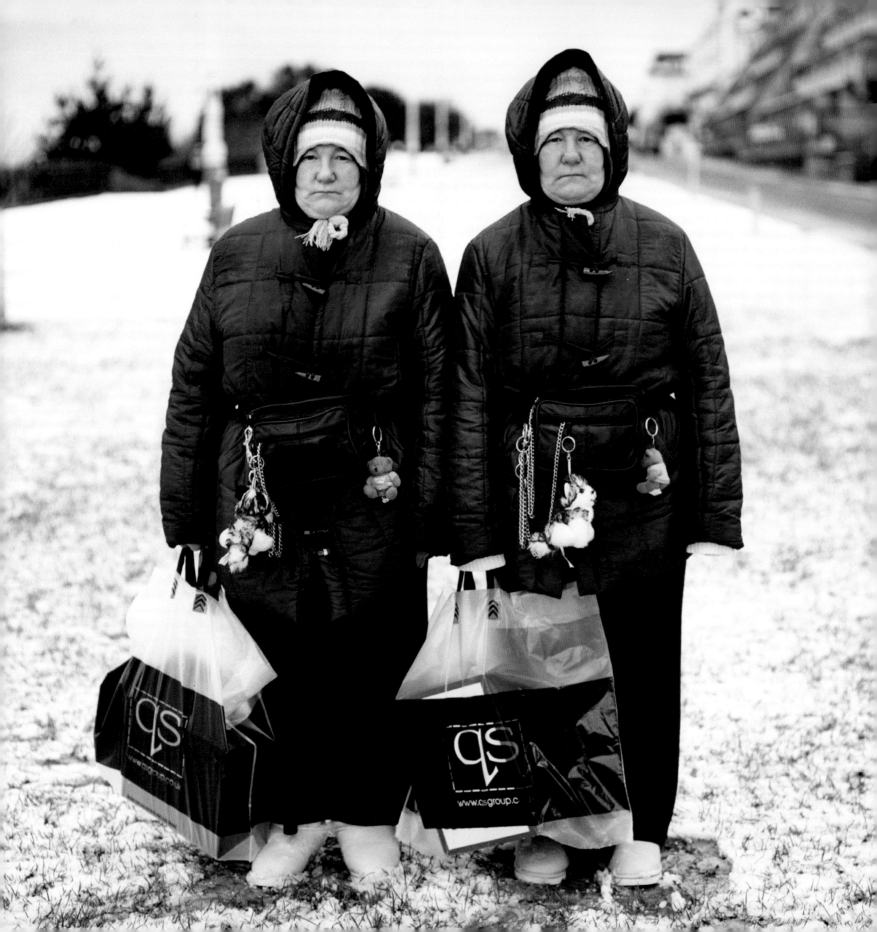

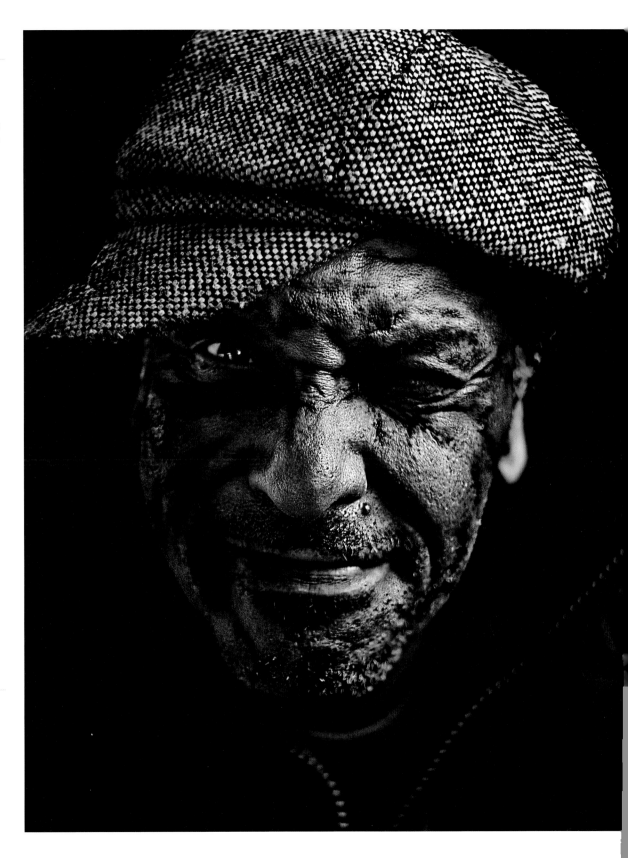

DAVID YEO

Twins
Folkestone, Kent

This was part of a personal project spent walking along the seafront in Folkestone during the Christmas holidays. This couple intrigued and fascinated me in equal measure. Everything about them is the same, from their facial expression to the teddy bears hanging from their bags. The snowy day highlighted their black coats.

KIZZIE MURRAY

Bobby
Slough, Berkshire

This is part of a personal project on homelessness, called *Forgotten Britain*. Stopping to talk to Bobby was the day that my approach to this project changed, as I decided to try and avoid the usual stereotypes of the homeless.

7

FASHION

Fashion captures the mood of 2014; its obsessions and trends, its values and beliefs. This is the category for images that reveal how popular culture has permeated our everyday life; studio or location images that thrill or shock by highlighting the striking, avant-garde or innovative nature of British fashion.

⊘ REBECCA MILLER / WINNER

Brit
Hartwell House, Aylesbury,
Buckinghamshire

This is part of a couture story that I shot for *Kensington and Chelsea Magazine*. Most of the dresses we shot were worth over £30,000, so the lavish Hartwell House was the perfect backdrop. This particular shot was taken in the drawing room.

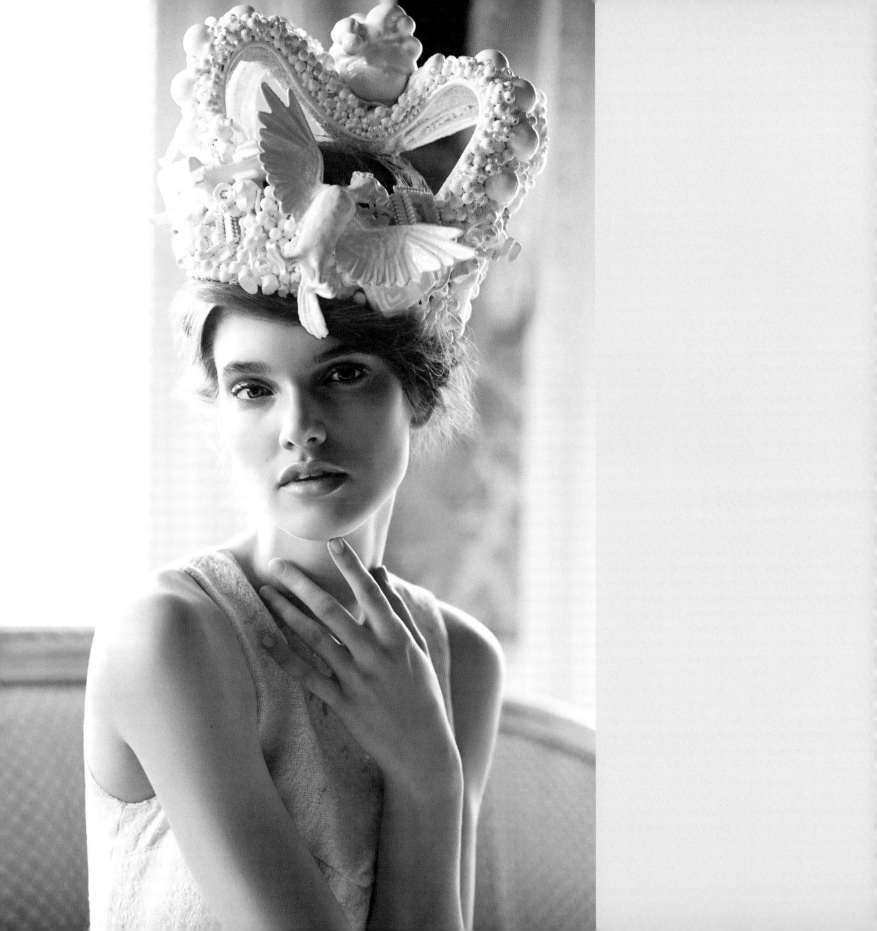

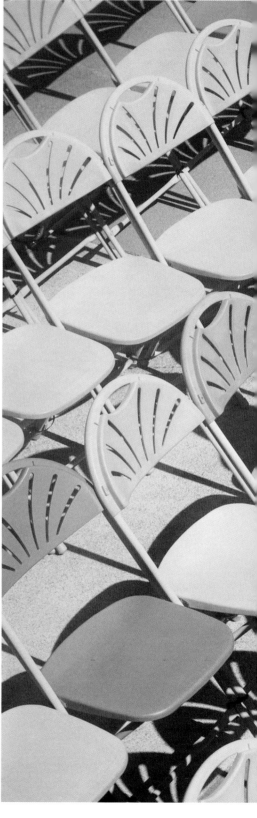

⬆ DAVID YEO / HIGHLY COMMENDED

Coats and Dogs:
Jessica with Cinders the Afghan Hound
My Studio, East London

They say that owners look like their dogs, and in this instance it's a very true saying. Jessica's coat exactly matches the colour and length of Cinders', and even the hair cascading down from their heads is similar. This is from a shoot for *Women's Health* magazine – sourcing and casting the dogs to match the coats was the trickiest part.

➡ REBECCA MILLER / HIGHLY COMMENDED

Elina
Eastbourne, East Sussex

This was part of a fashion editorial I shot on location in Eastbourne; this particular image was taken in the empty seating area in the bandstand. I've always loved watching people in the UK tilting their heads up toward the sun to really soak it in – this was one of the first things I noticed about British life when I moved here from California.

REBECCA MILLER
HIGHLY COMMENDED

Wedgwood
Stoke-on-Trent, Staffordshire

I was commissioned as part of the rebranding of Wedgwood to help restore the lustre of this iconic brand and reach out to a new generation. These images formed part of the second campaign for the luxury pottery manufacturer.

⊙ MAURIZIO MELOZZI

London Fashion Week
Somerset House, London

I took this image outside the catwalk area at Somerset House, during London Fashion Week. It was part of a personal project where I approached interesting-looking people and asked if I could photograph them against this black wall, treating the location like a studio. I was surprised at how many people agreed to participate.

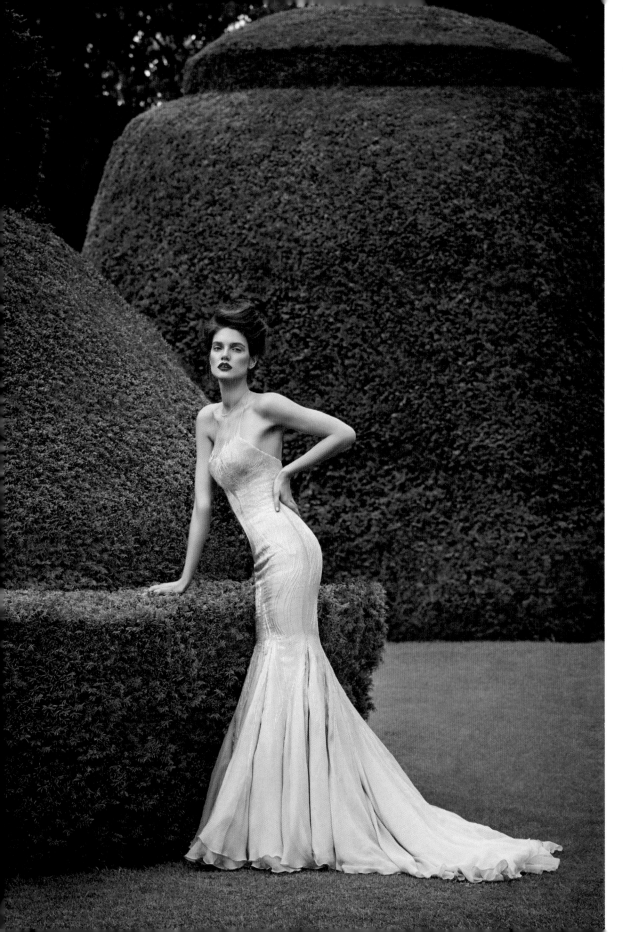

Brit
Hartwell House, Aylesbury,
Buckinghamshire

This was part of a couture story for
Kensington and Chelsea Magazine, which
was shot on location at Hartwell House
in Buckinghamshire. This particular
image was taken in the grounds of the
17th-century house. I have always loved
topiary and the associated attention
to detail – it feels so English to me.

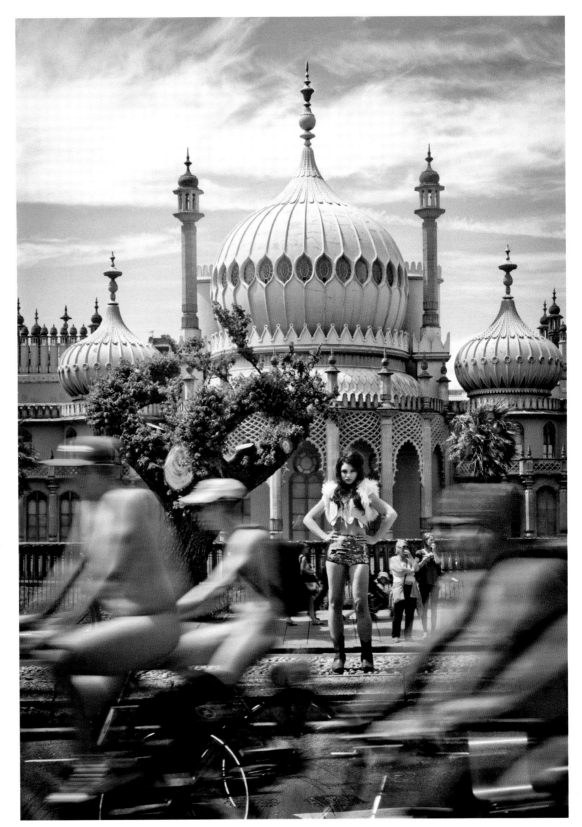

ERIKA SZOSTAK
HIGHLY COMMENDED

Overdressed
Brighton, East Sussex

Every year during Brighton's Naked Bike Ride, countless photographers train their cameras on the naked riders. I wanted to subvert that with a playful fashion shoot that focused on a clothed model against the backdrop of unclothed cyclists. The conditions were challenging, though, with many variables to contend with. For a start, the riders rode past quickly, which gave us no more than a few minutes to get a suitable gap between the cyclists and take the shot. There was also other traffic to deal with, crowds of spectators, harsh midday light and the sweltering heat.

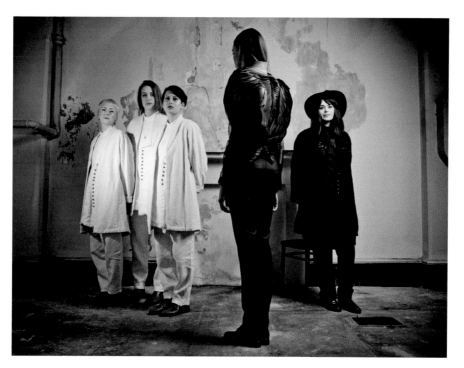

DAVID YEO

Fashion's Emerging Designers: Lauren B
The Vaults of Somerset House, London

This was shot for the *London Evening Standard* to celebrate emerging fashion designers and their innovative new styles. In this case, the subject was the fabulous peacock-feathered jacket designed by Lauren B. The trio in the background, in their pale colours, were juxtaposed to the left of the model, highlighting the vibrant colours of the jacket. Lauren B, the designer, looks on from the right, balancing the image in her iconic black outfit.

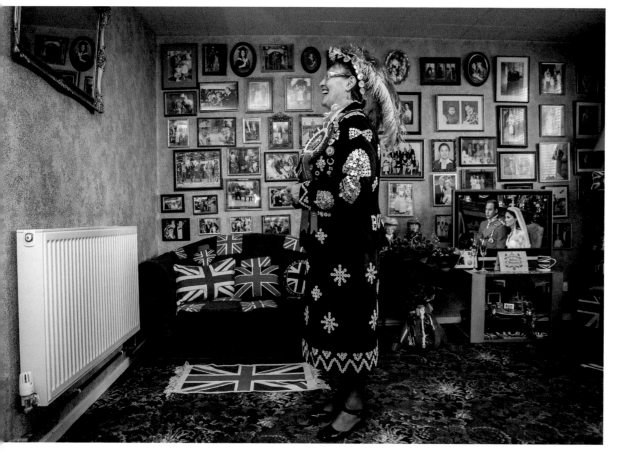

ANDREW BAKER

Royal Wedding
Wanstead, East London

Doreen Golding, Pearly Queen of Bow Bells and Old Kent Road, gets ready in her living room before attending an East London street party celebrating the royal wedding of Prince William to Kate Middleton on the 29th of April, 2011.

DAVID YEO

Kate's Torso: British Nails
West London

This was a busy project, documenting individuals that stood apart from the crowd at London Fashion Week. Kate's eyeball diamanté ring interested me, as I'd seen a similar one in a glass cabinet earlier. I was also drawn to her nails, the Barbie doll torso hanging from a chunky chain and her other rings.

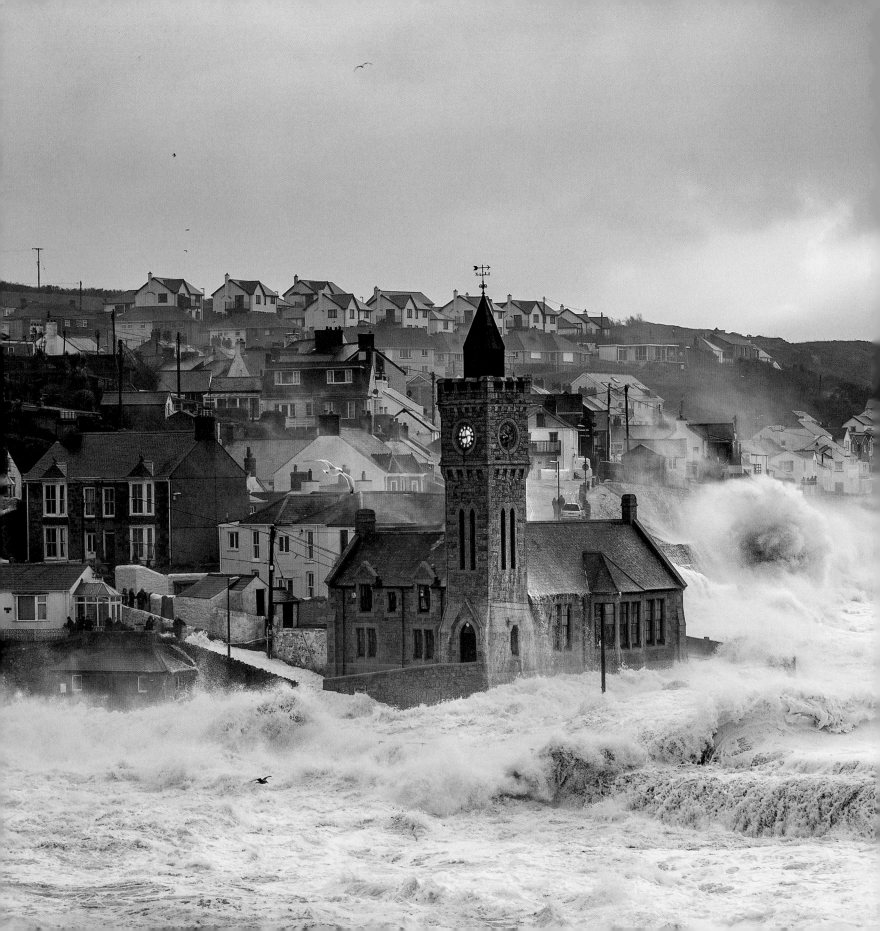

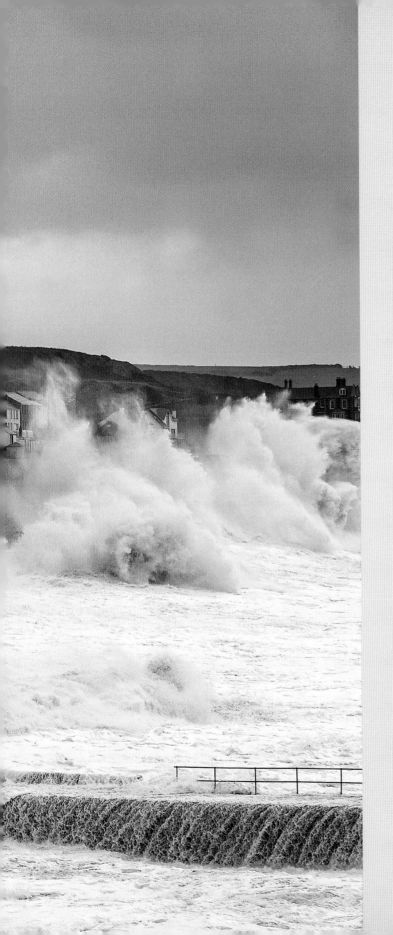

8
BRITISH WEATHER

We are blessed with four seasons that mould our landscape, coast, environment and communities. This category celebrates the great *British Weather* – a truly national obsession.

⊙ CARLA REGLER / WINNER

Porthleven Washout
Porthleven, Cornwall

We knew an ocean swell was coming, but didn't realise how big it was going to be. I had never seen the sea so high and vicious; the waves were breathtaking. Battered by the wind, a tripod was no use; shooting hand-held was the only option. I wedged myself against a fence and didn't move for about four hours.

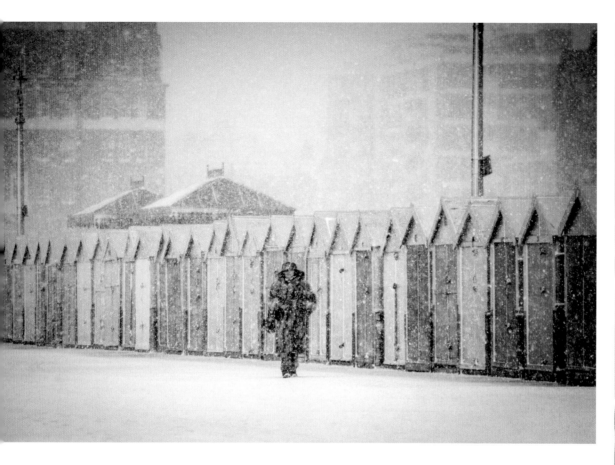

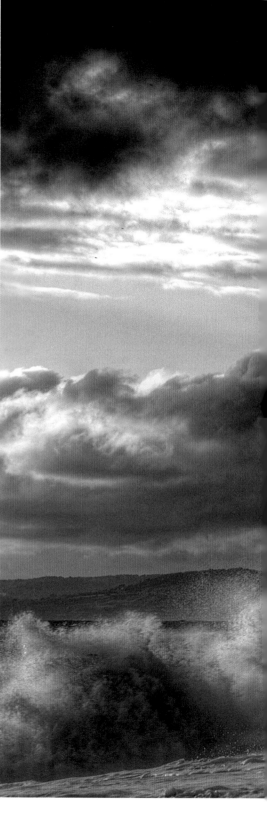

⬆ PAUL MANSFIELD
HIGHLY COMMENDED

Snowy Promenade
Hove, East Sussex

When a sudden snowstorm hit the Sussex coastline, I knew these colourful beach huts would make a great backdrop. I waited, and when this Russian-looking figure came into view I instinctively aimed the camera in her direction and grabbed the shot.

➡ STEVE LUCK
HIGHLY COMMENDED

Cliffs at Burton Bradstock
Burton Bradstock, Dorset

A lone figure looks out over churning seas and threatening skies from the cliff tops of Burton Bradstock, Dorset. Shot at the end of October, this image embodies the storms we often experience during autumn on the southwest coast. When I took this, the rain had passed and the skies were beginning to clear, creating weather conditions that often make for the most dramatic of photographs.

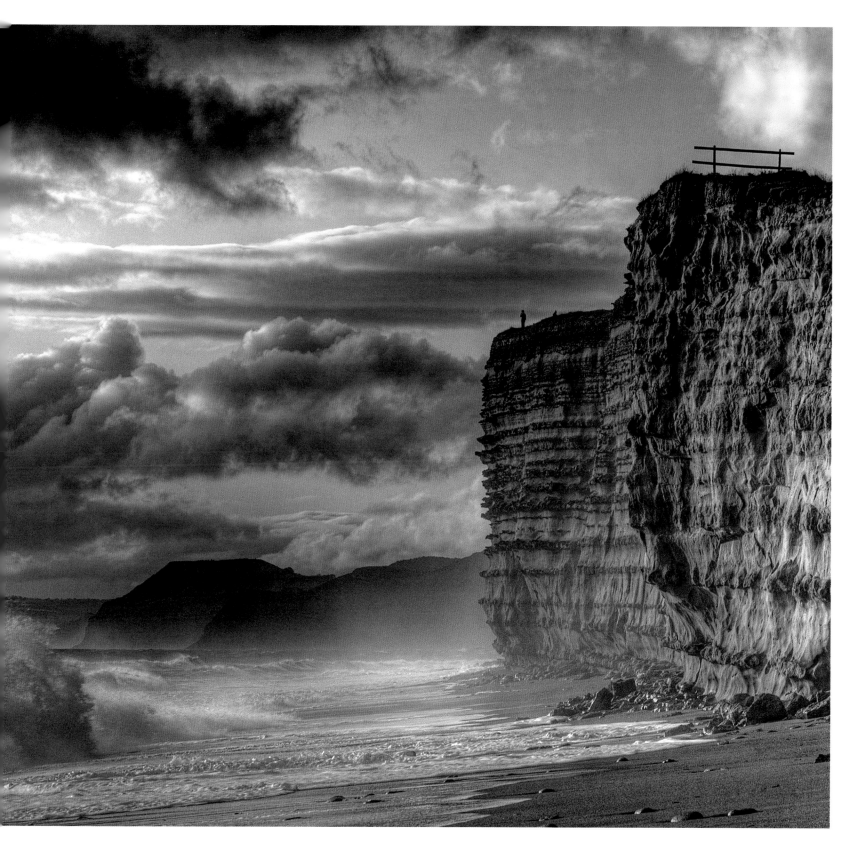

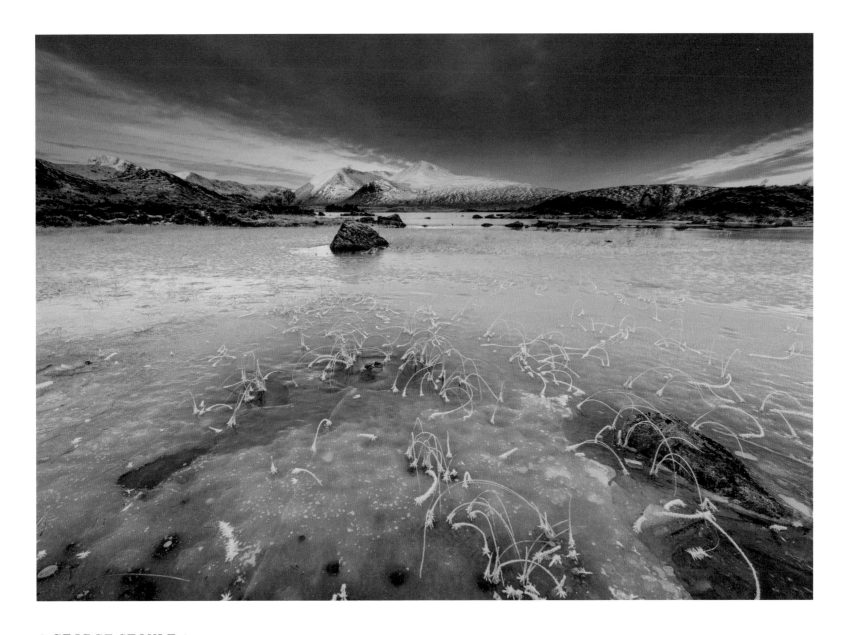

⊕ GEORGE STOYLE / HIGHLY COMMENDED

Frozen Dawn
Rannoch Moor, Scotland

This is a classic view of an iconic landscape photography location, taken at the best time of day. I wanted to focus on the foreground, using the slightly off-centre rocks and dramatic cloud formation to lead the eye to the mountains in the background, which had just started to reflect the light of the rising sun. A few moments before, the scene was a fairly drab grey, but as the sun came out the photograph came alive.

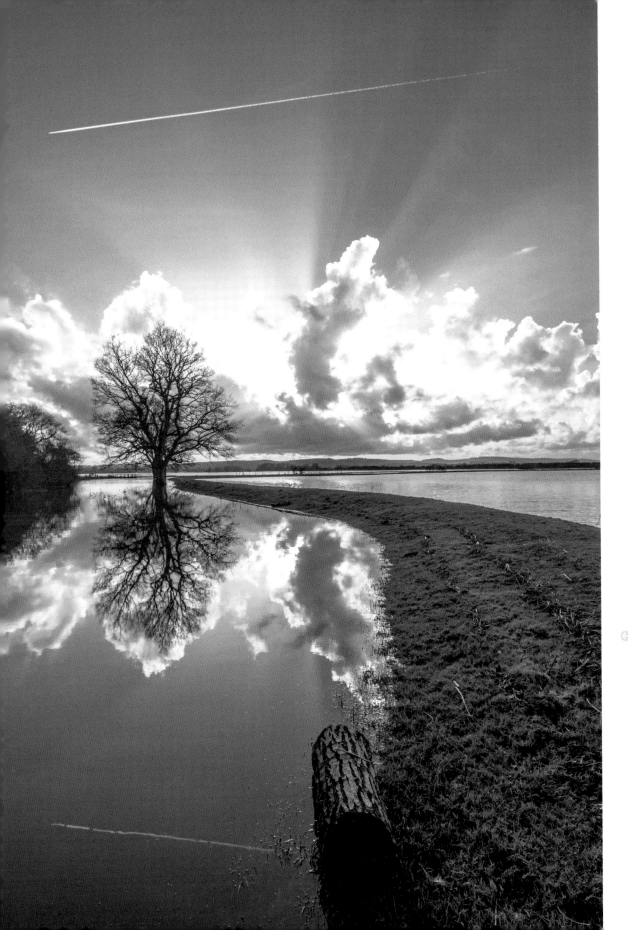

◉ ROBERT MAYNARD
HIGHLY COMMENDED

Floods on the Field
Pulborough, West Sussex

This was taken in February 2014, when the weather had been terrible for a month or so. My dad and I decided to drive to Pulborough, where we saw huge floods in the fields. We stopped the car, grabbed cameras and wellington boots, and walked down to the field. Waiting for sunset, suddenly the sun was behind the clouds and with the plane coming over the sky there was this beautiful reflection.

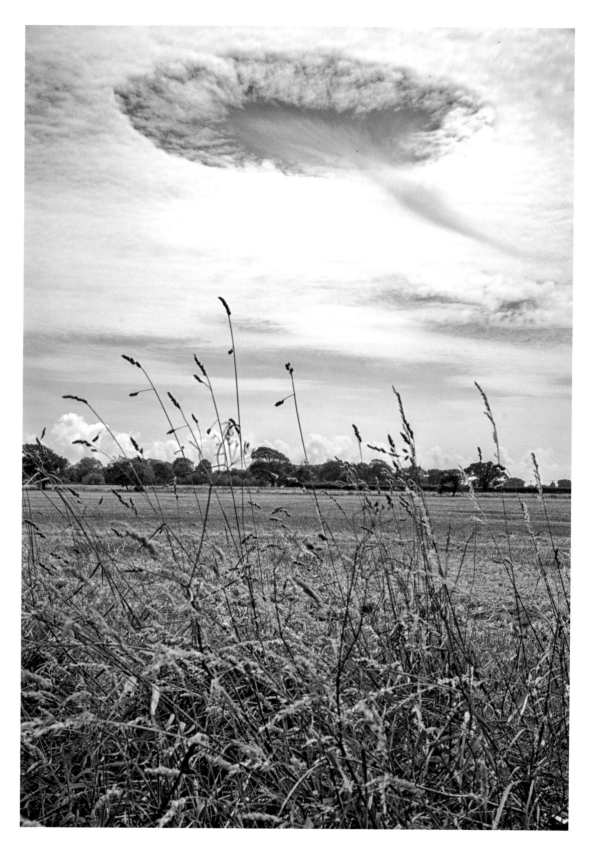

LOUIS DAVID BERK
HIGHLY COMMENDED

Tear in the Sky
Hayling Island, Hampshire

This cloud formation appeared above me as I was driving down the main road on Hayling Island. Intrigued, I managed to pull over, get out of the car and shoot this hand-held from a nearby field. I only learned afterwards that this is a rare cloud phenomenon known as a 'fallstreak hole' or 'punch hole'.

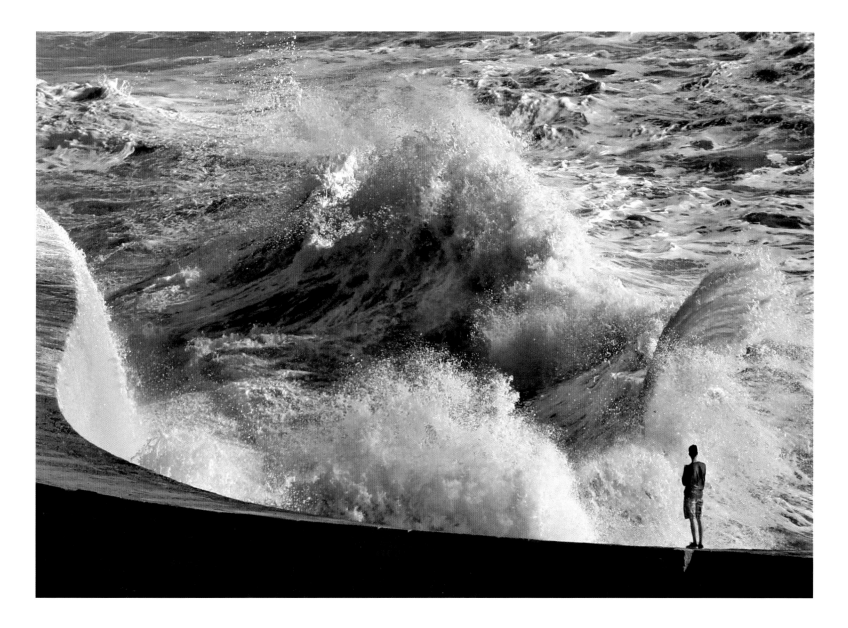

⊙ RICHARD AUSTIN

HIGHLY COMMENDED

Wave Power
Lyme Regis, Dorset

When the tide is high and there's a gale-force wind from the south west, the high wall at Lyme Regis – 'the Cobb' – takes the full force of the waves. Occasionally, people feel safe getting close to the action, but this isn't recommended. This photograph was taken from ¼ mile away from the safety of the surrounding cliffs.

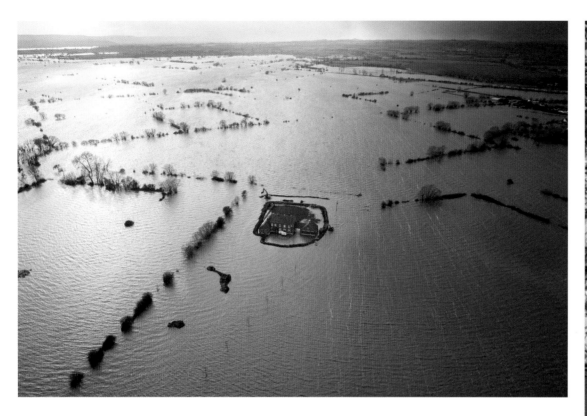

⬆ ADAM GRAY

Man versus Nature
Moorland, Somerset

The home of Sam Notaro is surrounded
on all sides by floodwater during severe
flooding on the Somerset Levels. Sam was
ultimately able to keep the floodwaters out
of his home by building a bund around
his property. The photograph was taken
while leaning out of the open door of a
helicopter, which had been hired to help
document the extent of the flooding.

➡ CHRISSIE WESTGATE

A Wet Sunday Afternoon in Essex
Mersea Island, Essex

Poacher was feeling rather dejected.
It had rained heavily and she had not
had her usual afternoon walk. As the sky
started to brighten she jumped up on the
window seat to assess the situation for
herself. I took this photograph when she
sat back down, hoping and waiting for
the word that we were going out at last.

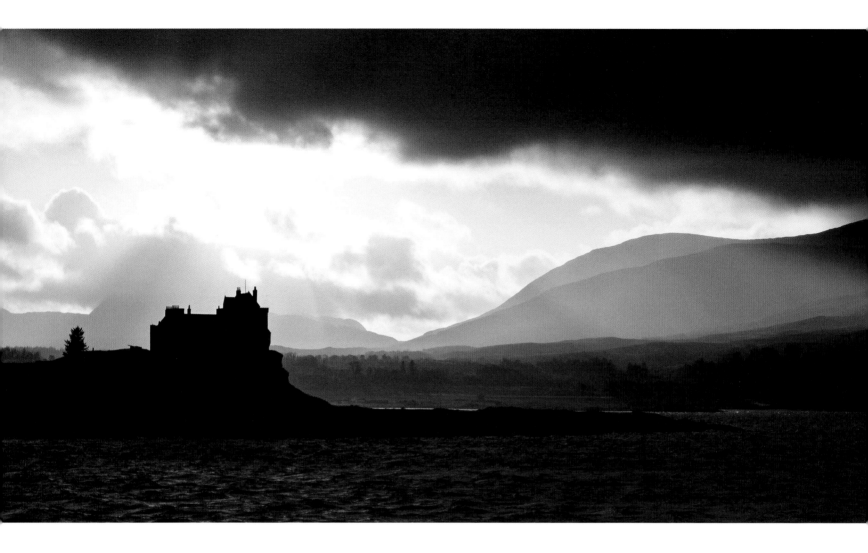

⬆ DREW BUCKLEY

Duart Castle
Duart Castle, Isle of Mull,
Scottish Highlands

This was taken on the ferry trip back
to Oban when I was visiting Mull. After
a day of typical Scottish weather some
fabulous light greeted us. The castle
looked great silhouetted against the hills
with the setting sun bursting through the
storm clouds behind it. Yet while this
image has a warm appearance to it, it
was very cold and windy when it was
taken; I just about managed to feel my
fingers to take the photograph.

⬆ CHAITANYA DESHPANDE

Omen
Brighton, East Sussex

With a storm forecast, I made the brave decision to go to Brighton and photograph an angry sea. I had 'perfect' conditions – angry sea, dark clouds and even the sun showing itself on the horizon. I had forgotten that it was still starling season, but I was thankful when they made their appearance, adding drama to an already dark scene.

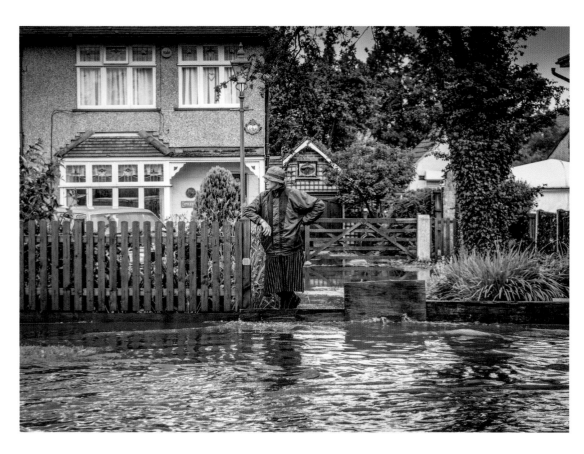

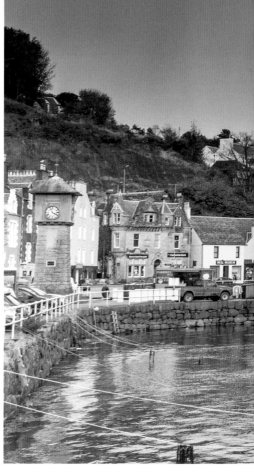

IAN FRANCIS

Holding Back the Flood
Hucknall, Nottinghamshire

A local man doing his best to hold back the floodwaters after a flash storm hit Hucknall in 2013.

ALAN JOHNSTONE

Searchlight
Elgol, Skye, Scotland

This was taken from the car park overlooking Elgol harbour. I was sheltering in the car from a torrential rain shower that was just clearing away when the sun broke through the clouds. I just had time to jump out of the car and get a few shots before it disappeared.

DREW BUCKLEY

Tobermory
Tobermory, Isle of Mull, Scottish Highlands

No visit to Mull would be complete without visiting Tobermory. A beautiful little picture postcard fishing port, it's a great place to take a camera. However, in autumn the Highlands tend to get more than their fair share of rain! After hiding in the car for 20 minutes or so, the rain passed and strong sunlight appeared. The rain streaks and vivid rainbow provided a great backdrop to this scene.

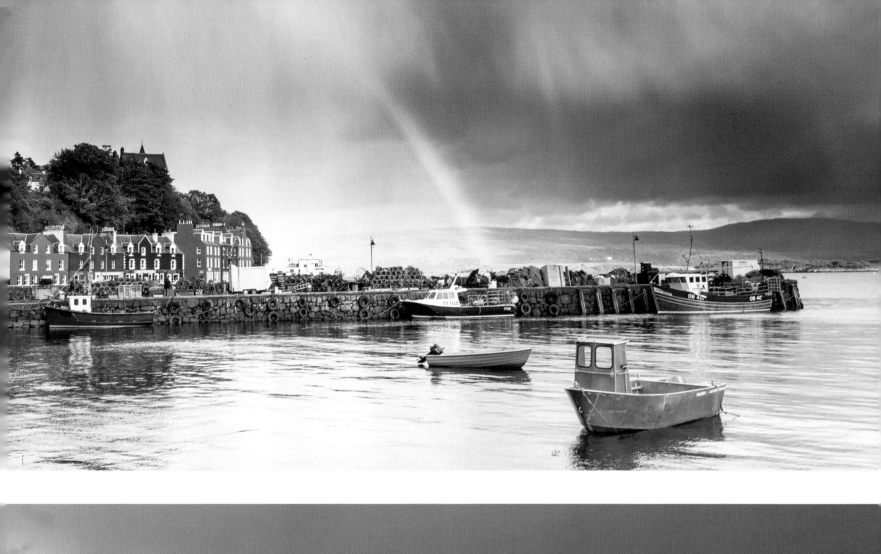

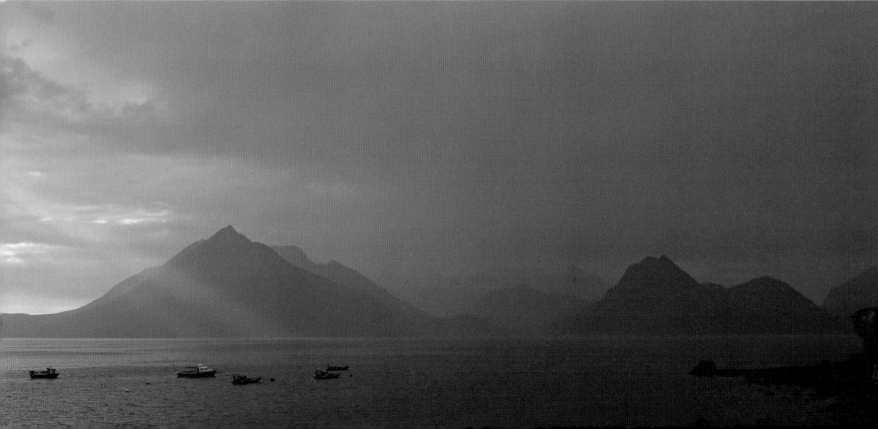

9
HISTORIC BRITAIN

Historic Britain celebrates our country's past, with images taken before the 1st of January, 1990.

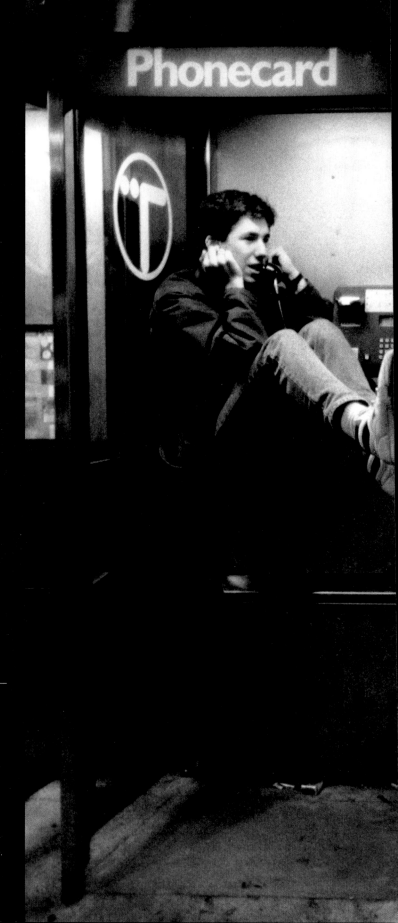

⊙ JOHN STURROCK / WINNER

Life Before the Mobile Phone (1987)
Finchley, North London

Before the invention of the mobile phone, teenagers used to hang out in phone boxes. I was driving home after working on a feature for the *Independent Magazine* about Margaret Thatcher's constituency in Finchley. I saw this scene, stopped the car, ran over and took a few photographs – I don't know if these teenagers noticed me.

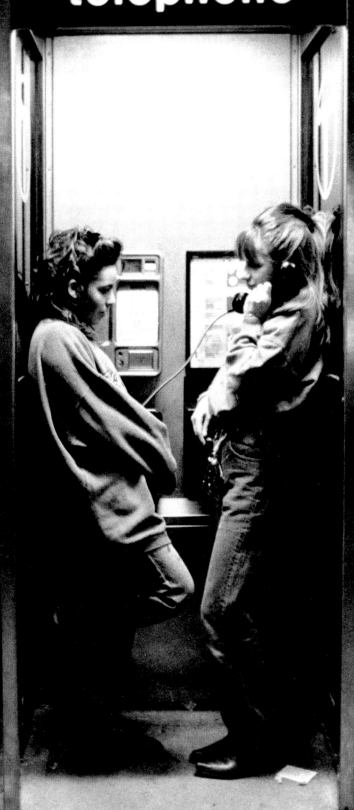
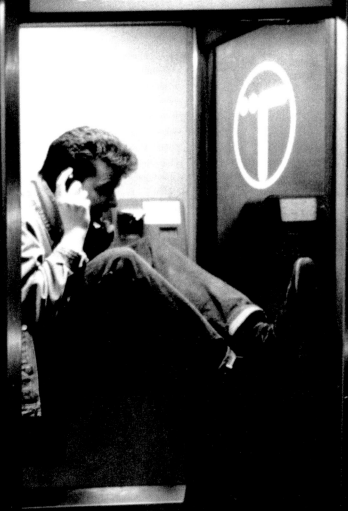

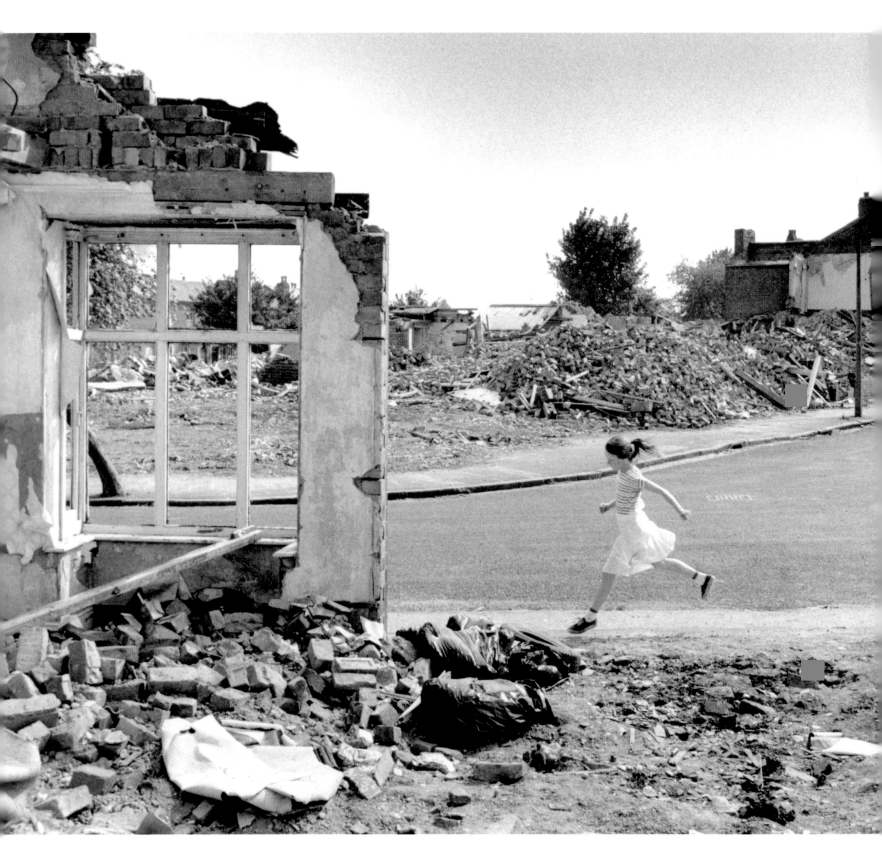

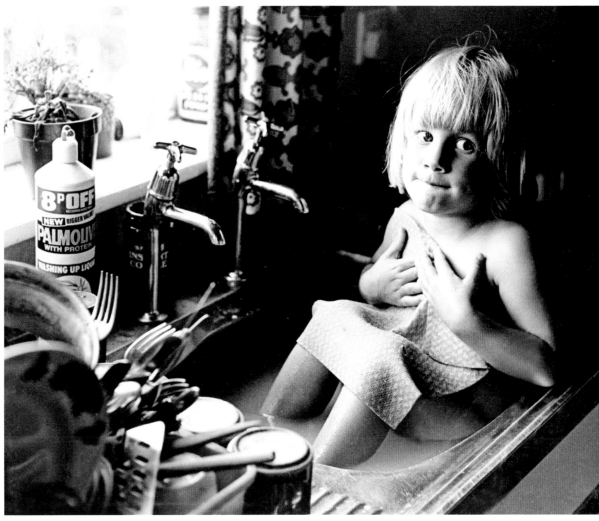

⊙ JOHN STURROCK / HIGHLY COMMENDED

A Magic Moment in Smethwick Desolation (1989)
Smethwick, West Midlands

A girl runs past derelict houses near the corner of Carlton Road and Whitehall Road in Smethwick, an area blighted by compulsory purchase orders. This photograph was taken as part of a feature for the *Observer Magazine* about Smethwick, after it was awarded the title of 'dirtiest town in Britain' in 1989.

⊙ JOHN STURROCK / HIGHLY COMMENDED

Bathtime in Tain (1976)
Tain, Ross and Cromarty, Scotland

A girl has a bath in the kitchen sink, in the highland town of Tain, on the south shore of the Dornoch Firth.

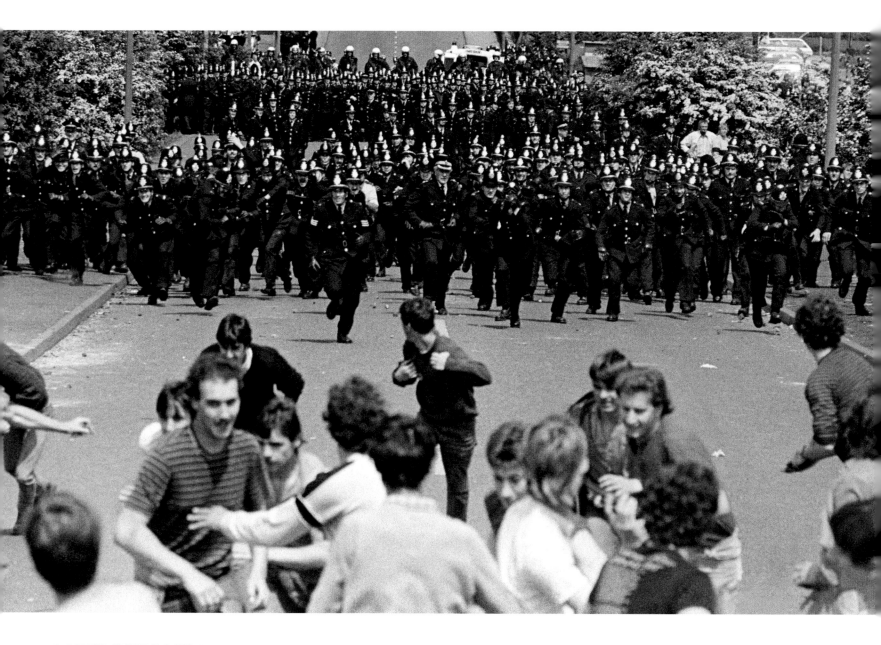

⬆ JOHN STURROCK / HIGHLY COMMENDED

**Police Charge Striking Miners at Orgreave
(30th May, 1984)**

Orgreave Coking Works, Near Sheffield, South Yorkshire

Police charge at picketing miners outside Orgreave coking works
during the miners' strike. This photo was taken in the early days
of the Orgreave picketing, before the police started using riot gear.

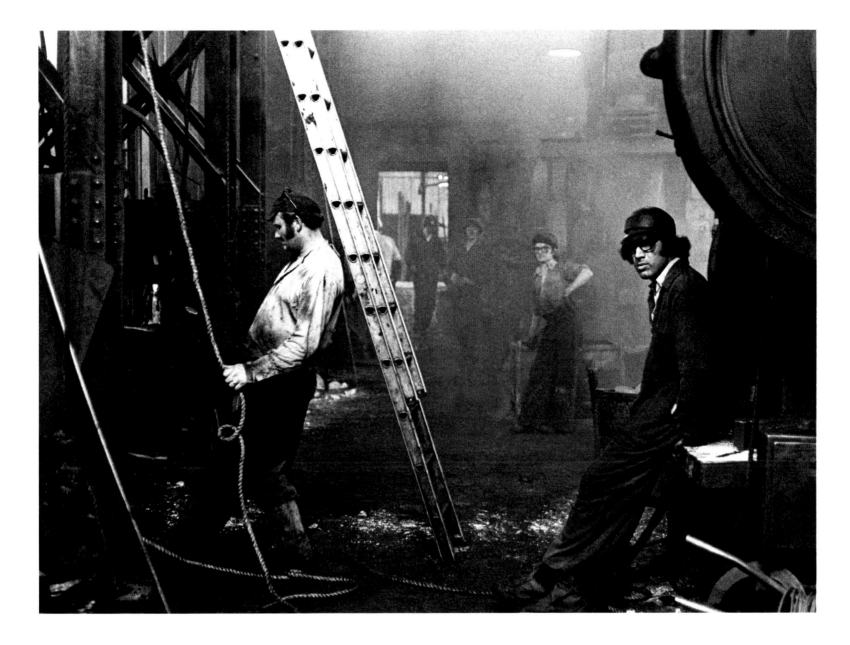

⬆ JANINE WIEDEL / HIGHLY COMMENDED

7AM at Smith's Drop Forge (1977)
Aston, Birmingham

Taken at 7AM, as the early morning light filtered into the dim
workshop. The Drop Forge produced most of the male-female
couplings for articulated lorries in Britain. The majority of the
workers (many from the same family) had been employed by the
company for their entire working lives. I was working on a two-
year project entitled *Vulcans Forge*, documenting industries in
the area.

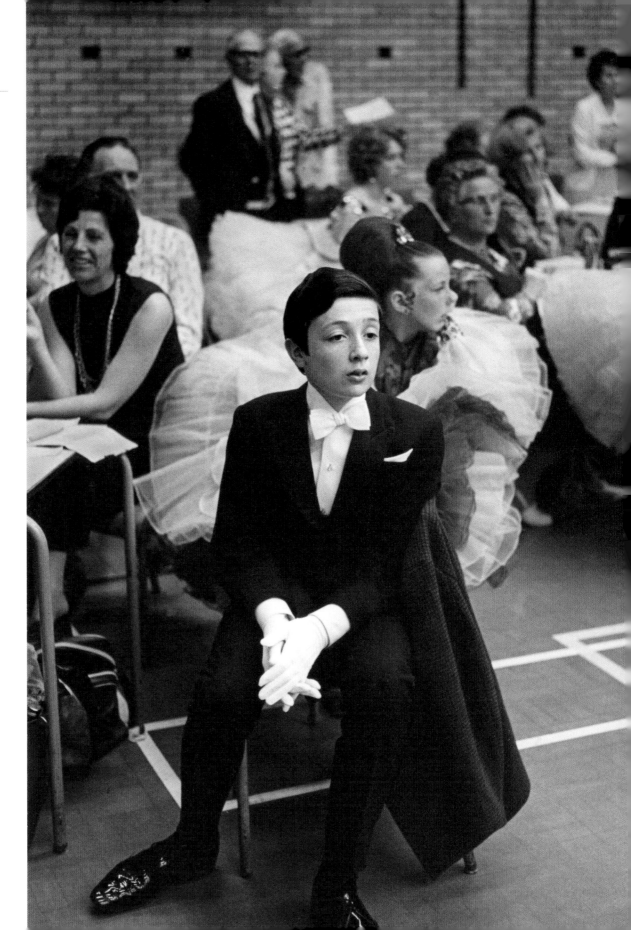

DAVID JONES
HIGHLY COMMENDED

"When Will It Be My Turn?" (1974)
Ebbw Vale Leisure Centre, Ebbw Vale,
Blaenau Gwent

While I was studying documentary
photography I set myself a project to
photograph a junior ballroom dancing
competition. As the low lighting at the
venue made it difficult to photograph
the movement of the dancers, I turned
the camera on the spectators instead.
This gave me a more engaging picture,
and one which, I felt, encapsulated the
whole event in a single image.

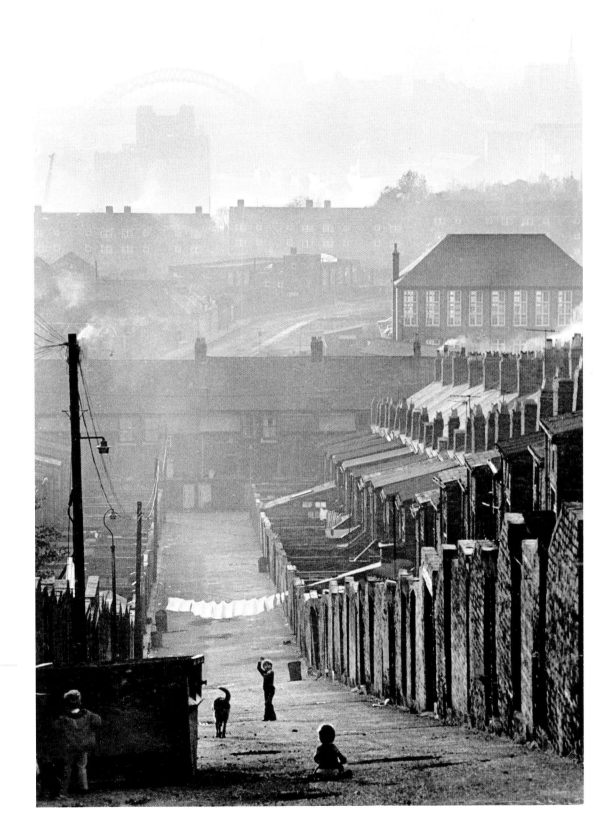

JOHN STURROCK

HIGHLY COMMENDED

Byker and the Tyne (1976)
Byker, Newcastle upon Tyne,
Tyne and Wear

A view of Newcastle and the ships
berthed on the Tyne from a terraced
street in Byker. These streets were
subsequently demolished as part
of the redevelopment of the area.

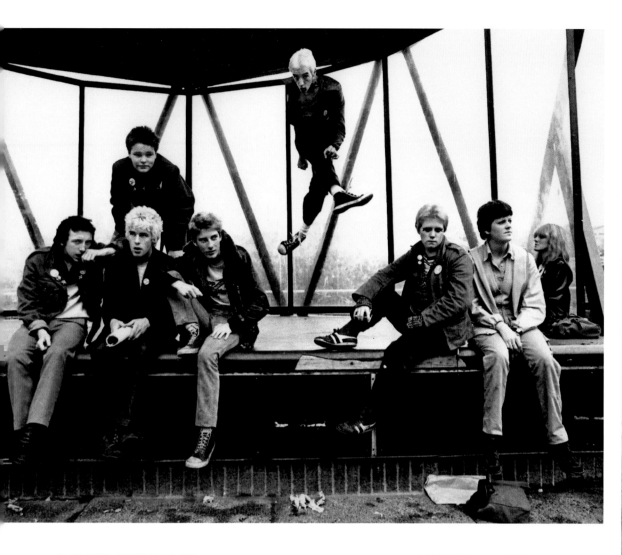

⬆ JOHN STURROCK

HIGHLY COMMENDED

Glasgow Punks (1979)
Glasgow

A group of unemployed youths
in Glasgow city centre.

➡ JOHN STURROCK

HIGHLY COMMENDED

**Woman and Baby in Smethwick
(1989)**
Smethwick, West Midlands

A mother and her baby in the backyard
of their terraced house in Smethwick.
This was taken for the *Observer Magazine*
after Smethwick was awarded the title
of 'dirtiest town in Britain'.

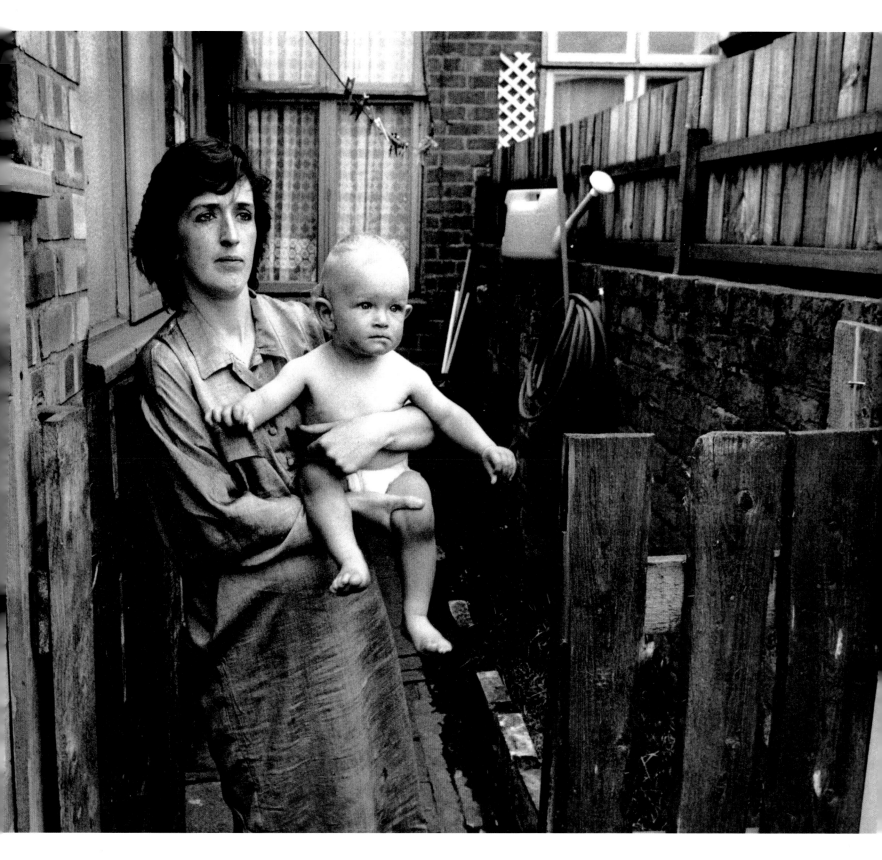

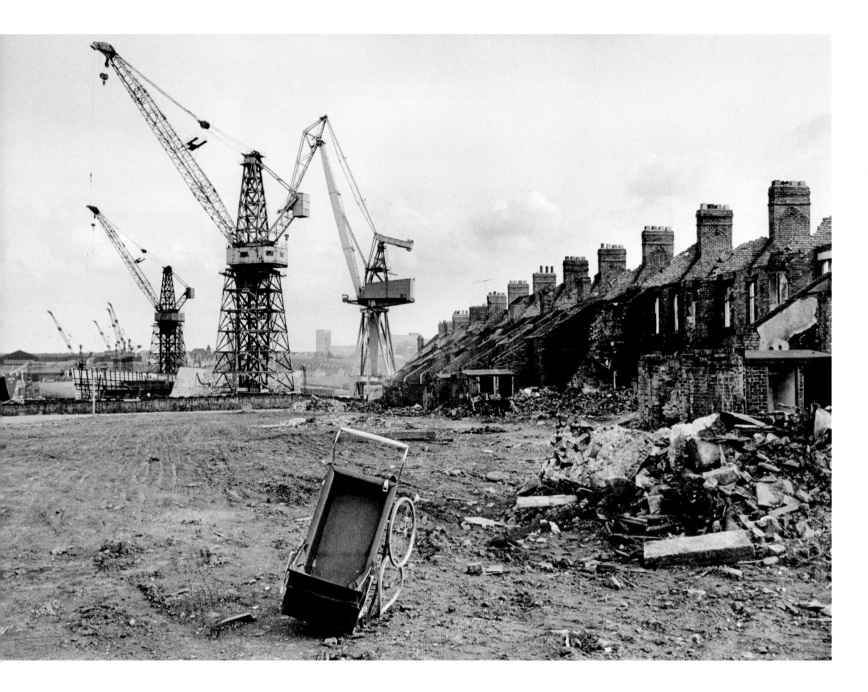

⬆ JOHN STURROCK

Swan Hunter Shipyard (1986)
Wallsend, Tyne and Wear

The Swan Hunter shipyard, seen
from derelict housing in Wallsend.

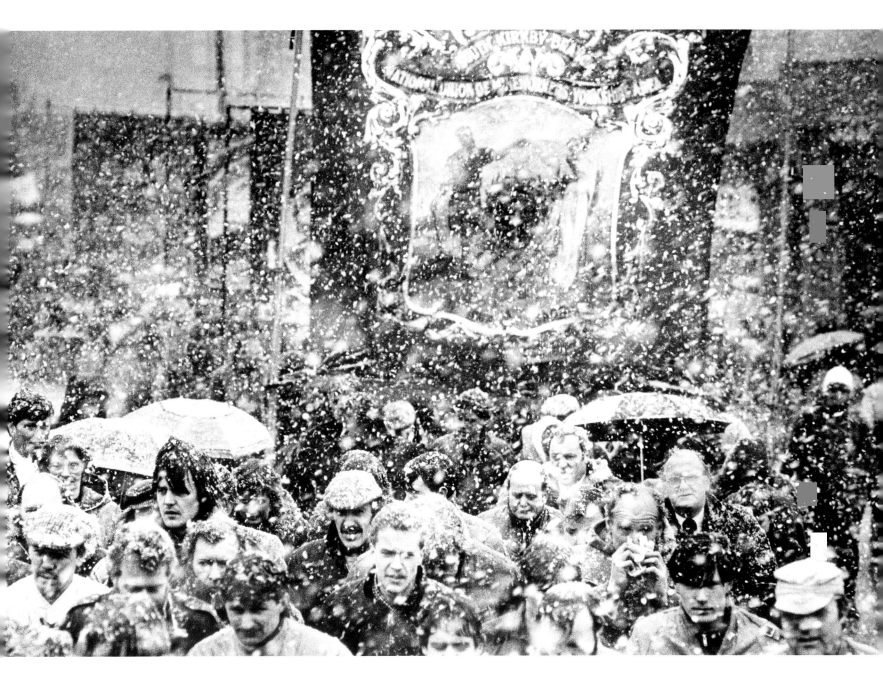

⊕ JOHN STURROCK

Miners' Memorial March (1985)
South Kirby, West Yorkshire

At the end of the miners' strike, on a cold, snowy day in March, a memorial is held in South Kirby on the first anniversary of the death of miner Davy Jones. Davy was killed on a picket line in Ollerton, Nottinghamshire on 15th March 1984, at the start of the strike.

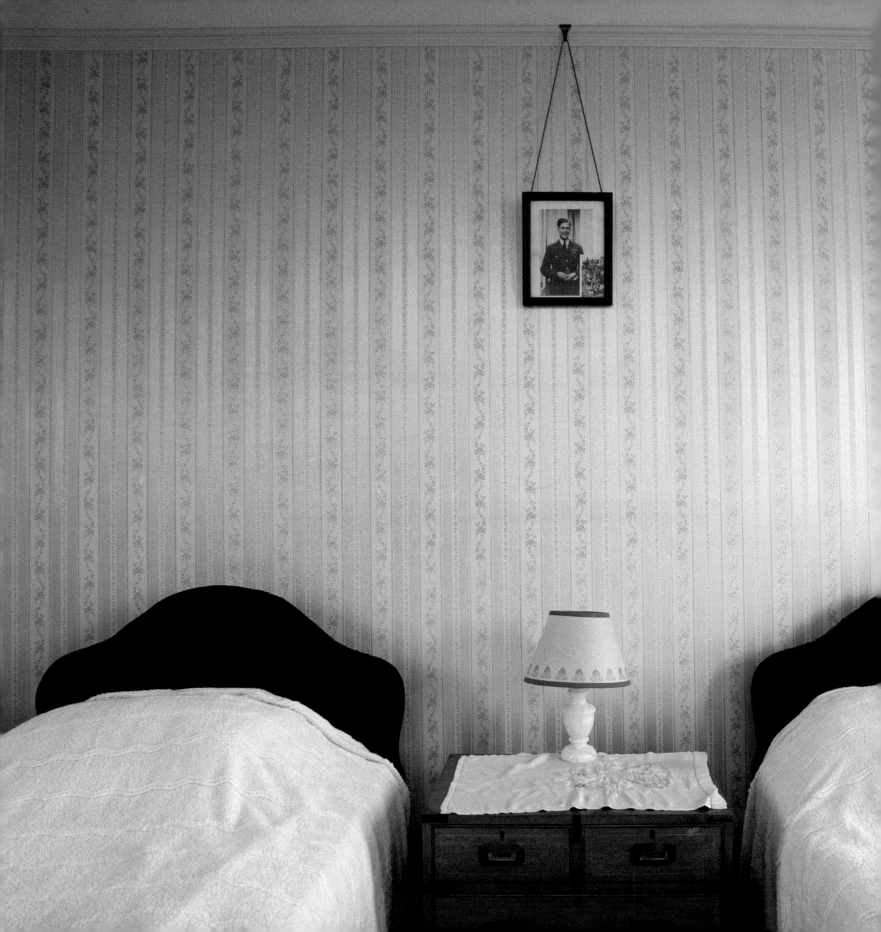

10

DOCUMENTARY SERIES

The *Documentary Series* celebrates portfolios of images that tell the story of any subject or topic that conveys life in Britain.

ZOË BARKER / WINNER

House of Two Sisters Series
Ryde, Isle of Wight

SISTERS' SHARED BEDROOM
Jean and Joy shared this bedroom from the 1950s until Jean passed away in 2008.

The main photograph on the wall shows family friend and Spitfire pilot, George Gribble. He victory-rolled over the house whenever he flew over the island. On 4 June, 1941, he bailed out over the sea near Dunkirk – he was never found.

The smaller photograph in the corner of the same frame is Bill Tudhope, a bomber pilot who was engaged to a cousin. He failed to return from a bombing mission over Germany in 1940.

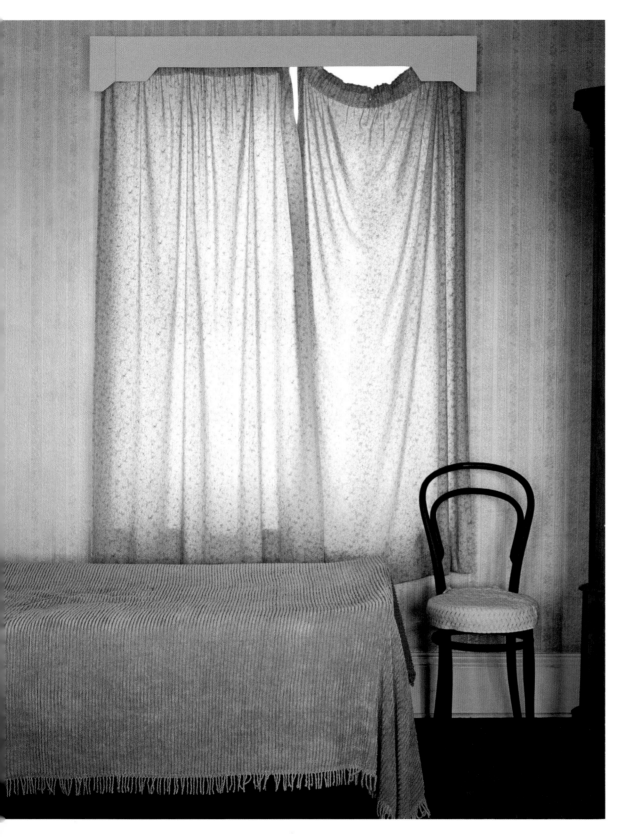

CANDLEWICK AND CURTAINS
Very much a family home in the early days, sisters Jean and Joy initially shared this large house with their mother and Aunt Edie. This was always kept as the spare room for visitors.

FRONT DOOR KEY
Jean and Joy were born in this house in 1916 and 1922 respectively. This was Jean's home all her life, but in 1957 Joy left to live in London. Neither married, and on retiring in 1981 Joy returned to live with her sister. They remained there together until Jean passed away.

Joy has now moved into a care home and the house has been sold.

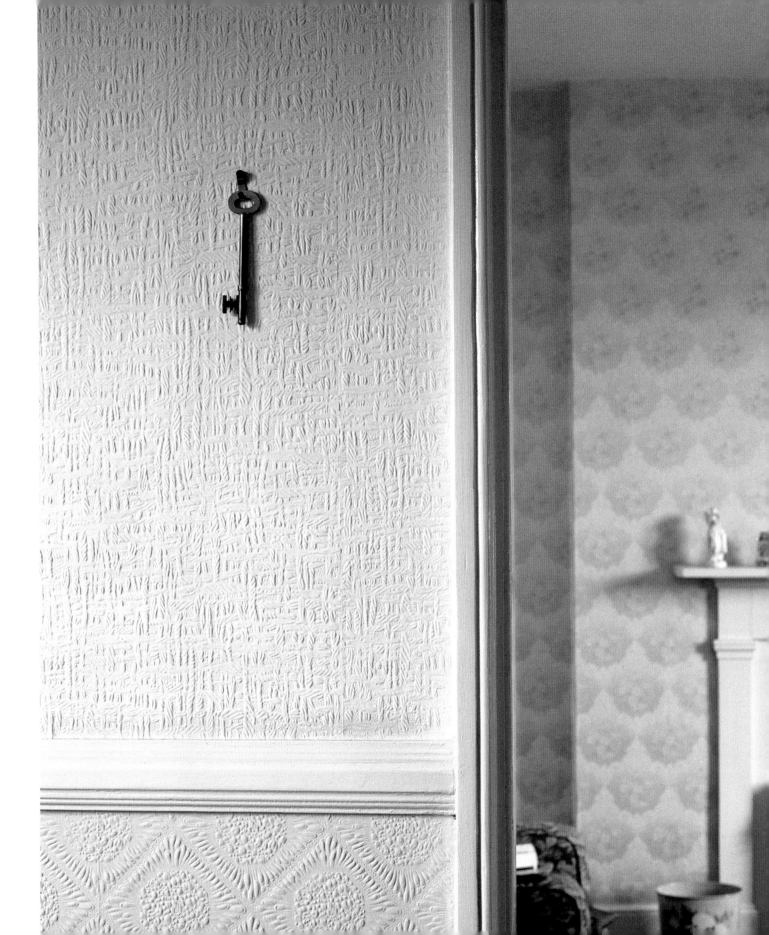

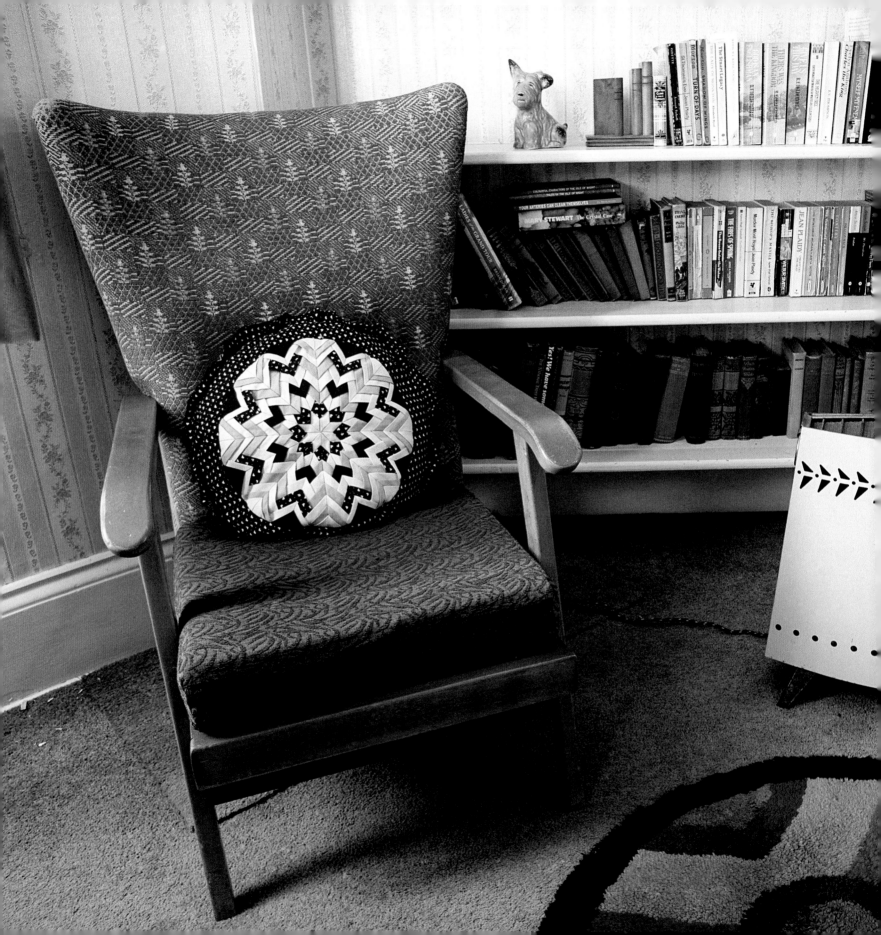

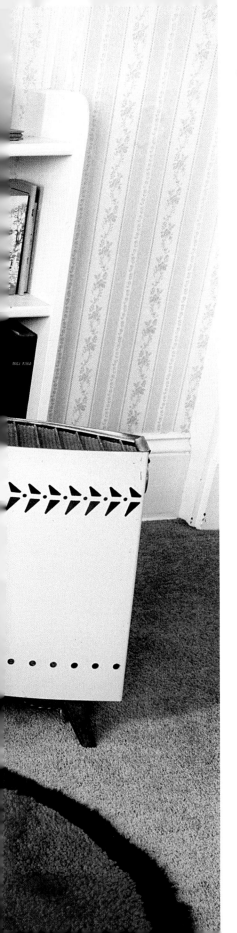

CHAIR AND HEATER
The rug was made by Aunt Edie's long-term boyfriend 'Uncle Bert'. The pair stepped out every Wednesday afternoon until he passed away. The family can only speculate why they never married.

Although they don't dare use it, the new owners of the house have kept this extraordinary heater. The blue dog belonged to Aunt Edie.

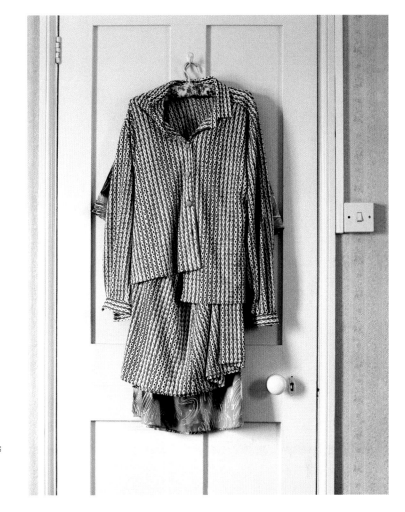

SUNDAY BEST DRESSES
Niece Gill remembers Jean wearing this two-piece on warm summer days. Both her aunts were smart dressers, even on ordinary days at home.

FOWLER'S TREACLE
The new owners of the house have kept this Fowler's Treacle tin and many other old containers, including over-the-counter medicines and salves, with a view to displaying them in the house in future.

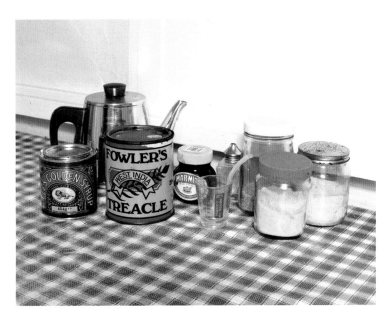

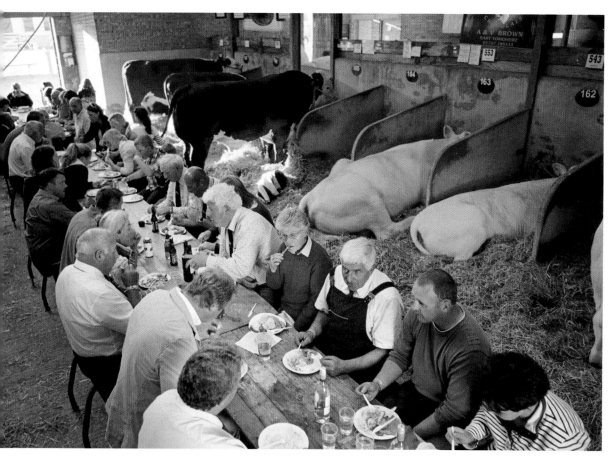

ARNHEL DE SERRA
HIGHLY COMMENDED

When the Sun Set Over the Royal
Various locations

These images are a humorous photographic journey through the UK's annual rural calendar of agricultural and country shows. It is estimated that six million people visit these shows every year, which is roughly ten percent of the population. For this project, I have travelled from Land's End to John O'Groats – and beyond, to Orkney – to capture rural life at its seasonal best.

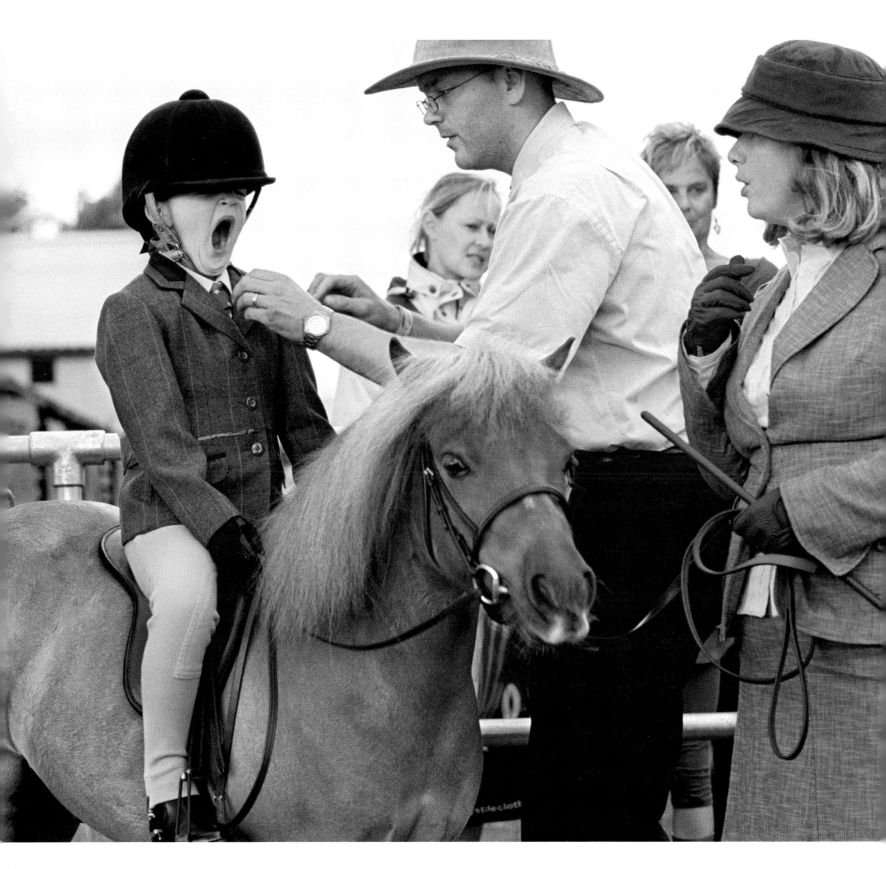

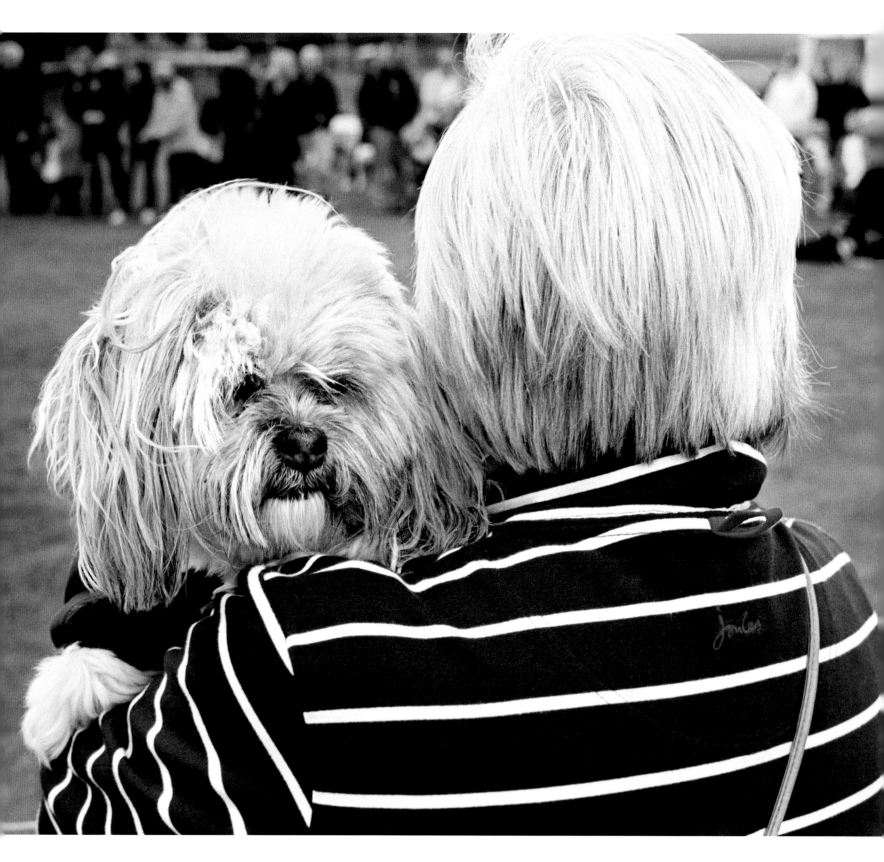

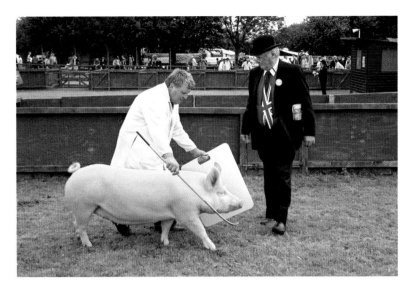

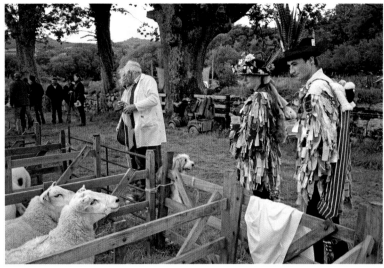

HEATHER BUCKLEY

Brighton Naked Bike Ride, 2014
Brighton, East Sussex

I arrived early on the day of the Brighton
Naked Bike Ride to make sure I was there
when the participants started gathering,
getting naked and painted for the ride.
I've been covering this event for years now,
so the organisers know me and many of the
people I photograph will have met me before.
My main focus is on the experience; the
challenge is to get something interesting
that isn't just about the nudity. I try and add
some humour, but I hope I show the people
in a dignified way.

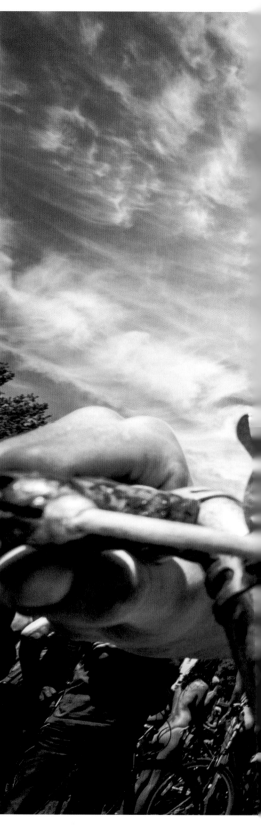

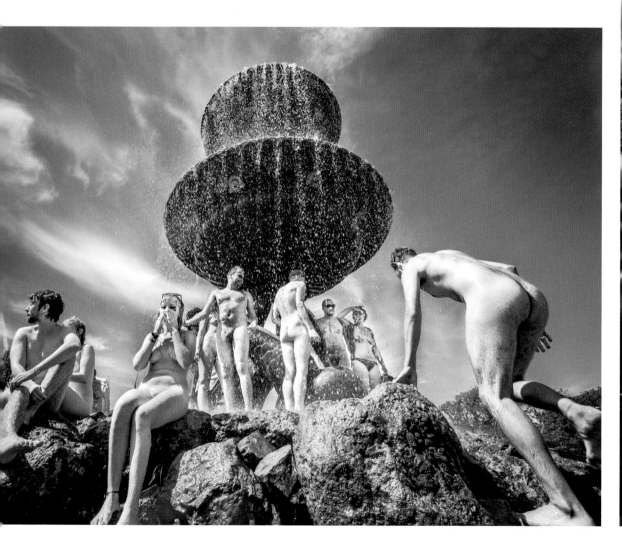

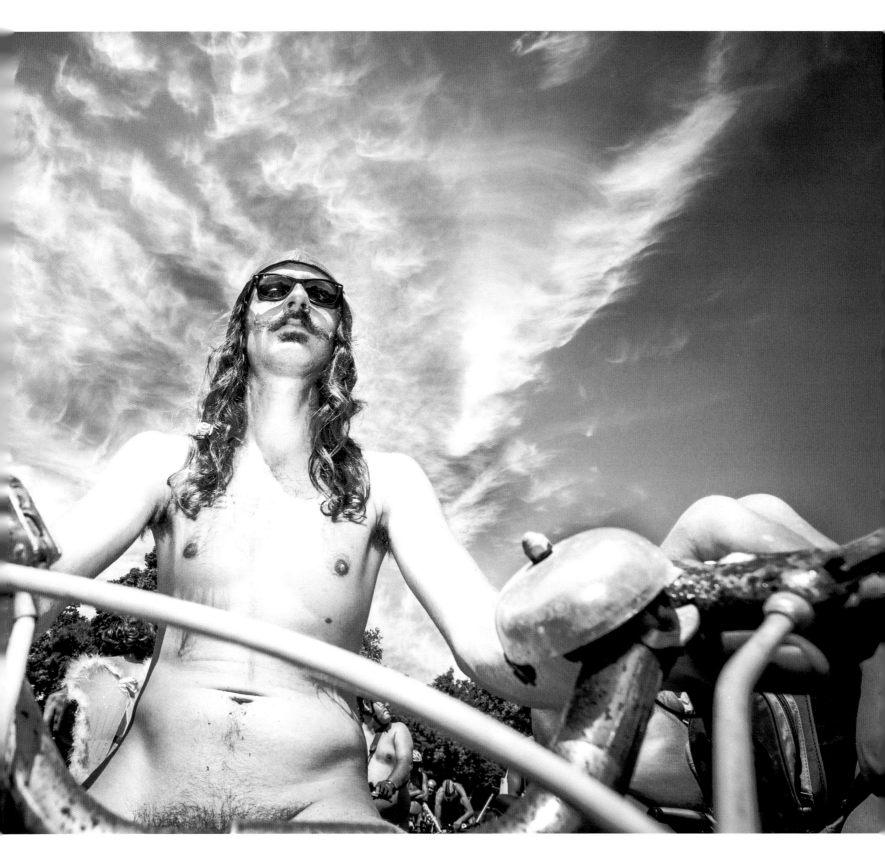

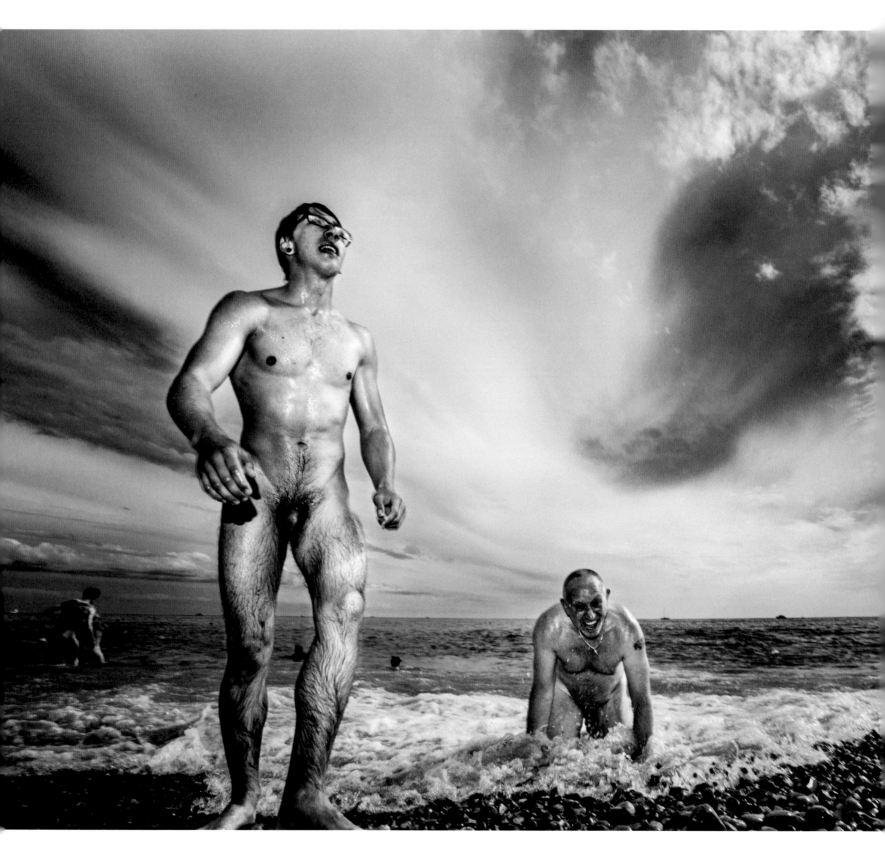

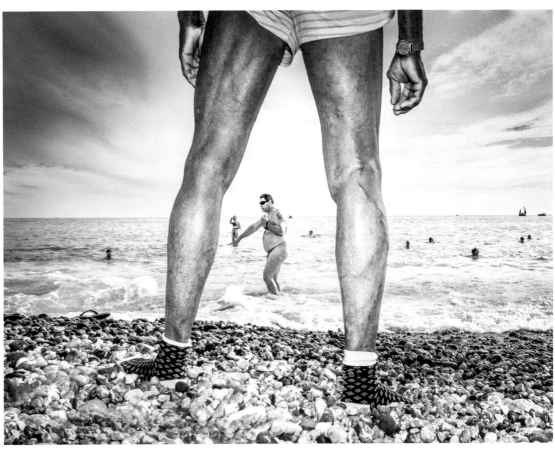

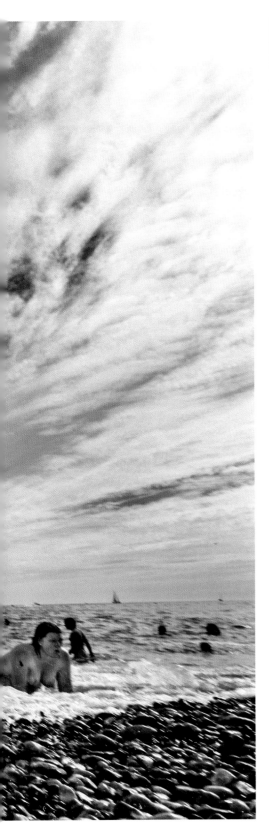

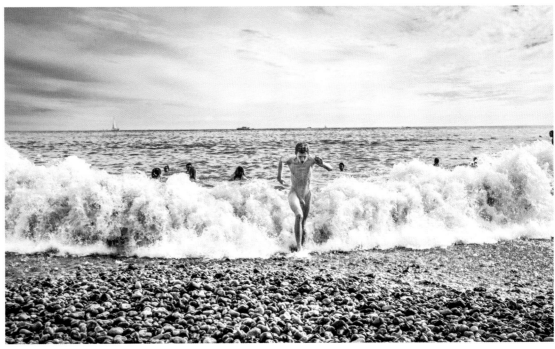

ARTIST DIRECTORY